ecstasy of the beats

ecstasy of the beats

beats

On the Road to Understanding

david creighton

THE DUNDURN GROUP
TORONTO

Editor: Michael Carroll Copy-editor: Jennifer Gallant
Design: Alison Carr Printer: TRI-GRAPHIC Printing Ltd.

Library and Archives Canada Cataloguing in Publication

Creighton, David
 Ecstasy of the beats : on the road to understanding / David Creighton.
Includes bibliographical references and index.
ISBN 978-1-55002-734-1
 1. Beat generation--Biography. 2 . Authors, American--20th century--Biography. I. Title.
PS228.B6C74 2007 810.9'0054 C2007-903544-2

1 2 3 4 5 11 10 09 08 07

Canada Conseil des Arts du Canada Canada Council for the Arts ONTARIO ARTS COUNCIL CONSEIL DES ARTS DE L'ONTARIO

We acknowledge the support of **The Canada Council for the Arts** and the **Ontario Arts Council** for our publishing program. We also acknowledge the financial support of the Government of Canada through the Book Publishing Industry Development Program and **The Association for the Export of Canadian Books**, and the Government of Ontario through the **Ontario Book Publishers Tax Credit** program, and the **Ontario Media Development Corporation**.

Care has been taken to trace the ownership of copyright material used in this book. The author and the publisher welcome any information enabling them to rectify any references or credits in subsequent editions.

J. Kirk Howard, President

Printed and bound in Canada.
Printed on recycled paper.
www.dundurn.com

Dundurn Press
3 Church Street, Suite 500
Toronto, Ontario, Canada
M5E 1M2

Gazelle Book Services Limited
White Cross Mills
High Town, Lancaster, England
LA1 4XS

Dundurn Press
2250 Military Road
Tonawanda, NY
U.S.A. 14150

For Carolyn

Contents

══

Acknowledgements

═══

The Beats earn abuse even now for their excesses, yet have given me perspective on issues of today — spirituality, hedonism, war, the environment — along with the pleasure of exploring their lives. So it was a labour of love to assemble this summation of what they seem to represent.

My thanks extend to several who knew the Beats and shared their views with me — Lawrence Ferlinghetti, John Sampas, John Cassady, James Grauerholz, Charles Plymell, Joyce Johnson, Jay Landesman, Ed Adler, David Amram, John Cohen, Peter Costa — but especially to Carolyn Cassady, the "Heart [of] Beat," whose guidance and hospitality I was deeply touched to receive.

For loyal support of this endeavour by The Dundurn Group, I'm grateful above all to Tony Hawke, Beth Bruder, Kirk Howard, Michael Carroll, Jennifer Gallant, Alison Carr, Erin Mallory, Ehren Cheung, and Debby de Groot.

Valuable help came from the Berg Collection's staff, Steve Edington, Paul Mahar, Michel Bornais, Roger Brunelle, Peter Robinson, Richard and Helene Gingras, John Ventimiglia, Jeff Spiegel, Joan Roberts, Barbara Johnson, Jerry Cimino, Rob Keefe, Pat Phenix, Mike Cartmell, Karen Holmes, Tracey Brink, Claire Wilkinson, Rob Sinding, and Andrew Rodwell. Thanks are due to Pat Upton for assistance with the book's maps. Special acknowledgement goes to Patrick Crean, the best writing teacher I ever had.

I thank my daughter, Melissa, for directions through cyberspace, also my wife, Judy, for total support regarding my project, text, and need to go on the road.

Prologue:

A Road Trip, a Road *Trip*!

═══

Manhattan, 2007

Here I was in a Greenwich Village club, January 2007, among students who had travelled across America from their upstate New York college. To San Francisco and around to here they'd gone, on paths of Jack Kerouac, to celebrate the publication of his novel *On the Road* a half-century ago.

I'd also visited places known to him and those crazy "Beats" — all the way to Morocco, actually — and now caught up with the kids at what was billed as an "Action Packed Evening of Wonderment." Local talent, some good enough to be on TV talk shows and *American Idol*, put on quite a show at the Bowery Poetry Club.

A girl did *The History of Western Philosophy in 90 Seconds*: okay, sure, the Beats also did some heavy thinking. "Zero Boy" gave a "vocal cartoon" of Kerouac and his sidekick, Neal Cassady, barrelling along in their car through thick and thin. A youth from the U.S. Merchant Marine (as was Jack) vehemently read a long poem in the spirit of Allen Ginsberg's *Howl*.

I loved a blond sketch comedian, Lang Fisher, who got laughs for insinuating lots of sex going on among the travellers. "So you're on a road trip, a road *trip!*" she burbled, then told about one taken with two other women into Kentucky: blowing a tire and seeing a guy cross the median in his black Trans Am to come to the rescue — "All right, ladies, I'm going to *help* you out!" — who then "spent three hours trying to figure it out" before conducting them to "this hillside crazy land" — trailers parked among trees, "like what *is* this place?" — but with spaghetti for all as the tire finally was replaced. Perfect: her tale was pure *On the Road.*

Notable in the show was vaudeville — clown acts, ventriloquism, audience interplay — so that all led up to Miss Saturn,

with wigs and sparkly attire and burlesque wiggles, who juggled something like forty hula hoops. The Beats loved the films of an "eccentric juggler" from vaudeville named W.C. Fields for his wheezy faux-genteel utterance — "I feel as if someone stepped on my tongue with muddy feet" — and flat-out wackiness. In *It's a Gift* he drives into a big reproduction of the *Venus de Milo*, then reflects that this object was to blame: "Ran right in front of the car!"

A student, Witt, afterwards told of his pleasure at "seeing America in one go," and now of an urge to read William Burroughs. What was he like? Like those onstage here, I replied, telling how he used the term *routines* to describe the bizarre scenarios of *Naked Lunch.*

Miss Saturn exemplifies a revival of vaudeville, adored by the Beats for its zany messages. Jack Kerouac's father had a printing operation that promoted vaudeville performers.

So I got interviewed — a course requirement, it turned out

— and pontificated on the Beats' quest for this very "wonderment." I tried to get across their wish for it on an upper level of ecstasy. The right to ecstasy is taken for granted now, but it wasn't then. All were expected to subjugate such joys to a higher cause — the Second World War and later the Cold War — though the Beats, controversially, went their own way.

So did many others, of course, but the Beats stood out for being inspired by great authors — Fyodor Dostoevsky, William Blake, Arthur Rimbaud, Marcel Proust, James Joyce, T.S. Eliot, William Shakespeare — and for becoming writers themselves with new expressive modes. They believed in the power of words.

I mentioned Johnny Depp's *Rolling Stone* piece, "Kerouac, Ginsberg, the Beats and Other Bastards Who Ruined My Life," about having a favourite Peter Frampton record thrown out at age thirteen by his brother. Forced to hear Van Morrison and thus to fathom "words that meant something," Depp smartened up and went on to the Beats: "Kerouac's train-of-thought writing style gave great inspiration for a train-of-thought existence — for better or for worse."

When Witt had enough on tape (me not getting to W.C. Fields), he explained about his enterprising little State University of New York in Potsdam. It happens to be not far from the St. Lawrence River where Kerouac's forebears had long resided. Some are likely to have been fur traders who once took paths far westward, as did the students.

The Beats, discoverers all, are perpetually rediscovered. Nine biographies have been written about Kerouac, Barry Miles titling his *King of the Beats* — yet no prince was he, but a pauper by choice. In *Visions of Cody*, Kerouac's alter ego Jack Duluoz testifies: "I accept lostness forever. Everything comes to me because I am poor." Unwontedly rich through the success of *On the Road*, he nonetheless called for "Dharma bums" to go questing with only the bare essentials in their backpacks.

Through the Beats we reach beyond our media-dominated age to a time when the imagination fed on great books, visions, deep discussion, raw experience, and family lore. Conservativism now, as in the 1950s, misconceives the Beats as slackers despite the astonishing scope of their effort. Neo-conservatives and neo-Beats will forever

square off, I suppose, arguing human-priority questions posed centuries ago by Jesus and Buddha.

None of the Beats were alive for the students to meet, Kerouac and Cassady having died in the 1960s, and Ginsberg and Burroughs thirty years later. Yet Carolyn Cassady, Neal's former wife, flourished still, and a 2005 visit to this gifted woman in England started off my own project — to tell straightforwardly who the Beats were, in a twentieth-century milieu now increasingly hard to fathom. Here's the tale of their adventure, and mine.

Go for Broke

Bracknell, England, 2005

U nder an hour from London, England, by train is a town, Bracknell, from which I continue to what Carolyn Cassady described as "a real woodsy road." Here among small postwar homes is a lime-green bungalow opened to me in May 2005 by this tiny woman, still attractive at eighty-two.

Famously, she was the lover of both Neal and Jack — and no shrinking violet upon moving to England in 1983. Well recognized here for marriage to that supremely free-spirited man, she's now close to a blithe Irish rocker named Bap Kennedy. The bathroom is marked by a sign reading VAN MORRISON'S DRESSING ROOM — liberated for her by Bap, a friend also of that singer. "They told me he is an ardent Kerouac fan," she tells me.

That ardour was felt by many rock stars — Bob Dylan, Jim Morrison, Janis Joplin — and Kerouac spoke of being contacted by John Lennon to explain that "beat" was part of his band's name and concept. "He was sorry he hadn't come to see me when they played Queens," said Kerouac (referring to the Beatles' first 1965 U.S.

concert at Shea Stadium). "I told him it's just as well, since my mother wouldn't let them in without a haircut." Nice story, Kerouac.

Bap recently asked Carolyn if she would do a background reading on a CD for his song "Moriarty's Blues." The passage is from her acclaimed 1990 memoir *Off the Road: My Years with Cassady, Kerouac and Ginsberg*. This was done at a studio also used by Van, she "taking photos every inch of the way" for her offspring — Cathy, Jami, John, all fans of the singer. She did the first chapter's ending in one take, "a cool sax" at the end. Now here's a souvenir of that fun, the sign, with a big red kiss planted on its plastic cover by "a crazy Irish girl friend."

The passage is about Carolyn's first meeting with Neal Cassady. Generally, I trust her version of things, and yet, asking where she first met Kerouac — a Denver bedsit she shared with Neal, *On the Road* indicates — I learn that she can't remember. "How unreliable memory is about some things," she concludes.

Scholars are even more removed from the past, and it's shocking to leaf through biographies in her living-room bookcase and note her acid corrections. (In one, about Neal's wish to put his "pretty body" on display: "Where do you get this stuff? These absolutes?") Carolyn starts clanging something discovered on a shelf. "Ginsberg's finger cymbals," she says, laughing. "Where's that prayer thing?" What a house: I wonder if one of Kerouac's lumberjack shirts will show up somewhere.

She puts on a video of herself being interviewed at a Prague conference on the Beats. It makes us laugh, having been shot by someone with a mini-camera attached to his head. The thing slips partway through to give a skewed angle, so that abruptly she's seen sideways and apparently down on the ground.

Yes, in Prague they love the Beats — and notably did so in Iron Curtain days when Ginsberg was crowned there as King of the May. Those in repressed or developing countries find in the Beats an example of liberation. Confabs about them are held as distantly as in China, where the young want to learn from them about mobility and choice.

Putting on Janet Foreman's documentary *The Beat Generation: An American Dream*, Carolyn responds as if at a ball game between hometown heroes and bums. Con man Herbert Huncke talks about

1: Go for Broke 17

heroin, and she asks, "Who cares about these people, ugh!" But she admits that Kerouac "was so interested in how Huncke got that way" — an addict and a thief — as to present him as someone "not ready for the scrap heap." We see the Beats at Columbia University, drawn to such underworld types.

Burroughs comes on, a Harvard grad older than the rest, whose avenue to ecstasy was through drugs. "Stupid" and "boring," says Carolyn — who has tried drugs, and is tolerant by nature, but fears loss of control. So did Burroughs, actually, decrying control mechanisms whether narcotic or political.

Ginsberg appears, amusing Carolyn with talk of the term *fiend* used to demonize: "dope fiend" and so on. But when footage of him reading the "Moloch" section of *Howl* begins, she hits the mute, exclaiming, "That's enough!" This gloomy part impresses many, she allows, but is too facile. "Everybody knows what's wrong, for Christ's sake. In all the media now is this negativity, and it's not productive or life-enhancing. Go for something good that's going on."

We come to Kerouac with Steve Allen on prime-time television in 1959. "And right now we'll look into Jack Kerouac's *On the Road*, and he'll lay a little on you," says Allen, tinkling a soft jazz tune on his white grand piano. The guest then flawlessly reads *On the Road*'s sublime concluding passage that ends: "I think of Dean Mor-i-ar-ty."

My tears arouse Carolyn to ask sternly, "What are you doing?" I withhold reply amid an interplay of strong emotion. She disappears to find a late photo of Jack — alcoholism's effects tragically evident — taken by a Long Island friend. "Doesn't that say it all?" she murmurs. "I cried when I saw that."

Farther on, someone is heard misdiagnosing Neal's early demise. "No, he *didn't* die of exposure!" Talking heads continue to arouse fury: "They're so unenlightened! Taking themselves so seriously!"

A scene near the end provides the only footage I've yet seen of Cassady's famed spontaneous rap. July 18, 1965, San Francisco's City Lights Bookstore: "Ginsberg was being interviewed, Neal just happened to show up." For that he received a third of the $250 Allen got for it.

Afterwards I replay the segment, fascinated by Neal's body language. That quick but relaxed wave of a hand, as if to greet someone

or swat a fly — I seem to recall such gestures made by characters known back in childhood. The same for the assuredness with which he leans back against a bookcase, hands planted against the sides of his head. Also a certain Charlie Chaplin rolling thrust of the torso. The way his eyebrows variously flick up and down, form an arch, give a sudden frown: broad mannerisms from long ago, vaudeville times.

The charisma now becomes more evident. As for the voice, I labour to write down what the man says, not comprehending but impressed by the jazzy rhythm of his delivery:

Neal: Well, all the extremists, all the civil rights, all the kids, anybody in any extremes —

Allen: On *both* sides?

Neal: On *every* side, that's right — we have a panoramic view of this thing, the earth's going to tilt a little bit, natural catastrophes are happening everywhere, all the forms are dead — I mean you can handle — say you talk to a policeman, you know — I came in here yesterday and a gentleman took me around and I looked like I'm high so I just let people think I was high. Everything has forms, everything is known and everything's changing and there's no *life* in the forms. Life goes where the forms are, you see, and I'm going to have to — all this is *hind*sight that you're talking about, it's already too late, the Pentagon is taking care of it all, we're doing this *deliberately* as far as that goes —

This very linguistic flow transformed, by example, Kerouac's writing. Few realize that his first novel, *The Town and the City*, chronicled a middle-class family's life in a heavy literary manner. *On the Road*, a much rawer book showing life as wild, confused,

outrageous, perverse, foolish, chaotic — the way it often turns out, that is — was written in the freer style of Cassady's letters to him.

Eminent U.S. critics in 1998 placed this slightly fictionalized adventure tale fifty-fifth among the last century's most important fictional works. It changed how people viewed the world, says Carolyn. "It's wonderful how he celebrates all kinds of human beings, life in every form, the tiniest American place. Jack thought about things and saw individual lives — that's really what turns everyone on."

I've gained a belief that this love for immediacy, this delight, was shared by the other Beats. Ginsberg might have spoken for all when he said, "Life should be ecstasy."

Afterwards I come upon a poignant still life of hers, *Railroad Blues*, detailing items linked with Neal's job as a brakeman and conductor with Southern Pacific. Despite a rowdy car-stealing youth, he long strove for the respectability of owning a home and fulfilling parental duties — benefits coveted along with a life of the mind. The woman globally known as "Queen of the Beats" bore his children while continuing her artistic pursuits; one of her oils here portrays Jami in ballet costume: "All afternoon at her dance lessons, and I went to every practice."

Here's her 1952 photo of Neal and Jack hugging each other in front of the Cassadys' San Francisco home, taken soon before Neal departed on a long railway shift with a suggestive remark about leaving the two alone. Irritated by this affront to monogamy, and more so by his clear-cut blessing on an affair, she initiated one — perhaps the best known of all Beat experiments. "I wasn't in favour of sharing my affections with two men," she tells me. "Neither of them knew how to arouse a woman, and Jack was apologetic. But I liked all the hugging, never had it as a child." So much for those *On the Road* studs.

She asks whether I'd like to hear the audiotape this pair made in 1953. Hey, is the pope Catholic? "The master tape," she explains, "it's all I have since somebody nicked the copy."

Carolyn gets the tape into the player backwards, then correctly, but believes that she has to rewind it. A wrong button is pressed and the BBC's Saturday afternoon jazz program comes on. Now she would rather hear that. Also, by family parlance she notes that

"the sun's past the yardarm" — meaning our afternoon wine session is overdue.

Later she does manage to get the tape going, and laughs to hear her husband cry "Yeaaah" while Kerouac reads from his novel *Dr. Sax*: "Shows their mutual appreciation of each other, how Neal supports Jack." Here's Cassady reading some Proust, and Kerouac doing some scat singing. A dream departure back to 1953: "There's some Miles Davis on this — Jack was by himself, his eyes were closed — it's our song."

The extended dialogue in *Visions of Cody* that Jack transcribed — where might be the tape for that? "We kept recording over the same tape to save money," she explains. Little more than this treasure now remains, hanging by a thread.

We have dinner at my hotel's restaurant and then, waiting for the taxi, see a falling star. This leads us to talk about Cassady's own flame-out, dying mysteriously in Mexico. His son, John, dug up a story that Neal, near the end, would have upon his shoulder a parrot,

Carolyn Cassady dines out with me, happy to take a break from writing her autobiography, which is certain to become a classic about the Beat era and possibly the last by anyone who lived through it.

gifted at imitating his rap. We laugh over this, though regretful that no recording of the bird's feat was made.

A two-year jail term for marijuana possession ended Cassady's railway career, much disorienting him, and he and Carolyn divorced in 1963; neither of them ever remarried. Not conventionally religious, Carolyn never thought of the Beats' unorthodox behaviour as sinful — which Jack and Neal did, being Catholic-trained — and never antagonized LuAnne Henderson, Neal's first wife, who ever remained close to him.

Her tolerance of Neal's pleasure-seeking is revealed by a new 490-page volume of Cassady's correspondence, superbly edited by scholar Dave Moore. But in a January 1966 letter she asks that Neal no longer casually drop by, having shown John "that the life here that you rejected is for the birds — that any discipline, school work, self-improvement, efforts for the future, respect for rules, me or the law is asinine." This is more like the woman I've gotten to know, firm of conviction, and John turned out to be a sunny individual loved by all.

Prominent in Neal's final years was the strip-dancer Anne Murphy. Carolyn has a professional photo of this dazzler in costume with a long bare midriff and flashing smile, inscribed, "To Carolyn with *love!*" The world of showbiz.

"Highly sexed, so she didn't need arousal," she reflects. "Neal's 'healing sex,' holy cow — Anne wrote about it beautifully."

In childhood Carolyn spent hours copying Varga pin-up girls, "to the consternation of my mother, who saw them as sex symbols." Burlesque shows don't demean women, she feels: "What better way to use their ultimate God-designed physical form than to share it with lots of people, not just horny men as prostitutes?"

On the Road's second page shows an avowal by Neal ("Dean Moriarty") that "sex was the one and only holy and important thing in life." Carolyn regards the body as "a marvellous instrument" (having drawn it since being "old enough to hold a pencil") and the genitals as "our most spiritual connection with creation." Yet it is the mind that matters, she argues, believing Burroughs and Ginsberg to be "stuck below the belt. So infantile."

What positive benefits were in her marriage, beyond the

excitement and children? "I learned from Neal," she says, "that you don't have to let anyone else tell you how to think and feel."

On another visit, I ask whether the Beats might be comparable to England's Romantic poets — the drug-addicted Burroughs as Samuel Taylor Coleridge, Jack the self-documenting William Wordsworth, Allen as Percy Shelley (though also emulating William Blake), Neal as Lord Byron, Carolyn as that womanizer's respectable wife — and all espousing "the language really used by men" as championed in *Lyrical Ballads*. Does that make sense?

I get an unqualified yes: "The Romantics were typical Beats, all rebels against convention and despised by the social order." To be a writer, and "naughty," made up the essentials. "Shelley offered Mary to his friend, and in San Francisco it was similar." So there we have it.

The Beats looked to the future but also to the literary past. Many admire Burroughs for a post-modern kind of irony, yet his favourite poem was that staple of valedictory orations, Alfred Tennyson's "Ulysses":

> I cannot rest from travel: I will drink
> Life to the lees: all times I have enjoyed
> Greatly, have suffered greatly, both with those
> That loved me, and alone …

We look at a BBC videotape about the English Romantics, *Pandaemonium*, in which the Coleridge character is dynamically played by Linus Roache — in Carolyn's view, the perfect actor to represent Neal. It's the facial mobility she likes, as shown also by Laurence Olivier and very few others. Hollywood has chosen Nick Nolte, who on these terms is entirely wrong for the role.

Carolyn is in a book club, five books at a pound each and also another at the proper price — for which she chose Jude Morgan's *Passion*, about women involved with Romantic poets. "Well, of course, Coleridge was a drug addict," she reflects. "Byron as Neal Cassady, I was noticing the similarity — lots of Neal in Byron, except that he didn't write poetry."

Carolyn became absorbed in the women's interconnecting tales,

from a family standpoint: "They were always breeding, Byron's half-sister, Augusta, ending up with six kids. Byron picks up a child and says, 'What a likeness!' That is, his own — and in front of everyone." The Byron/Shelley story vis-à-vis that of the radical Beats, she avers, is "just as bad if not worse."

Romantic poets tend to die young, and both Neal and Jack left this earth in their forties. Ahead were the documentaries and biographies giving so many stereotypes, distortions, lies. "Our little private togetherness," Carolyn reflects. "The most personal, intimate time of my life — now it's an industry and I hate it." An industry run largely by academics who are comfortably off, unlike this discerning woman happy for any gigs that come along.

Strange that those long-ago Romantics are deemed just fine for high-school English, and the Beats, often, as inadvisable. Their themes were equally subversive, just about. And both speculated freely regarding out-of-space existence, Wordsworth's "Ode on the Intimations of Immortality" evoking some perfect place visited by human souls before entrapment in mere flesh, as conceived by Plato:

> Our birth is but a sleep and a forgetting:
> The Soul that rises with us, our life's Star,
> Hath had elsewhere its setting,
> And cometh from afar:
> Not in entire forgetfulness,
> And not in utter nakedness,
> But trailing clouds of glory do we come
> From God, who is our home …

For Wordsworth there are glimpses of that perfect place, memories, possible within ordinary life. We then go beyond the humdrum into ecstasy — *ekstasis* in Greek, meaning to stand outside our usual self to sense the great beyond. Our true home is thus spiritual. Here's the "Oversoul" avowed also by that pillar of American Romanticism, Ralph Waldo Emerson. The prophet-healer Edgar Cayce spoke to Carolyn and Neal in these terms. "We're all ideas in the mind of God, as Cayce said," she remarks. "More at home out of the body."

If so, where might Cassady be now? Working out his karma in another life, as do we all, she's sure. The two gained readings of previous incarnations, Neal sobbing to learn of the horrendous lives he'd previously had. "On the way to becoming enlightened I'm supposed to have had 196 lives — three with Neal, only one with Jack," she reflects. "Jami, John, and I were together many times. It's lots of fun to speculate."

For Carolyn such thinking gives a stepping-off point to clear-cut forms of belief. Readable at a sitting, says she, is a volume precious to Neal during his imprisonment: *Lessons in Truth*, "a slim tiny little book, but it's all there." Here is a new edition acquired while with a congregation of the Unity denomination at Maidenhead in Berkshire; an older one gave her and Neal many of the answers they sought: "We were up all night talking about it, then did researching on our own."

The author, H. Emilie Cady, is described as a medical doctor whose book "has been inspiring people since 1894." It states views often given to me by Carolyn: that God is not "a big personage or man somewhere in a beautiful region in the sky, called 'heaven' … nor is He a stern, angry judge…. God as Spirit is the invisible life and intelligence underlying all physical things…. There is but one Mind in the universe." Christian metaphysics, very much on that theme, offers "the Bible as the story of mankind's spiritual evolution."

There's a thicker book, her treasured *Metaphysical Bible Dictionary*, that "provides all the symbolism." On the deck overlooking Carolyn's garden of Zenlike simplicity, tall trees all around, she lights up one of her thin brown cigarettes, rearranges flowers afloat in our table's miniature pool, and opens this Unity School of Christianity volume. Here's what I had hoped for: a near glimpse of the Beats' search for spiritual wisdom.

In a quiet, emphatic voice she reads the entry for "Herod," signifying the dominant ego: "temporal because it does not understand man's true origins or the laws of man's being. It is narrow, jealous, destructive." The appeal of this interpretation seems clear, Carolyn having often been at the mercy of such dark forces. Yet in spiritual glory, we must assume, lie *man's true origins*.

Carolyn and Neal had a trial-and-error approach to religion, as in so much else. Kerouac favoured instead the long-established Buddhist faith, as did Ginsberg and Burroughs. Eastern religion became popular largely through their influence, though Jack was in Carolyn's view not a logical thinker, but drawn to Buddhism mainly in its poetic aspects. And he had little use for Cayce's views, making for a theological split among these close friends.

Both Jack and Neal were raised in Roman Catholicism. Carolyn likes its avowal of tradition, "love thy parents" and so on, but scorns deviance from Jesus and his teachings: "I wonder how many Bible thumpers ever read the Sermon on the Mount? Catholics slaughtered everyone who tried to." Neal did go beyond Catholic dogma, she feels, "to believe that God is just energy, not a person."

And Quebec Catholicism at least led Kerouac toward a pursuit of the spiritual: "Most of the time he was searching and would ask, 'Is this holy, is that holy?'" Those finding holiness gain spiritual ecstasy, entering a kind of trance in the presence of the sacred. Salvation Army worship early in my life gave a sense of this in "holiness meetings," music and the spoken word leading the soul ever upward.

On my last visit, Carolyn tells of departing from the United States in 1983 to claim a life of her own: "I just wanted to live it up." She stayed at first in the London residence of multi-faceted Jay Landesman and his songwriting wife, Fran, making for smooth entry to Soho clubs like Groucho's. "You've got to meet Carolyn Cassady," Jay would remark to the likes of Yoko Ono and Bob Geldof.

On the sleeve of Jay's memoir, *Rebel Without Applause*, he and Fran are shown as a couple shimmering with laid-back sexuality. "For the Divine Carolyn," says the inscription, "who was there with her support before anyone else — and here we are in London and enjoying ourselves — wow! What a life — Love, Jay."

Carolyn had bought a subscription to Jay's small magazine, *Neurotica*, "trying to be hip." He and Fran wrote a musical, *The Nervous Set*, based largely on his experience with the Beats (and those bogus spinoffs called beatniks). The cover for its album of songs has a Jules Feiffer cartoon of a dancer in jeans and scarf, beatnikly snapping his fingers to some internal tempo.

Off we go to the Yorkshire Rose pub, where Carolyn is recognized by an adulatory young bartender from Portugal who well knows the Beats: perfect. Having had an extra glass of wine or two at home and the same here, we get into a very good mood over this attention.

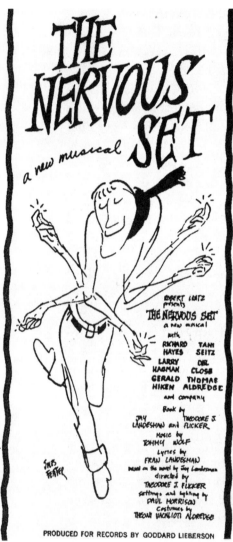

Again the Landesmans come up. "Overwhelmingly generous, the Jews," says Carolyn. "Jay — his stance, brilliance, sparkle, sense of decency, uncanny insights — and giving all the time!" She asks what you call a master of seduction. "Don Juan, right — that theatrical thing."

Abruptly, she turns morose: Jay's not going to be here much longer (he's eighty-eight) and perhaps I'll never get to know this special man. "Every individual is unique, every blade of grass; you're unique, I'm unique, he's unique."

I submit that Jay carried forward something of Kerouac — and Carolyn, often irked by my note taking, commands, "Write that down! Repeat it!" So I do, as she expands upon this: "Jay declared his freedom from American materialism. We both found in London a higher sensibility — I knew it before I came, not sure that he did. And I'm so happy anyone cares about Jay!"

She's exalted, finally letting her true soul appear: "Such a

The songs for The Nervous Set *were "tailored to the assorted beatniks, squares and snobs who populate the three acts," said* Variety. *"The appealing hero and heroine are storm-tossed between the wacky world of the editor's milieu and the sane domesticity the girl craves." One like Carolyn Cassady, no doubt.*

showman! To every interviewer I told about Jay! He's the most im-
portant feature of my living in England!" Praise for this monarchical
land flows: "I love all the pomp and ceremony — that gold coach, the
young men, the discipline." And so unlike mere hippiedom.

"Give us joy in life — like fairy stories, Cinderella and all that. In
comparison to America, where there's nothing to hang your dreams
on!" Only the Indians are "totally romantic," she states. "There has to
be beauty!"

I ask whether she means they are *transcendent.* "Above politics,
certainly," she says. That was Kerouac's stance. "He wanted to be
the greatest writer since Shakespeare! But his sensitivity and open-
mindedness and notions of sin — they ruined him, and all that was
accentuated by being misunderstood."

Here's the best moment between us, spoiled when I venture a
question about respectability. "You bring me down," says Carolyn
angrily, calling me a "journalist." But afterwards she exults: "It was
like old times! Go for broke!"

I'm reminded of Kerouac's well-known *On the Road* credo: "The
only people for me are the mad ones, the ones who are mad to live,
mad to talk, mad to be saved, desirous of everything at the same
time." Those rash words are now elevator music in any discussion of
the Beats, yet Carolyn has breathed new life into them.

Back home, she brings out a crumbling scrapbook from her
youth, romantic visions revealed by newspaper clippings pasted on
the inside cover: "Dining and Dancing," "Monte Proser's Copaca-
bana," "Cotillion Room/Hotel Pierre." Also "Ration Menus for the
Week" and "Loose Talk Costs Lives": wartime New York in 1943,
spent by Carolyn on college credits gained through theatre-fabric
research.

"My greatest New Year's ever was that year," she recalls. With
friends she went to Manhattan nightspots and ended up where
Guy Lombardo provided the music. "We'd all made fun of him, but
he was wonderful to dance to." Later she was escorted by brother
Chuck to the graduation dance held in town for U.S. Navy Reserve
midshipmen: "All the white uniforms!"

On a St. James Theater playbill for the new musical she at-
tended on research assignment, *Oklahoma!,* the credits appear right

after a Camel cigarettes ad showing a Flying Fortress bomber amid smiling, bullet-wreathed gunners. I made balsa wood models of such warplanes during the war, gleeful about combat, but now those smiles seem unlikely.

Carolyn's forthcoming autobiography will tell of her war effort, giving therapy to wounded servicemen. Victory came, of course, through nuclear means. "The atom bomb knocked us out. It was an unbelievable thing," she reflects. "I don't want to know anything about war. We understood what was wrong with the world."

Here are snapshots of Carolyn at a friend's home that Easter: the two posed seriously against bare tree branches, then making moustaches out of their stoles — and she alone, laughing, a blond beauty full of life. "That was a great time to be in New York, I can tell you."

"Beat" is taken to mean exhaustion in the low-life sense lent by Huncke, known for his hip way of pronouncing the term. Now I see connotations of vitality, inner strength, defiance. Against dull demand, going for broke.

Yet is that simply Carolyn's take, inapplicable to the Beats as a whole? When I first met her, in Paris, taking questions about *Off the Road*, someone asked whether any current group had the same energy. "I hope not," she replied. And then added, of the example set by Neal and his friends, "Not my idea of role models — these were pretty destructive people."

Big minuses alongside the pluses: that's only to be expected. We say goodbye, and I go on to trace old paths of the Beats in New York, where in that wartime year of 1943, coincidentally, they first came together.

Put Up Your
Dukes and Write!

===

New York City, 1940s

2

COLUMBIA UNIVERSITY

This summer of 2005 brings news about the Christie's auction house sale of a 1957 letter by Kerouac, proposing to Marlon Brando that he buy film rights for *On the Road* — the star taking Dean's role while Jack plays himself: "Come on now, Marlon, put up your dukes and write!" Brando never replied, and now, after the actor's death, this missive is sold for $33,600.

The plot would have to be compressed "into one all-inclusive trip," said Kerouac, "one vast round trip from New York to Denver to Frisco to Mexico to New Orleans to New York again." That's roughly how I've planned my big cross-continental Greyhound ride along Beat pathways in July.

From Canada by bus I travel to Buffalo's terminal, buying an Ameripass there, and continue east. With a single wee-hours stop for snacks at "Great Bend U.S.A.," my overnight trip to New York takes

less than eight hours, and for this I commend the athletic-looking young black driver. "One cup of coffee," says he, pleased by the attention. "Get your proper rest, that's what does it. Pays the bills!"

From the Manhattan depot I head right up toward Columbia University. Just off-campus at Riverside Church, Carolyn told me, her brother Chuck's Midshipmen's School graduation exercises were held in February 1943: "All the guys in uniform — and all that hoopla of USO shows and war bond sales!" A few women from her college, Bennington, did their bit in the war by going off to be camp followers: "They thought it was terribly patriotic!"

Kerouac, a Columbia hanger-on, was immersed in writing. He cited his literary idol, novelist Thomas Wolfe, in a letter written that January to hometown friend Bill Ryan, for a focus upon "the essential and everlasting America, not the V-for-Victory America." Authors during wartime "have to combine both Americas," said he in this message never mailed — Ryan having died in the South Pacific.

Early in 1943, Jack began seeing a leggy Detroit girl named Edie Parker. Her boyfriend, Henri Cru, who had become his friend at the Horace Mann prep school, casually asked him to keep an eye on her during a U.S. Merchant Marine stint. Edie in 1987 recalled, to journalist Gerald Peary, Cru's exact words to her: "I want you to meet a most wonderful genius writer." That she did, and later, taken out by Jack, she famously bowled him over by downing six sauerkraut hot dogs. The pair promptly became lovers.

Thus originated the Beat Generation. For through Edie he met Lucien Carr, a wild eighteen-year-old from St. Louis, who in turn introduced him to Ginsberg and Burroughs. "Lou was the glue," Allen would often say. Sardonic and troubled, Carr at the University of Chicago had mimed suicide by placing his head in an unlit gas oven — as a performance, he told one psychiatrist. Jack shared with Lucien a playfulness (once being rolled by him along Broadway in a barrel) and a passion for French literature, fostering what they called a "New Vision."

Beat historian Ann Charters, in her introduction to *The Portable Beat Reader*, gives Carr's take on this. "It was a rebellious group, I suppose, of which there are many on campuses, but it was one that really was dedicated to a 'New Vision,'" he states. "It was trying to

look at the world in a new light, trying to look at the world in a way that gave it some meaning. Trying to find values … that were valid. And it was through literature all this was supposed to be done."

Edie, asked by Peary why Kerouac fell in love with her, replied, "I was gorgeous then. Also, I was tomboyish. Nothing ever shocked me." At least as readily as the males, she went for broke. Carolyn suggests a lack of mental balance, adding that no publisher was found for her autobiography, *You'll Be Okay*, because much was found to have been made up. Seeing a portion of this on the Internet, I notice some inaccuracy and yet also the ring of truth in her character sketches.

As for Carr, "his movements were like mercury over rocks. His eyes were slanted — almost oriental — and pure green. So green they dazzled you." Lucien in art class "was very intent on his work and noticed nothing else. All of a sudden this dishevelled boy lets out a loud long whistle saying, 'Not bad! Not bad!' admiring his sketch." Here's the trait that made Carr unique for Kerouac: never concealing what he felt.

Edie was adored by a gangster named Lucky who, when somebody at a bar merely said hello to her, stabbed this person. Forthwith she swore off such demented company. Much later she became a friend of Carolyn's but also a rival for Jack in retrospect, once asserting that she alone knew the angle at which he slept in bed. "We didn't sleep," retorted the Queen of the Beats.

Jack had come to Columbia in 1940 on a football scholarship and yet, as Carolyn states, was a "klutz" in comparison with Neal — inept at executing plays, though a superb broken-field runner. Next year he bolted to Hartford, Connecticut, with a vow of commitment to writing. Not earning enough for regular meals, he once fainted from malnutrition at a marginal job. But persistently he would brush cockroaches from his rented Underwood to write, certainly putting up his dukes in this high cause. Shortly, he returned to his hometown of Lowell, Massachusetts, and did sportswriting with the local *Sun*.

One day Jack conceived his "Duluoz Legend," forming "one enormous comedy" through interrelated novels modelled on Marcel Proust's, his reminiscences written on the fly rather than in a

cork-lined room. Proust died in the very year Jack was born, though an overlap of several months seems to negate any soul-passage.

Kerouac's people were close-knit in accordance with their ancestral French-Canadian custom. The father, Leo, was understandably keen to have his son rise at university and make good through remunerative toil, while raising children of his own. Leo hated war, as did most Quebeckers, yet valued the opportunities presented by America. Thus, to quit Columbia University could only be seen as perversity amounting to madness. Jack's doting mother, Gabrielle (or "Memere," Granny), suffered the early loss of a sainted first son, Gerard, and then supported the literary aims of this unusual second-born male through the manufacture of shoes.

Union Theological Seminary, up Broadway from Columbia, offered wartime accommodation then to Carr. Once, in his seventh-floor room, he played a record of the Brahms Trio No. 1 that unwittingly drew to his door a geekish youth living opposite: Ginsberg. "He was kind of Arab sheik looking with oily hair and watery eyes and he wore thick horn-rimmed glasses that he kept pushing into his face," Edie says of Allen. "He always told you what you wanted to hear — he had a canny, intelligent tongue and a sixth sense of how to win his personal war with life and you couldn't help but love him because you really felt he loved you too. But then when you left him you had doubts."

This New Jersey–born radical, then writing poems in an Edgar Allan Poe style, wished to meet a real writer. Allen was advised by Carr, early in 1944, to visit Edie's off-campus apartment for a chat with her ever-scribbling boyfriend, a kind of sailor named Jack. When not doing wartime U.S. Merchant Marine service, he lived either around the campus or, on weekends, in the New York suburb of Ozone Park to which his family had ventured.

Kerouac's 1968 *Paris Review* account shows Carr entering through the fire escape with a claim of being chased by killers, Ginsberg next with a load of books: "Sixteen years old with his ears sticking out," Kerouac recalled. "He says, Well, discretion is the better part of valor! I said, Aw shutup. You little twitch." Jack offered a beer to the budding poet (then eighteen, actually).

When Allen left the seminary for new premises (surely using

its 122th Street doorway), he said goodbye to every hall and stair.
Jack, who was accompanying him, acknowledged similar thoughts:
viewing his family at dinner made him feel like a ghost watching
ghosts eat their ghost food. Everything was a dream; therefore, said
Ginsberg, all should be tender with one another — and that shared
insight forged a lifelong attachment between the two.

On the steps of the seminary's library I chat with an adminis-
trator, mentioning Ginsberg's goodbyes, and am asked to repeat the
anecdote in all its details: "There are many stories about this place,
but I've never heard that one. I'll share it."

421 WEST 118TH STREET

Eddie Parker, living just off Amsterdam Avenue at 421 West 118th
Street, roomed with the extraordinary Joan Vollmer in 1943–44.
Her life being little documented thus far, of all the Beats she seems
the ghostliest. Joan had beauty, a husband named Paul Adams then
on foreign battlefields, a daughter born in 1944 (by a lover, but at-
tributed to Paul), and a growing drug problem eventually shared
with William Burroughs. "She was brilliant, good company," conjec-
tures Carolyn. "Inspirational both intellectually and personally —
and to be attractive to Bill Burroughs, that's something."

Burroughs first met Vollmer in February 1944 in apartment 62,
the two an odd couple in light of his homosexuality. Graduating
from Harvard University in English literature, he had travelled in
Europe and in Vienna had contemplated becoming a psychoanalyst,
yet never channelled his intellectual gifts along such paths. In 1939
Burroughs was ousted from Manhattan's Taft Hotel upon being
found in bed with a teenage male hustler, for whom he later cut off
his own left little finger's last joint as proof of fidelity. (Arthur Rim-
baud, admired by the Beats, was similarly lacking a finger — shot off
by his lover Paul Verlaine during a quarrel.)

Now, at thirty, Burroughs completed the primary Columbia
group of what became known as Beats. Edie saw him as "a com-
bination of Sherlock Holmes, Wyatt Earp and Abraham Lincoln

— dressed like Holmes, fascinated with guns like Earp and is kind
and soft speaking in expressing his thoughts like Lincoln. And is
sexless like all three."

Carr had been followed to New York by David Kammerer, his
muscular scoutmaster back in St. Louis. Thought to have had ho-
mosexual motives, he was drawn by some force to wherever Carr
attended schools — Massachusetts, Maine, Illinois, and now here.
Carr's fatal appeal was to be good-looking in a sexually ambigu-
ous way. Kammerer "never had time to zip his fly," Edie recalled.

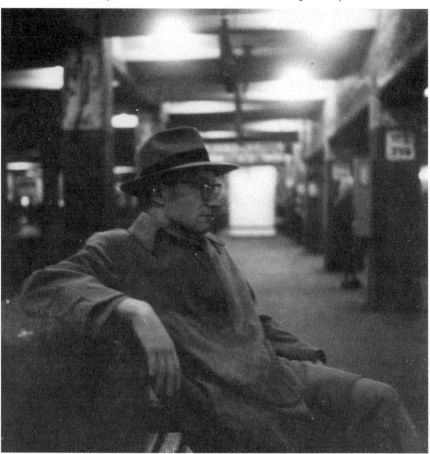

*Who was this poker-faced man in suit and tie, the drug-addicted writer who (accidentally, it
was thought) shot his wife? A man able, for good or ill, to state exactly what he felt. William
Burroughs at rest in a New York City subway station in 1953. Photograph courtesy of the Allen
Ginsberg Trust.*

"Breathless when he spoke — wringing his hands in full speed anxiety. And all this directed at Lucien, 1/2 his age. He drove us all to silence because all he ate and breathed was L."

On August 13, 1944, Kerouac and Carr tracked down the *Robert Hayes*, on which they hoped to sail for France and thereby witness the liberation of Paris. Barely thwarted in this aim, they headed uptown, and early the next day, at apartment 62, Lucien shook Jack's arm to declare that he had stabbed Kammerer to death in Riverside Park with a Boy Scout knife and pushed his body into the Hudson River.

Kammerer is thought to have been in the throes of desire, threatening to murder this youth soon to be out of reach in Europe, but was slain instead. What really happened? Carr's early 1950s girlfriend, Liza Williams, heard a mild account from the man himself, which she paraphrased in the *Rolling Stone Book of the Beats*. It began in the off-campus West End Bar, said he:

> Finally one night I was drinking with Jack, and David came in and I couldn't take it any more. I told David I wanted to talk to him and he should come with me down to the lawn by the river where it would be quiet. We went down there and he reached for me, I went mad and took my pocket knife and stabbed him.

Carr gained Kerouac's help to dispose of Kammerer's eyeglasses (in Morningside Park near the apartment) and later turned himself in, reading Rimbaud until the Coast Guard found the body. He was taken to a lower Manhattan prison, the Tombs, and Kerouac was transported to a Bronx jail as a material witness for not having reported the crime. "I only watched him bury the glasses," Jack declared.

Kerouac was hurt that Leo wouldn't put up the bail money, though Edie agreed to have her family do so on the condition that Jack would marry her. Leo and Memere came to visit, forgiving him for this misstep. The newlyweds travelled to Edie's home in Detroit's wealthiest suburb, for what turned out to be a short-lived union.

Charges against Kerouac were dropped, while his friend re-
ceived a penitentiary term for manslaughter, serving two years until
paroled. Only now, with Carr's recent death after a distinguished
career with United Press International, is the defence plea likely to
bear close examination. No alternative story to his own was ever
advanced, nor did proof arise that the victim had stalked him —
or was even homosexual. The unstable Carr, who got Kammerer to
write essays in his name at Columbia, may himself have been the
manipulator.

Burroughs, also arrested for failure to report but bailed out by
his father, collaborated with Kerouac on a murder mystery of simi-
lar incident, *And the Hippos Were Boiled in Their Tanks*. Ginsberg
read some of it aloud, stumbling over the phrase "naked lust" so that
it came out as "naked lunch." Kerouac at once seized on this as an
effective book title and Burroughs, of course, so employed it.

How far above the norm, those early Beats asked, may superior
persons go? Fragments of an unpublished novel by Ginsberg (now
in the Stanford University Library's Special Collections) show Carr
as the eccentric Claude de Maubri, contemptuous of leftist views
held by Goldstein (Allen), who shouts, "My multitudes," and Claude
replies, "Your rabble."

419 WEST 115TH STREET

In September 1944, Joan Vollmer moved to 419 West 115th Street,
taking apartment 35 (no longer existing as such, its large space hav-
ing been subdivided). Soon she was joined by Edie and hence by
Jack, close friends who happened to be still married. Here as well
was Haldon Chase, a Denverite who would bring Cassady into the
mix (and who later would so disavow Beat associations as to bring
out a rifle when Kerouac biographer Gerald Nicosia approached his
home).

A mutual journey into the arcane has bizarre moments as in
November 1944 when Kerouac, self-consciously the Artist, formed
a string tourniquet on one finger to extract blood for writing on a

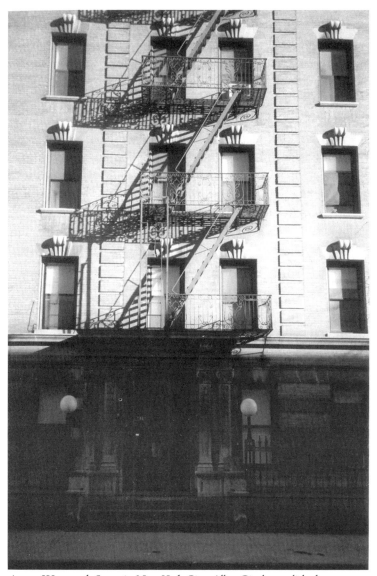

At 419 West 115th Street in New York City, Allen Ginsberg relished apartment 35's family mood — sleeping together, pooling resources for food, conducting encounter sessions — in what might later have been called a crash pad.

card. "Blood," he inscribed, using this fluid, and in ink he added, "The Blood of the Poet." On the back he also wrote in blood a line from Friedrich Nietzsche: "Art is the highest task and the proper metaphysical activity of this life." The New Vision thus survived in tandem with desire for Carr's girlfriend, Celine, at a time when Edie began living with Jack again. All were living *in extremis*.

In March 1945, Kerouac wrote sister Caroline ("Nin"), whose first marriage to a local Catholic had been annulled, to speak of happiness felt here and dullness at home. Leo and Memere had adjusted to American life and now coped with a shift from town to city, equally momentous and dictated by circumstances of war. The resulting psychic chasm he probed by writing *The Town and the City*, based on division of himself among its characters. Oswald Spengler's *Decline of the West* describes an urbanism causing many to leave community life behind, and the Kerouacs are shown in these terms as peasant-level folk adapting to modernity.

When the war ended and combat veteran Paul Adams came one day in his army boots to the apartment on West 115th, he found his wife, Joan, and her fatalistic pals high on drugs. This former law student, indignantly asking what he had gone and fought for, was told to descend from his "character heights." A wretched moment, soon to be followed by divorce.

Spengler's verdict on the West — that it was suffering inevitable decline — was often cited by Burroughs. Having pondered this cultural process through study of the Mayans and Aztecs, he urged his friends to gain a sharper historical basis for their dreams — and this at a time when, to many, America's postwar promise seemed imminent.

An internationalist viewpoint held by Burroughs, and also by Joan, conflicted with novelist Thomas Wolfe's epic national vision, argued by Kerouac and Chase. Ginsberg's stance was at first "non-Wolfean," but later diverged toward that of Kerouac, who was praised for being more American than Ginsberg himself. In the fall of 1945 they acted out the polarity as vaudeville-style routines: Kerouac in Leo's straw hat as the naive American in Paris, Chase a mountaineering Child of the Rainbow, Ginsberg with a bowler hat as the Well-Groomed Hungarian, Burroughs in wig and skirt as a

giggling, simpering Lesbian Countess. Innocence versus urbanity? Straight/gay? Developed to surreal lengths, such routines became central to Burroughs's style.

Burroughs, taking a Columbia course, moved into number 419 in January 1946 and now became Joan's lover — heterosexual for the only time in his life (apparently after Ginsberg and Kerouac played Cupid for them). Burroughs stayed till April, when a narcotics charge led to a suspended sentence requiring him to enter his parents' custody back where he was born, in St. Louis.

Edie and Jack, Lucien and Allen, Joan and Bill: the Beats in their youth. The mood deteriorated by late spring, Joan's heavy Benzedrine use causing temporary unbalance that made her compulsively broom the place for hours on end. Evicted during the fall of 1946 and picked up with her daughter, Julie, in Times Square by police, she was taken to Bellevue Hospital and sprung by Burroughs on a return to town — perhaps deliberately coaxed back by the crisis — and at once conceived William Junior, born the next year after the family (linked by common-law marriage) moved to Texas.

West End Bar

A primary off-campus meeting place for the Beats was the West End Bar at 2911 Broadway. A "Kerouac Corner," with photos of the author, is shown to me by manager Jeff Spiegel. "Too few of him are left," says he. "Not enough people today are struggling, with his kind of anguish." Today's privileged college-goers may be hellraisers like the Beats, that is, but generally without the life of the mind the Beats also experienced.

In December 1946, Cassady appeared here out of the Midwest with his child-bride, LuAnne Henderson. He had come to see Haldon Chase, a Denver acquaintance, and his first meeting with Ginsberg was here. "We had just ordered our drinks," Neal recalls in an addendum to his memoir *The First Third*, "when Hal recognized a voice and said 'that's Allen Ginsberg' just as a head popped up from the next booth and looked at me. He had coal-black hair

At the West End Bar in Manhattan (manager Jeff Spiegel at left), Joan Vollmer met a number of lovers and also like-minded Edie Parker, the two then moving into the West 118th Street apartment that became an initial "Salon of the Beats."

which struck me first." Introductions were made and traits noted (Neal struck by Allen's big-city Jewishness).

All sat down in their own booths and then Allen, again sticking up his head, remarked on LuAnne's "strange" name. A year earlier she had been only sixteen on marrying Cassady, then nineteen. They were from similarly chaotic homes, this shapely girl with long curls being lusted after by a handsome stepfather.

Kerouac met Cassady in January 1947 at a Spanish Harlem flat. In *On the Road*, Dean Moriarty is first seen "bobbing his head, always looking down, nodding like a young boxer to instructions, to make you think he was listening to every word, throwing in a thousand 'Yeses' and 'That's rights.'"

TIMES SQUARE

Near Times Square a kind of Beat Hotel awaits me, the bottom-level Carter. Its bellhop, right out of Jim Jarmusch's *Mystery Train*,

wears a sky-blue uniform and responds, when I ask how he's doing, "Carter-Hotel. Bat-man." My room is stark enough to be in an Edward Hopper oil.

On Times Square earlier, Jack had done backstage interviews for his prep school's paper in the Paramount Theater, then at 1501 Broadway — now the World Wrestling Entertainment store's address — and impressed friends once by saying, "Let's go up to Glenn Miller's office." This they did, though without seeing that bandleader famed for entertaining U.S. troops (and soon to die in the cause).

Vaudeville-circuit performers once made it big here, in the heart of showbiz America. The Palace Theatre had been a major venue for that genre before Hollywood took it over. Vaudevillian effects of wild confusion emulated by Burroughs produced in *Naked Lunch* the scene of a patron at gourmet king Robert's restaurant summoning hungry hogs to slop the food and devour the chef himself: "Poor bastards don't know enough to appreciate him." Going to the limit in such routines was no fun, Burroughs indicated; they tore him apart.

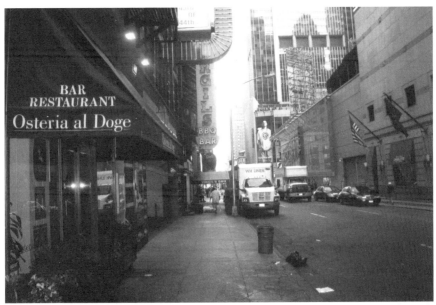

The restaurant Osteria al Doge is now located at 142–44 West Forty-fourth Street, formerly the site of Dazian's. Down the street on the right, facing Times Square, is the site of Hector's Cafeteria.

Carolyn in 1943–44 learned about theatrical fabrics just off Times Square at Dazian's, 142–144 West Forty-fourth Street, now an upscale restaurant's address. Hector's Cafeteria was then just down the street at 1506 Broadway and, coincidentally, Neal and LuAnne in 1946 would walk there directly from the Fiftieth Street bus depot, as *On the Road*'s second paragraph shows, to spend limited funds "on beautiful big glazed cakes and creampuffs." The Toys "R" Us flagship store with its indoor Ferris wheel operates here now.

A sweet tooth and nostalgia bring me to the Times Square Howard Johnson's — last of them all, says my server, Juan. The soda fountain has stools unoccupied for ages and a list (old-fashioned lettering) of ice cream flavours once offered all across America. Such restaurants, discovered by my Toronto neighbours with new cars out on U.S. highways after the war, were in a chain of eating places said to be sparkling clean. "Good choice!" says Juan of my order for a banana split, in the spirit of Hector's Cafeteria.

Times Square during the 1970s was perceived to be in decline, and pleased my son and daughter for that very reason as we booked into a cheap hotel later cited in a rock music film, *The Last Waltz*, as truly low-life. We salted away lines like "Speak to me, Daddy," by a short-order cook waiting for my choice of burgers, and thus found hereabouts a remnant of the Beats' world before Disneyfication in the 1990s.

Drawn to Times Square during the Second World War were military personnel and also, in those disturbed times, youths from across America who had been raised on Depression-era idealism gone sour. *The Town and the City* has five Wolfean pages itemizing a wide assortment, including merchant seamen with whom Jack had worked, gambled, got drunk: "always a wonder to see such a face and hauntingly expect to see it again years later in some other night's-market of the world."

When the war shockingly ended with nuclear assault upon Japan, Kerouac's friends readily linked this with the closing line of "The Second Coming" by W.B. Yeats: "And what rough beast, its hour come round at last,/Slouches towards Bethlehem to be born?" As the Soviet Union and the United States cast off their wartime

unity to fight the Cold War, mere atomic bombs lost status to hydrogen bombs of incalculable menace.

A dark essay by Ginsberg was inserted into *The Town and the City* to exhibit mania by himself ("Leon Levinksy") about an "atomic disease" soon to afflict all. This would commence in Times Square at the "Nickel-O" amusement arcade (based on the twenty-four-hour Pokerino pinball hangout) — a kind of Biblical plague destined to kill everyone and return the world to its original state. Here's the portentous mood later conveyed by *Howl*: "Everyone feels like a Zombie, and somewhere at the ends of the night, the great magician, the great Dracula-figure of modern disintegration and madness, the wise genius behind it all, the Devil if you will, is running the whole thing with his string of oaths and his hexes."

Nearby on West Forty-second Street, Bickford's Cafeteria at number 225 drew a Dostoevskian crowd. Long harbouring an electronics shop, the site has resumed something of its former role as a Pax Wholesome Food location: little tables, full-length mirrors, jazz, and food healthier than in the 1940s. Ginsberg mopped floors

Pax Wholesome Food operates at 225 West Forty-second Street on the site of Bickford's Cafeteria, where students down from Columbia University in the 1940s picked up the lingo of square, hip, *and* beat *from Herbert Huncke, always sporting a cigarette holder, eyes ever on the street.*

here once, noting a flow of individuals between this dive and Fugazzi's Bar & Grill in Greenwich Village "who sank all night in submarine light of Bickford's floated out and sat through the stale beer afternoon in desolate Fugazzi's, listening to the crack of doom on the hydrogen jukebox."

A regular here was Herbert Huncke, thirty in 1945, who at twelve had fled his well-to-do Chicago home with a map and a dime to hitchhike east, giving his first-ever oral sex to a stranger for ten dollars. Brought home, he was busted for drugs at fourteen, and stole throughout a long life to provide for kicks. Here he would be at the window, for fear of missing some acquaintance wishing to unload hot goods.

Taking up his post, so to speak, I view a street cleansed of the peep shows and massage parlours recently abounding here. Opposite at number 220 a marquee-fronted McDonald's supplants Grant's Cafeteria, described by John Clellon Holmes in his Beat novel Go. A "wild conflict of smells" prevailed. Servers were "like unshaven wizards," and among the tables moved "greasy, beardless busboys, like somnambulists."

Carolyn during the war did occupational therapy in California with "hundreds of damaged men" from the Pacific campaign, and Holmes also attended such casualties at a Long Island U.S. Navy hospital, many still with combat dressings on. Her phrase "go for broke" was used significantly by Holmes in his well-known 1952 article, "This Is the Beat Generation." Those raised amid wars hot and cold, he said, were pushed to the limit: "A man is beat whenever he goes for broke, and wages the sum of his resources on a single number; and the young generation has done that continually since early youth."

MIDTOWN

At the New York Public Library I acquire the yellow admittance slip needed for visits to the third-floor Berg Collection. In 2001 the library received, for $10 million, the long-contested literary and

personal archives of Jack Kerouac. These span a hugely creative life from age eleven, the Québécois work ethic of his parents having bred in him a devotion to the writing task.

In this Ionic-pillared room I request numerous writings, alive though their author is not. Kerouac's pads go in and out of standard envelopes now, not his shirt pocket. Entries are in pencil, each letter printed separately. And naturally I must behold that card reading "The Blood of the Poet," with its string tourniquet still attached.

From this place of communion beyond the grave I walk to Rockefeller Center, alive with tourists. It was created by John D. Rockefeller, Jr., who set up a gold-lettered credo where tourists pose for the lens: "I BELIEVE in the supreme worth of the individual and in his right to life, liberty and the pursuit of happiness." Unhappily, labour unrest at a Rockefeller mine caused intervention by the Colorado militia, thirteen people dying in the 1914 Ludlow Massacre.

The Rockefeller family name was then cleansed by Burroughs's mother's brother, Ivy Lee, so adept at image control that he was called "the father of public relations" — or, to his detractors, "Poison Ivy." A central Beat preoccupation was the freedom to enjoy, and Burroughs studied its antithesis: control mechanisms of U.S. business moguls and Mayan priests alike.

The Time-Life Corporation, long established at Rockefeller Center, often belittled the Beats in its magazines. Yet serious writers held potential power by writing "the script for the reality film," said Burroughs in a 1985 essay, "Remembering Jack Kerouac," noting that Jack "opened a million coffee bars and sold a million pairs of Levi's to both sexes." Thus writers, by forming "a real tight union," might "have the world right by the words." The Beats formed no such powerhouse but rather a mere cluster of friends who, as poet Hettie Jones noted, could have all fitted into her living room.

Competing reality studios are the focus of an interview with Ginsberg recorded by Gordon Ball in *Allen Verbatim*. "The openhearted sensibility, the sensibility of 'the happy nut,' that Kerouac was praising, the openhearted sensibility that he proposed, was rejected by the nation," said Ginsberg. "The weekly news magazines thought it was naive in the face of the giant holocaust the military

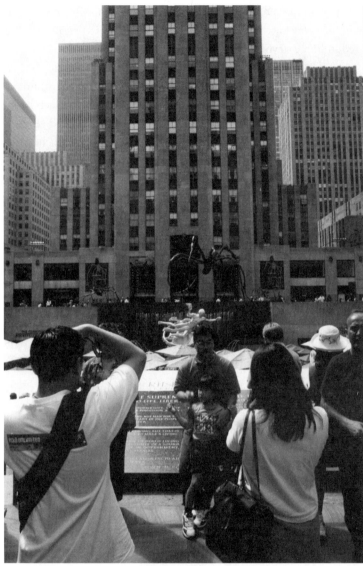

Rockefeller Center ("I Believe" credo behind foreground tourists) was created by the Rockefeller family, served by public-relations expert Ivy Lee, who later received $33,000 from I.G. Farben, manufacturer of the death-camp gas Zyklon-B, for improving the Nazi Party's image. William Burroughs, his nephew, saw Nazism's dark side as a student in Vienna, and married a German Jewish woman, Ilse Klapper, to lend the status needed to let her flee the Nazi invasion.

mind created and perpetuated; so Kerouac's art was never really appreciated or understood or accepted, though it was the right medicine for the nation."

But there's a wrinkle to this, involving Carr as a skilled "breaking news" editor at UPI. A former boss of his there, Peter Costa, told me of the extraordinary instincts he had about a story's real news angle. As Ginsberg was often at Carr's newsroom when desiring coverage of some political cause, it seems that the Beats did at least have that foot in the reality studio's door.

The Beats' model for spontaneity was jazz, and on West Fifty-second Street were jazz clubs Kerouac frequented. I would come down from Toronto for visits to these spots, which sprang up here when Rockefeller Center's construction displaced speakeasies from its site. Here at the 21 Club, cigarette girl jobs were taken by Edie, who also loved jazz. In such favourite places as the Three Deuces, then at number 72, Billie Holiday would sit at their table — though, alas, all of those small jazz meccas are long gone.

A Walk of Fame venture, honouring musicians with sidewalk texts, has been abandoned, only a few stars now remaining and these indecipherable. I mention their fate to the CBS Building's security guard, a soft-spoken, middle-aged black man who reflects, "So many nice days have gone in the wind."

Performing tonight in the Algonquin Hotel's Oak Room is Mary Cleere Haran, gifted at romanticizing the big city. A jazzy piano beat heralds the singer in an off-shoulder black gown. "Let's do it, let's fall in love": Cole Porter's comic rhymings produce smiles. "Take it, fellas," she cries before coming back, stronger, belting the song out with feeling, poetry, communication — then up onto the piano, American woman in all her humour and desirability. Smiles spread as more snatches of songs register: "For this will be my shining hour…." "How do you hold a moonbeam in your hand …?"

"Movie stars were so great to look at," Mary says between melodies, "wearing divine evening clothes, not in that serious European way but having fun." She tells us about an accordion-playing grandmother, her brief Marxist phase, the Catholic school where sex was warned against as "a beastly thing to be endured." Now, seeking out what is "the deepest and most real," she recreates a pre-nuclear

American moment when "there was warmth, heart, tenderness — all the things I love."

Kerouac endeavoured through his art to bridge the tender and the tough. In *The Town and the City*, "the nostalgic reverie of old songs" is often recalled — "April in Paris," "April Showers," "These Foolish Things," "Boulevard of Broken Dreams" — tunes "stealing back to haunt me in the faint melody above the pitter-pattering rain." Something *to hang your dreams on*, as Carolyn Cassady said.

Back I go to Times Square and the Carter, where polyglot conversation goes on beneath the neon-rimmed ceiling mirrors. From my Hopper bedroom at three the next morning I head out, restless, to the twenty-four-hour Cosmos Diner and find only two patrons there, young women laughing about their johns. Mobsters never come here, says my server — and thus, so much for any Beat-style brush with the underworld.

OZONE PARK

The next morning I take an A-train, the Eighth Avenue Express, such as Kerouac often rode between Manhattan and his parents' home in Ozone Park. That's my destination, too. The pretty girl opposite me bends to her cellphone as minutes pass, until a text message comes through to ignite a big smile. Nearly all aboard are plugged in to recorded music — as were the Beats to some extent, though preferably hearing jazz up close for real in downtown clubs. Email, of course, is much in their first-thought-best-thought tradition.

At Cross Bay Boulevard I descend, reconceptualizing the world back to 1943–49 when the Kerouacs lived at number 133–01. Leo, shifting from showbiz publication to linotype work on Canal Street in Manhattan, deplored living among New Yorkers deemed colder than those he knew in Lowell. But Memere, employed in a Brooklyn shoe factory, was pleased by a wider choice of Saturday night pleasures.

Passersby would hear, from the family's upstairs flat, sounds reminiscent of Quebec. In Lowell, when Kerouac's cousins would

pay their regular visits, Jack would prepare home-style baked beans for them before all gathered around their old piano to sing Québécois songs in the spirit of their mother country. Memere loved to play tunes like "Canadian Love Song," and Jack was able to do several jazz chords.

Into number 133–01 came packaged entertainment, of course — comic strips like *Li'l Abner* in newspapers, *The Shadow* and New York Yankee ball games on radio — from which Kerouac derived imagery of a freer, simpler America. More immediate images of freedom were then given by hoboes at one's doorstep — into the 1940s, at least — to whom my mother would readily offer sandwiches: "You can eat on the porch."

In 1946 Leo was dying, having developed cancer of the spleen, and Jack tended his needs in filial loyalty. Alcoholism had already so marred his father's digestive tract that any food would be liquefied at once, providing no nutrients. Ever avowing that a man "should make the best" of his troubles, he withheld complaint over the bimonthly torment of having fluid drained from his abdomen.

One April morning Jack heard what he thought was loud snoring but was actually the death rattle. He went over to find Leo dead in his armchair and held his father for the last time, marvelling that printer's ink had permanently stained his hands. Leo had extracted from his son a solemn pledge: Jack would, after Leo's death, look after his mother. So for Jack the idea of himself raising a family, Holmes notes, came up against two other impulses: this responsibility regarding Memere, and a "pole toward chaos" drawing him into raw experience.

The Town and the City shows three sons of George Martin (Leo Kerouac) thrashing out their views at the time of his funeral. Joe, akin to Cassady in his love of cars, catches a fish and leaves it on the hook to keep fresh in the stream. Peter, the Kerouac persona, wonders if its suffering fulfills some divine purpose — this being simply a joke for the Burroughs-like Francis. There's a final image of Peter as a hitchhiker one rainy night, alone, on a westward path, remembering his father, looking "towards tapers burning warmly in the towns."

One novel thus ends with directional signs toward another, with an apparent hope of rediscovering village warmth somewhere

out beyond. By the side doorway is a plaque stating that Kerouac here wrote *The Town and the City* and also "planned *On the Road*, his seminal novel that would define the Beat Generation." We're thus told of a major transition, not only in Kerouac's work, but also in American writing as a whole.

Dean Moriarty, the catalyst of change in *On the Road*, is often seen at the fictional 133–01 Cross Bay (said in the novel to be in Paterson, New Jersey), as when in need of a bed after Marylou (LuAnne) has gone off: "There was Dean, bowing, shuffling obsequiously in the dark of the hall." Sal Paradise (Jack), asked to show "how to write," sizes him up as both a con and a madman.

I visualize Sal taking Dean for beers in the local bar (now Glen Patrick's), as stated in the novel, also for straight talk to this school dropout intent on being a "real intellectual." Patently incoherent is Dean's rap about Arthur Schopenhauer.

On another visit Dean, leaning above Sal at the typewriter, urges a night out: "Come on man, those girls won't wait, make it fast." Doing so, Sal comes up with one of the best chapters in the novel he's working on (actually, *The Town and the City*'s 1.11, about starring in a big high-school football game). Dean returns for other writing bouts, yelling, "Man, wow, there's so many things to do, so many things to write!"

Sal then makes a key acknowledgement: "I began to learn from him as much as he probably learned from me." How to get words down "without modified restraints" is Dean's avid concern and also Sal's, now, as this kid wipes sweat from his face in unfettered zeal: "And a kind of holy lightning I saw flashing from his excitement and his visions, which he described so torrentially that people in buses looked around to see the 'overexcited nut.'"

Had Cassady merely conned Jack about wishing to write? To Denver friends at Columbia, Neal had written "personal letters" as taught at high school — though far racier than prescribed, capturing adventures just as he'd told them in the rhythmic tones of his rap. Kerouac, seeking truer lyricism than what academic standards allowed, found in Neal's spontaneity a better model — and learned also what Carolyn would, about self-reliance en route to joy. As Gerald Nicosia suggests in *Memory Babe*, a solution to Jack's Wolfean/

non-Wolfean split was in this free spirit, "the only one capable of unifying them simply because he was both."

Sal also tells how engrossed in Dean is Carlo Marx (Ginsberg): "Their energies met head-on, I was a lout compared, I couldn't keep up with them. The whole mad swirl of everything that was to come began then." Stories of Manhattan characters are told by Carlo, of those out west by Dean. Having tired of college sophistication, Sal is supremely drawn to such people who explode and burn like "fabulous yellow roman candles."

In March 1947, when Neal departed for Denver (from the old Greyhound depot at 244–48 Thirty-fourth Street), the three were eager to meet again and took photo booth portraits to remember one another by. "Hurry up please it's time," Ginsberg repeated in allusion to T.S. Eliot's *The Waste Land* as the clock came up to the 6:30 p.m. moment of departure.

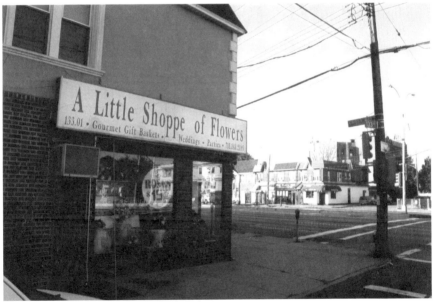

Jack Kerouac had the corner room at number 133–01 Cross Bay Boulevard in Ozone Park above A Little Shoppe of Flowers, which now operates there instead of a drugstore. Family members often frequented a bar now called Glen Patrick's (visible across the street) to fill a kettle with beer for some whoopee in their flat.

Jack had the corner room at number 133–01. Below, where A Little Shoppe of Flowers now operates, was a drugstore with a pay telephone used as travel plans developed. Primarily, there was the mail, and in a Kansas City bar on March 7, Cassady wrote lustily about what had just happened on his westbound ride, his "Great Sex Letter" telling how in Indianapolis a pretty woman took the seat alongside him and, fully seduced by his talk, by 2:00 a.m. was "swearing eternal love, complete subjectivity to me & immediate satisfaction." He was frustrated at St. Louis when she went off with a sister but renewed such wiles on another girl who got on at Columbia, Missouri. In a Kansas City park she fully yielded — "all my pent up emotion seeking release in this young virgin (& she was) who is, by the way, a *school teacher!*"

On the Road shows Sal Paradise relishing western lands after reading volumes about pioneers and "savoring names like Platte and Cimarron and so on." Atavistically, Jack himself would follow Quebeckers who long ago explored those plains. Halting labours on *The Town and the City*, he left its half-completed manuscript on his desk and went on the road.

Ragged and Ecstatic Joy

Denver, 1940s

3

VIA GREYHOUND

The Beats' westward paths — along Kerouac's 1947 route to California, also down through Mexico, then into California — I now follow by Greyhound. At the outset for Sal Paradise are crying infants and hot sun, while for me there's an express overnight air-conditioned coach making pit stops at air-conditioned service areas, with no wailing tots as yet.

The woman beside me now is returning to Wisconsin after seeing a boyfriend, one of several she met on the Internet: "If you gain their trust, it's okay to go out and say hello." Few women in the Beat era knew such freedoms. *On the Road* shows Sal on a bus into Detroit once, asking a pretty seatmate about what was truly desired in life — by her, her father, and finally her brother — but "nobody could tell." Here was the Beat impulse's very antithesis.

In Chicago I eat at Lou Mitchell's — "best breakfast on the

planet" — where Route 66 aficionados get a postcard to be stamped, this being near the start of its westward path, now largely defunct. The noon bus brings me in three hours to the Mississippi River, which Kerouac reached by hitchhiking.

Much in mind is a family car trip also taken in 1947, for our first postwar revisit to my birth state of California. We passed though Des Moines on July 9 — right along Kerouac's route, although two weeks before he hitchhiked through with sleeping bag and cooking gear in a large rucksack. We would have pulled over to give him a lift, readiness to pick up strangers being a trait of those times. "Everybody hitchhiked," Carolyn recalls. "Everybody respected everyone else in one big family. Back then a criminal was seen as totally sick, and now child abduction is so common it's hardly noticeable."

In *On the Road*, unsuccessful thumbing farther along requires Sal to take a bus that enters Council Bluffs, visions swirling of wagon parties parleying there once. In Omaha he first sees a cowboy — no such human forms evident to me amid traffic pouring down one-way streets — and with another cowboy he later gets a ride to Grand Island.

Sal is drawn to ordinary persons, like those at a "homemade diner" where "the greatest laugh in the world" issues from a rough-hewn farmer who comes booming in, "calling Maw's name, and she made the sweetest cherry pie in Nebraska." His carefree manner moves Sal to reflect, "Wham, listen to that man laugh. That's the West, here I am in the West."

Coming up soon for Sal is "the greatest ride" of his life, from two smiling young Minnesota bumpkins bound for Los Angeles after delivering farm machinery. In their now-empty truck they pick up everyone looking for a ride: "Somebody passed a bottle of rotgut, the bottom of it. I took a big swig in the wild, lyrical, drizzling air of Nebraska."

Truck driver Tom, from Indiana, tells me that eighteen-wheelers on the interstate are invariably full, thanks to computerized dispatching, "otherwise companies wouldn't make money." So Sal's sort of ride would be unlikely today — nor might any unsealed boxcars be found for free transport. Pretty well over with, the adventure and bravado of that.

At North Platte the brothers stop and come around to the back, one saying "Pisscall!" and the other, "Time to eat!" Almost the only ones with money to buy food, they bring everyone into a restaurant "run by a bunch of women" for hamburgers and coffee. Sal goes off

A photograph of my family's brand-new car, a 1947 Mercury Town Sedan (my brother alongside) is marred by light entering our old camera's bellows. Lingering Depression-era mindset: you couldn't just throw away an heirloom!

to buy a bottle of whiskey to warm up the passengers, noting "immense vistas of the plains behind every sad street."

Found wherever we descend from our Greyhound is an identical set-up: convenience store with packaged food to eat on the hoof, columned gas station, elevated signs with company logos, flashing motel ads such as the one at North Platte: WELCOME/EXCELLENCE/ MGR RECEPTION/CONGRATS TO/OUR STAFF! Amid such functional interstate bleakness, I never see anyone venturing carefree laughter or even a smile. Has something changed in America?

So to Ogallala, where Sal walks into "the least likely place in the world, a kind of lonely Plains soda fountain for the local teenage boys and girls. They were dancing, a few of them, to the music on the jukebox." A pamphlet lists four chain eateries now in Ogallala: Arby's, Pizza Hut, Country Kitchen, Valentino's — none, presumably, with such a joyful ambience.

Sidney, farther along, is trumpeted in a brochure showing a cowboy on horseback downtown, where you're invited to view its "thought-provoking War Memorial" and yes, to "shop till you drop." My family went through Sidney in 1936 while heading from California to Canada, receipts showing five gallons of Silver Shell bought in town on July 14: ninety-eight cents at a Cheyenne Petroleum pump.

My brother and I are almost exact contemporaries of Neal Cassady and LuAnne Henderson, who in 1946, as newlyweds, served at a rich lawyer's home in Sidney. "I'd have to do things over three and four times, cleaning blinds and scrubbing toilets," says LuAnne in *Jack's Book: An Oral Biography*, edited by Barry Gifford and Lawrence Lee. When she had to clean the porch during a blizzard, he took a Lincoln belonging to her uncle in town and drove them eastward until it broke down, their escape continuing by bus to New York.

Wild indeed was Cassady, though Jack, as Sal, saw in him simply the "ragged and ecstatic joy of pure being." And underlying that joy was the task of writing, which for me justifies their many human failings.

Sidney's brochure also cites the Interstate 80 Golden Link six miles west of town: a six-inch brass strip laid across its lanes to

signify "the joining of the east and west in Nebraska." Mentioning this to the driver, who has seen this and always wondered what it was, I'm told, "Huh! Thank you!" But I'm asleep when we cross that little-known Golden Link. A half-decade after Jack's 1947 trip this Dwight Eisenhower interstate system was begun, modelled on Germany's autobahns whereon Nazi troops and *matériel* were so easily mobilized. Efficient, yes, but ruinous to Kerouac's image of a free-spirited America.

Sal, bundled up under the truck's tarpaulin, shares whiskey with the others, and hears a man known as Mississippi Gene quietly singing. On reaching Cheyenne he diverges to make a connection to Denver, where Chad King (Hal Chase) meets him at the bus station.

Downtown

On Sixteenth Street rises a Denver landmark, the Daniels & Fisher Tower, modelled after St. Mark's bell tower in Venice and once belonging to the demolished May department store. LuAnne's mother had a bar a block away on Curtis Street within the long-vanished McVittie's Restaurant (where Cassady also romanced a waitress considerably older than he). In 1947 Ginsberg vacuum-cleaned the store's second-floor area, occupying an entire city block.

Neal, who got him the job, drove a May Company station wagon conveying customers between the old store and the Cherry Creek parking lot. Taking the free shuttle bus down Sixteenth, I wish to converse with its driver, toiling much as Cassady did, but am cut off by a glass partition. I get off to see one of his haunts, Pederson's Pool Hall at 1523 Glenarm Street, but this address became defunct when the street-spanning megastructure, the Denver Pavilions, was built in the 1990s.

Beyond Civic Center Park is the Denver Art Museum, where Chase worked on Indian basketry in 1947. He and the other Columbia graduates naturally went on to their respectable career choices, business success, and family obligations. The moment when

Cassady had appeared on campus was now a dim memory, and his low-class background was abundantly clear.

Nearby stands the town library, recently much enlarged, where Cassady would often read — as did other Beats at such Carnegie institutions — and I'm able to read a copy of *The First Third* upon premises once haunted by its author. This memoir was brought out posthumously by Carolyn, after a final draft's yellowed pages happened to turn up — never finished, Neal having been too busy living his life to write much of it down.

His mother, Maud Scheuer (spelled "Maude" in the memoir), is described as an unusually beautiful farm girl married off in 1906 at sixteen and having eight children before her husband, a lawyer, died of apoplexy sixteen years later. The scene shifts to a stylish Des Moines country club, where the still-lovely Maud is wooed by Neal Cassady Senior. His alcoholic turn-the-other-cheek stance went with a degree of lechery and deceit, says Carolyn, who married an offspring of this improbable marriage.

THE COLBURN

The Colburn, at 980 Grant Street, was a hotel in 1947, with Carolyn as the only resident under fifty, and the only single girl. A Denver University teaching assistant pursuing a fine arts and theatre arts MA, she also set up a theatre arts department for the Denver Art Museum.

In the lobby there's still a pay phone such as was used that March to reach Carolyn, on the third floor, by future retail-lumber businessman Bill Tomson. He had come with Cassady, in a Manhattan-bought pin-striped suit, and she agreed to have them come up. At the moment of being introduced to Neal, says she in *Off the Road*, "the sweep of his blue eyes made me feel I had been thoroughly appraised. Inwardly I cursed Bill's failure to warn me."

As voiced on that "Moriarty's Blues" CD, Carolyn later grabbed her coat to accompany the men in collecting Neal's belongings from his home. To a hotel room strewn with feminine items they walked,

then to a small short-order café. Seeing him argue here with a pret-
ty girl aroused confusion, capped by realization that this was his
wife. Neal rejoined Carolyn, and without any word about this, sug-
gested hearing records in a music store. This theatre expert was
now mesmerized by the stage presence of a well-practised Romeo:
from theatre studied to theatre lived.

"No, we don't rent rooms by the night," the woman at the desk
says, laughing. It's been a residence "for the homeless" since 1991
(Section 8 subsidies to renters), though nobody here has a historical
sense going beyond 1991. A resident chimes in with more about this
place before its redemption: "A *terrible* story. Broken windows. And
the *drugs?*"

Cassady wrote to Ginsberg in June about this new girl, seem-
ingly too straight for him, who knew about theatrical matters and
gave a feeling of peace. "I was a middle-class educated girl who'd
never have met him otherwise," she told me. "Neal's motive was to
become respectable, so he had a purpose in this and was conning
me. Doing everything to get me interested, showing me his most
colourful self."

Enter footloose Al Hinkle, to whom, along with his future wife,
Helen, *Off the Road* would be dedicated. Hinkle now passed along
a message: "We're all going to get together at your hotel room, Neal
said, to celebrate his homecoming." Carolyn accommodated this
wish and thereby met LuAnne, who burbled about happiness with
Neal — this rogue shortly raising two fingers as a signal that he
would return at that hour. And right at two, gingerly, Carolyn let
him in to share her hideaway bed.

Once in the hotel's bar, Carolyn shared drinks with Cassady,
and then on returning to her room found LuAnne, who insisted
on relinquishing Neal to her, a more suitable match. Further com-
plication was to arrive with Ginsberg, who was hoping to resume a
sexual relationship begun with Cassady at Columbia, even though
heterosexual love preoccupied his partner. Cassady now indicated
dislike for sex with him and suggested that the two should move
in with a girl. Carolyn mentioned a "motherly fondness" she felt for
this twenty-year-old, whose overall behaviour was hardly accept-
able, and yet she "loved him as a family member."

Denver's Colburn Hotel decayed alarmingly before refurbishment as low-rent housing, I was told: "a puke-coloured" paint scheme was left "to remember how bad the place could be. It was fenced in, cordoned off until the funding went through."

Out of money, Allen was given the couch in the room to sleep on. Neal, when asked by Carolyn whether he had been told they were lovers, implied that it was time they were. And only then did the lovemaking begin. Ginsberg, who wrote of "terrible nights" at the Colborn, told Carolyn of being glad for her happiness — although her screams were not of joy, she tells me, but from the pain of lovemaking with little tenderness. It was when Cassady asked to marry Carolyn — setting in motion a lengthy process of annulling the marriage with LuAnne — that the two decided to live together.

Kerouac, in 1947, now entered the picture. *On the Road* shows Sal wanting to know Dean's "schedule" and learning from Carlo that this human dynamo would make love to Marylou (LuAnne) until one o'clock, rush over to Camille (Carolyn) for the same, break off to spend most of the time with Ginsberg, then return to Marylou at six.

Dean undertakes to fix Sal up with a waitress then coming off work, promising to return in exactly two hours, which he does on schedule. Unmentioned by Kerouac in his novel is a very special evening at a tavern, described in *Off the Road*, when Carolyn found him warmer than Cassady. And Jack uttered regrets, while they danced, that Neal had seen her first.

Carolyn ended college days with performance in a play and moved out to stay on-campus during its run, but she revisited the hotel for a surprise farewell with Neal. Shocked to find him there with LuAnne and Allen, all of them naked, she saw the whole thing as a phantasm and departed with friends to California. Kerouac also went on to that destination, while Neal accompanied Ginsberg on a visit to Burroughs in Texas.

At Capitol Hill Books I meet young male clerks with a distinct response to the Beats. One of them "doesn't relate" to *On the Road*, yet is riveted by the tape of Kerouac's reading from it on *The Steve Allen Plymouth Show*. Another is ambivalent about the Beats' influence because he underwent a drug problem, yet tells that reading *Howl* made him cry.

UNION STATION AREA

I'm staying at one of Denver's old hotels, the Oxford, where sherry is dispensed at evening. Rail passengers came in multitudes from nearby Union Station until after the war, when Larimer Street tramps began moving into the area. Swiftly declining later, the hotel in 1983 was spared demolition out of hope that it might revitalize the area.

So it did. And Larimer Street retains none of the unsavoury places mentioned by Cassady in *The First Third*. At number 1727 on a much-reconstructed block was the Zaza Theater, offering him a plethora of Hollywood magic, and an adjoining barbershop where his father worked. The Citizens' Mission once stood at number 1617, providing Cassady with breakfasts and dinners served by white-aproned women, "smiling on us and busy with a 'cause.'" His father evermore fancied seeing "so-and-so up at the Mission" to gain a steady job.

The Metropolitan Hotel, 227 Sixteenth Street at Market, became home for the two after Neal Senior's divorce when Neal Junior was six. Long gone and even then near collapse, it had numerous cubicles renting for a few cents a night, theirs on the top floor and shared with a legless man with child abuse in mind called "Shorty." Such marginal types abounded, as told in *The First Third* with Proustian embroidery, little Neal alone presenting "a replica of childhood to which their vision could daily turn."

In such dire conditions may be found clues to his later life. Impossible to remain unscathed and not to cherish the domesticity kindly offered by Carolyn. For fifteen years he remained wedded to her but eventually was done in, perhaps, by having here gained "unorthodox freedoms not ordinarily to be had by American boys of six."

At the Barth Hotel, now for the "assisted living" of those unable to manage on their own, soft accordion tunes are rendered by a blind man. Hearing the murmur of conversation, I appreciate Cassady's comment on talk shared by his father with cronies: "facts establishing that much of the life they had known was in common:

types of mutual friends, cities visited, things done there," along with "many general statements about Truth and Life, which contained the collective intelligence of all America's bums." Neal himself was such a raconteur, the best Allen and Jack ever heard.

And yet, what sinners such men were. I get an inkling of this from Dave, one of the Oxford's tuxedo-and-tails doormen. Driving a pickup truck "before '83" to the former Terminal Bar (now an upscale fish house) to collect his father doing construction work there, he saw the bums in a row on the sidewalk. "When I went in, I told them to get away from my dad's truck, and grabbed this two-by-four," he recalls. "My father always laughed a lot about that — 'What were you doing with that two-by-four?' — but there I was, only eighty pounds and ready for action."

Dave at age ten resolved never to drink, largely because of the lifestyle chosen by two cousins. "There was 'Patch,' he had his eye shot out, always fist-fighting when he was drunk. They'd throw a man under a car to make him helpless, then kick until his face was one big scab."

Kerouac's *Visions of Cody* places Cody Pomeray (Neal) in this world: "poor pitiful kid actually just out of reform school with no money, no mother, and if you saw him dead on the sidewalk with a cop standing over him you'd walk on in a hurry, in silence. Oh life, who is that?"

At the Wynkoop Brewing Company, in a noble turn-of-the-century building, the affluent play billiards amid big contemporary paintings. I try to connect this place with the grittier circumstances of hunchbacked pool shark Jim Holmes, who in *Visions of Cody* (as Tom Watson) was "so tragically interesting, so diseased and beautiful, potent because he could beat anybody yet be so obscurely defeated as he slouched down in the press of the crowd, sometimes flashing a languid sad smile in answer to the shouts of dishwashers and dryclean pressers but usually just enduring eternity on the spot he occupied."

Jim Holmes gives in *Jack's Book* a perceptive view, in turn, of Cassady. "You couldn't hardly help but love the man, and I mean that literally," he states. Having two women in different hotel rooms and rushing between the two showed that "sex was a game for him,

and also it was proof of manhood." He shuns the view that Cassady was a con artist, noting that he never cared whether he won at pool or lost, and thus explains Neal's need to be active: "To keep his mind occupied because of this death wish that he had. He didn't want to think about dying, and that was in the back of his mind all the time. Many of these people, though, I guess didn't know."

I bear in mind what Carolyn said of Cassady's later years: that he did his best to get himself killed. Jim Holmes's account she very much endorses, as offering a key to Neal's personality.

In early youth on each Sunday from spring to fall, Neal would head north for the South Platte River with his ne'er-do-well father. At Union Station they would angle left — "circling busy men loading mail and baggage in the cars just behind hissing engines" — to reach fields (Confluence Park now part of it) that were once a hoboes' jungle of vast extent. Neal Senior would never approach large groups of rail yard tramps, "thinking I was a prize of one sort or another," and adds that "at every chance, bums asked for my presence on hunting trips." Acts otherwise kept secret, for being degenerate, were acknowledged as part of everyday life.

Following such youthful adventures were those of the grown-up man — also of local friends Bob and Beverly Burford and Ed White — in marijuana-smoking. The Elitch Gardens Amusement Park, off Speer Boulevard (much of it later moved northward to I-25), was deemed a safe place at night, emptied for what became known as "Elitching" — reefer madness well before the 1960s.

At My Brother's Bar at 2376 Fifteenth Street, patrons receive free copies of a letter from Colorado State Reformatory by Cassady, at nineteen, asking a friend to settle his bar tab here. The friend was Justin Brierly, a Columbia graduate teaching at prestigious East High School, who screened local students for admission to the college. By that means, Chase became one of a disproportionate number of Denverites to attend. Brierly rented houses in town and at one, finding Cassady romancing the maid and noting also keen intelligence, introduced him to Chase — whom this hellraiser visited in New York and thus met Jack and Allen.

In *Jack's Book*, Tomson, a fellow student at East, describes Brierly's great interest in Neal, thought to use "homosexual relationships"

in gaining benefits. Cassady played bisexuality as a survival game, Carolyn tells me. In reference to Brierly, she says: "Neal was always up for sex no matter what in any form. Like Lord Byron. All from Neal's ghastly childhood."

My Brother's Bar, Denver's oldest pub still serving drinks, displays Neal Cassady's letter mounted on Carolyn Cassady's 1952 photo of him and Jack Kerouac in masculine embrace.

FIVE POINTS AREA

At what is called the Five Points stands a single hotel/jazz club remaining from those years, the Rossonian, where the likes of Billie Holiday and Charlie Parker once performed. Neal grew up when jazz of the highest musical merit was all around, and it profoundly shaped his sensibility. Nearby on this rainy afternoon, I find the former Puritan Pie Company building opposite the site of the Snowden Apartments (910 Twenty-sixth Street), where Cassady's mother placed her family on three occasions. Before dying in 1936, Maud lent him proper manners and a humorous outlook.

Neal, when not with his alcoholic father, would join his mother's large family and take abuse from what Carolyn calls his "brutal, battling half-brothers." Often heard at the Snowden were "exciting feminine whoops of laughter," writes Cassady, who from a very young age desired the mother of a friend — a tart forever being "squired by one man or another to the Tivoli's stage show

Near Denver's Snowden Apartments, now an empty lot, whiskey was bootlegged by Neal Cassady's half-brothers, the smells masked by those from Puritan Pie (its former premises seen beyond). One half-brother, Jimmy, tried to suffocate Neal behind a fold-up bed.

with dinner before and drinks after." Such forthright libido, such wild intimacies.

Neal's poverty meant no discipline and no rules, says Carolyn. "As the twig is bent, so grows the branch. It was hard for him to understand restrictions: what's the point?"

To Ebert Public School, Neal in boyhood would ply a "careful zig-zag" route from the Metropolitan, his game being "to find hurrying shortcuts, and to not waste a step." At the school — now with vandal-deterring metal screens on all windows — was the small library from which he signed out Alexandre Dumas's *The Count of Monte Cristo.* From the movie version he had learned its story, how a sailor long incarcerated wrongfully was able to escape, assume an aristocrat's identity, and gain revenge.

Young Neal carried the large volume about, reading even while on the go, until it appeared to have been stolen by a rich school chum. Three years later in the alley behind his house, Neal's sadistic brother Jimmy wedged a cat into a wall cavity and smashed the creature to death — whereupon the lost treasure finally reappeared, underneath. "I scraped off the fresh blood and bits of entrail," Neal writes, "and smoothed the weather-stained pages with great care before pressing the book to my grateful bosom." A triumph of inspirational word over evil deed, perhaps.

At Holy Ghost Church young Neal assisted priests when this was only a basement structure, unlike the Colorado-marble pile now nearly overwhelmed by an adjacent high-rise office building. There he was proud to have "served a year as an altar boy without missing a day."

The start of the 11:30 a.m. Mass prompts a homeless man, slumped in my pew, to get up and leave. During a 1982 cold snap, I've read, popular priest "Father Woody" opened the church doors to receive four hundred such people — causing an outcry, despite the use of incense to mask their smell. He told parishioners that "if they wanted sterilized people sitting next to them, they should go to another church."

"Blessed are the poor in spirit," declared Jesus in the Beatitudes, "for theirs is the kingdom of heaven." Kerouac in 1954, during a moment of tearful insight, would conflate *Beat* with *beatitude.* The

downtrodden, the beaten, by this view are able to attain spiritual ecstasy.

Our service is to be followed by "the sacrament of confession," says a notice. I sense the required candour in a listing of questions by which to examine the conscience:

1. Have friendship with God and holiness in Christ been the goal of my life? …
4. Have I honored my parents, spouse and family members? …
8. Have I lied? Have I gossiped, insulted someone, or harmed anyone's reputation? …

The Mass proceeds, amid the smoke of incense, to where the priest lifts his hands above the Holy Sacrament: "This is my body … do this in remembrance of me.… This is the Lamb of God that takes away the sins of the world." Worshippers move forward to receive the Body and Blood of Christ.

Those wishing to confess their sins line up by the booths of divulgence, a red light going on as each enters. I remember Salvation Army services of my youth, ex-drunkards and ex-blasphemers testifying how Jesus had saved them. Confession, Kerouac came to believe, was a means for the best writing: "the most painful personal wrung-out tossed from cradle warm protective mind," as stated in his "Essentials of Spontaneous Prose." The voice would be "like a fist coming down on a table with each complete utterance, bang!"

Kerouac once quoted Mark 13:11 in a letter to his editor, Malcolm Cowley, about the spontaneous utterance he aimed for: "It is not ye that speak, but the Holy Ghost." Cowley warned that sometimes what may sound like the Holy Ghost "turns out to be Simple Simon."

Very much of a confession is Cassady's December 1950 "Big Letter" to Kerouac, detailing first the suicide attempt and hospital recovery of girlfriend Joan Anderson. It went on to numerous lovemakings with another, Mary Freeland ("Cherry Mary") — in parks, cemeteries, snowbanks, bathrooms, rented trucks, "so many places that Denver was covered with our peckertracks" — until her

mother arranged for a dressing-down at home by the monsignor (a prelate specially dignified by a pope). This turned out to be Neal's godfather, Harlan Fischer, who had often seen him here during an altar boy stint given as three years:

> I've never seen a chin drop so far so fast, it literally banged his breastbone. "Neal!! Neal!, my boy!, at last I've found my boy!" his voice broke as he said the last word and his Adam's apple refused to articulate further because all it gave out was a strangled blubber. Choked with emotion, he violently clasped me to him and flung his eyes to heaven fervently thanking his God.

The scene was less Wild West than the eighteenth-century England of Henry Fielding. Cassady, who had thought of becoming a priest before vanishing "down the pleasanter path of evil," welcomed the omission of any lecture by his godfather, being then "too full of blissful joy." Later indeed venturing a reproof, the old man was interrupted: "I was sorry for it, but we were worlds apart and it would now do no good for him to try and come closer." So that was that.

Officialdom "will condemn the hot-blooded lifelover with their cold papers on a desk," writes Kerouac in *Desolation Angels*, affirming his Québécois blood. "They sin by lifelessness! They are the ogres of Law entering the holy realm of sin!"

A Plank Where All the Angels Dove Off

San Francisco, 1940s–1960s

4

HAIGHT-ASHBURY

On the final lap to San Francisco I get to know a barefoot kid with a skateboard and a surreptitious bottle of beer, who was kicked off a Greyhound by the driver last night and had to sleep in an alleyway. He follows Grateful Dead members now touring as "The Other Ones," using the first names of those soldiering on "since Jerry died" (Jerry Garcia, of heroin addiction in 1995). Also he repeats old-timer phrases — "vibes," "man" — evoking his love for the Deadhead scene. He's thus looking for community, perhaps? "Exactly."

I continue to Oakland, my birthplace, then onto the Bay Bridge as Salvadoran children opposite me squeal with excitement. In radiant morning we climb the long trail of girders, swerve to penetrate Yerba Buena Island, ascend to where San Francisco's grid comes into view, go yet higher between suspension-bridge cables, and finally swoop into the City of Dreams.

Kerouac missed all this on first arriving in 1947, being asleep on the bus. It's wrong to think of him "bumming" across the land, as many do, for he went west seeking employment on a round-the-world liner out of San Francisco. This job never panned out — nor did his romance with "the Mexican girl," Terry, begun in Los Angeles and ended amid oppressive cotton-field toil. California breeds disappointment, even in this city where you're expected to have flowers in your hair.

I book into the Red Victorian Bed, Breakfast and Art at 1665 Haight, two blocks from Ashbury Street in that storied neighbourhood. Its website interested me, all about "room themes celebrating hippiedom and the Summer of Love and bathrooms named Starlight, Love, Infinity and Bird's Nest." I'm pleased to be given its Earth Charter Room.

My costume on such trips is a suit, disguising my research intent and with enough pockets for all I need. Strolling the area thus evokes gratuitous praise from a bystander. "Nice suit," he remarks in laid-back tones, "and I like your attitude too, gutsy." Here's an ironic twist on the "generation gap" of a half-century ago, when America's older population abhorred the society taking shape in San Francisco.

But mentally I head farther back, once more to 1947, when Carolyn on arrival from Denver lived in the Richmond district at 561A Twenty-fourth Avenue. She wrote to Neal every day. Along he came from New York by Greyhound — also in a suit, preventing wrinkles to the jacket by folding it carefully underneath whenever he sat down. Neal for all his faults had "dignity," she told me.

"Don't worry about your boy Neal," he wrote to Kerouac in November, "he's found what he wants." With Carolyn discovering "greater satisfaction" than ever before, he pumped gas to bolster household funds. In early writing efforts, he tried to avoid triteness while recollecting his early life. "Carolyn has practically gotten married to me in the eyes of her family," he added next month, "and unless I break quickly things may become drastic." Also, LuAnne had come to town and, their marriage not yet annulled, was now "a constant thorn."

Number 561A is just north of Golden Gate Park where, twenty years later, providers of free food and raiment called the "Diggers"

consulted an astrologer and set January 14 as the date of a "Gather-
ing of Tribes for a Human Be-In" to be held here. Ginsberg was
front and centre within the Polo Field, where this agency gave out
thousands of turkey sandwiches made of LSD-laced bread. All had
been urged to bring costumes, bells, beads, and flowers. This four-
hour event began with a "special mantra for removing disasters"
by Ginsberg, and a circumambulation of the field "to drive away
demons and bad influences." Then as the sun descended, thirty
thousand souls heard Allen chanting *om sri maitreya* while a para-
chutist descended onto the field — God Himself seemingly having
dropped by.

The nearby de Young Museum during 1947 was toured by Cas-
sady after getting suitably high on marijuana. Things went consid-
erably further in the Summer of Love, naturally, and when I mingle
with frenetic drummers of Hippie Hill, at its east end, a girl asks
whether I had graced these regions at that time. Well, no, I reply, but
mention how its reverberations spread all the way to Toronto.

At the Red Victorian next morning, Breakfast Conversation is
laid on. "Everything is ego-driven in the U.S.," one guest remarks,

*At San Francisco's Red Victorian Bed, Breakfast and Art, founder and chief decorator Sami
Sunchild (middle) will put down a card giving useful rules for Breakfast Conversations. "We
need to be listening," says she.*

lauding the 1960s by contrast. With everyone moderately keen about hippiedom, I weigh in with a reference to the Beat author Jack Kerouac. He scorned its values, I point out, facing blank stares.

Back in the Summer of Love, what might have been discussed? Drug-dealer killings, as international cartels seized the moment, the two hundred or so runaway minors being picked up by authorities each month, the Charles Manson commune around the corner at 636 Cole. On October 6, a dream of all-conquering love forgotten, Diggers marked "The death of Hippie, devoted son of Mass Media." At sunrise in Buena Vista Park as Taps was played, some eighty mourners heaped a box with hash pipes, drugs, and underground newspapers and cremated them.

Checking out of the Red Victorian, I stroll just beyond Buena Vista Park to 160 Alpine Crescent. In 1948 Neal, finally gaining annulment of his union with LuAnne — who had gone back to Denver — married Carolyn on April Fool's Day and, several weeks later, took up residence with her on these high slopes.

Signs of impending misery appeared that June in a letter to Jack of buying a Packard coupe earlier: "Raced 14,000 miles in 85 days — gave it back." Regarding his birthday, in February: "stole a 38 calibre revolver — several times had it to my temple — tried for 14 hrs. — sweat, nausea, fear — couldn't pull the trigger." Carolyn mentioned learning through this letter, recently, of a "4 way orgy" he had been in, just before their marriage, and this made her cry for days — decades after it had surreptitiously occurred.

On July 5, Neal wrote to Jack about life hoped for among friends — Ginsberg, Holmes, Tomson, "dear beautiful brother Huncke" — on a ranch communally shared. Burroughs would not likely be included, "but I do love him and Joan so much you know — pure speculation, but maybe visits at any rate." At the nucleus would be Memere and Carolyn. "No hard and fast, naturally, rules or obligations or expectancies or any such bourgeois strains in our veins toward them," he adds.

Hinkle, having also moved to the city, got Neal a training job with the Southern Pacific Railroad. Convulsing Carolyn with railway lingo humorously tossed out, Neal was also "beside himself with delight" over the birth in September of a first child, Cathleen.

Carolyn Cassady drew a diagram for me of the interior of 160 Alpine Crescent (middle) — pleasant enough, though the house was difficult to climb to when she became heavy with Cathleen.

Respectability was his at last. But Carolyn at this time was turned down by the Hollywood firm where she had hoped to become a costume designer, and her spouse yearned to head east again for a renewal of friendship with Jack.

Southern Pacific now reduced the number of freight-train brakemen to two and Neal was laid off. He wished for a brief "vacation." And as Hinkle was to marry a quiet religious girl, Helen, Neal offered them a "honeymoon drive" to New York, in the process bringing Kerouac back here.

So Carolyn, seeing one day a new maroon-and-silver 1949 Hudson parked on Alpine Drive, learned of this auto expedition — though not that LuAnne would be picked up in Denver — and was soon left alone with Cathy, as *On the Road*'s best-remembered car trip unfolded. Funds for the ranch had been diverted, significantly, into the purchase of that car.

109 Liberty Street

Carolyn now moved farther east to 109 Liberty Street, architecturally acclaimed these days for its Italianate window mouldings. At what was then an apartment, mother and child were rejoined late in January 1949 by Neal for a stressful reconciliation. Carolyn gave the cold shoulder until won over by his manic rehearsal of cookware sales — "a W.C. Fields patent-medicine routine with each pan, exaggerating all the 'unique' features and adding a few of his own invention," she writes in *Off the Road*. Soon he became discouraged, however, by "a few rejections and slammed doors."

My father, similarly dismayed on his 1924 arrival from Canada by the challenge of becoming a freight solicitor downtown, persevered in the face of family requirements (by the likes of me). Golden opportunities provided here were then dimmed by the Great Depression, inducing him to haul the family back to Canada with a hand-built trailer hooked behind our car.

In 1949 LuAnne persistently phoned number 109 for Cassady — who, told by Carolyn to leave, later returned, holding a hand injured when he tormentedly struck LuAnne (herself unharmed), so that she drove him for repairs to the General Hospital. LuAnne just then also arrived in a cab, and Carolyn, ever the portrait artist, sized up a new luscious aura in her. The ex-wife didn't want Cassady back, her fiancé then being due to show up from overseas — and indeed, became pregnant almost at once upon marrying him. "Neal loved LuAnne all his life, but that was a physical thing," Carolyn told me. "His first love. He didn't do anything for LuAnne, unable to be a one-woman man."

A few blocks away around then, Kerouac stood by a fish-and-chips shop on Market Street's north side, just west of Van Ness, and received a terrified look from a woman inside, fearful that he would rob it. He (as Sal in *On the Road*) imagined that this was his own mother from two centuries previously — in England, he her footpad son — and thus attained an ecstasy always hoped for: stepping across time into timelessness and hurrying "to a plank where all the angels dove off and flew into the holy void of uncreated emptiness,

the potent and inconceivable radiances shining in bright Mind Essence, innumerable lotus-lands falling open in the magic mothswarm of heaven."

This sense of innumerable deaths and rebirths (akin to reincarnation vistas later conjectured by Carolyn and Neal) appears also in an untitled story of Jack's from around 1950–51, in which the Cassady character is taken apparently beyond the last streetlamp to an enigmatic fate — the "Angel Plank" — before awakening from nightmare. A preoccupation of all the Beats was this leap into another existence — renewably human, or ghostlike, or angelic.

We may note that Kerouac's "point of ecstasy" was reached at a totally Beat hour. He had been dumped with LuAnne, on arrival, farther down Market at O'Farrell, and the pair took a room on credit at the Blackstone Hotel (340 O'Farrell, demolished). A nightclub singer upturned an iron to heat up their pork and beans, and neon signage flashed outside the window. Sal is later shown, distraught with hunger, viewing Marylou at Larkin and Geary with an older man as she seemed to prostitute herself. LuAnne in *Jack's Book* indicates dining with this person because he owned a bar, and with the vain hope of getting a job there.

A young man comes to a great city. He is now in the arms of the princess, but all is not as it should be. Dreams of earthly pleasure turn to a nightmare of basic human need. Then comes the ecstatic revelation.

29 RUSSELL STREET

I head by cable car to where the Cassadys later took up residence in mid-1949 at 29 Russell Street on Russian Hill. In August, Kerouac assented to Neal's urgings for a visit here, irksome to Carolyn for stirring wanderlust in her husband. Pregnant now with Jami, one day she was told by Neal in a note of being Manhattan-bound with Jack, never to trouble her again. No visit to LuAnne was planned, and yet in Denver, crazily, Cassady stole six cars in succession while seeking his father.

"He would say that he never deprived anyone of anything," Carolyn ruefully told me. "I bought the story of him *borrowing* cars. LuAnne's uncle's Lincoln in 1946: he rationalized that one. Actually he would strip them, sell the parts — oh, dear. I also rationalized a lot."

Earlier Jack had earned a $1,000 advance for publication of *The Town and the City*, and coaxed to a rented Denver house Memere and Nin's entire family, to fulfill the communal-living dream — ruined by a spiritual gap opening between him and his kinfolk. They returned east as the book, expected to provide means for supporting Memere, soon dropped from sight like other first novels. After most of the advance was gone, Jack unloaded produce from boxcars — the hardest work of his life, he said.

Now, he and Neal got out of Denver in a Cadillac limousine to be delivered to a rich man in Chicago. Cassady turned it almost into a wreck (along old Route 6), attaining speeds that terrified Kerouac into getting down on the floor so as to recall the risk of torpedoes on wartime ocean crossings. Later he represented that mad driver, the "Shrouded Traveler," as pursuing him in a flaming jalopy. "Just one of Jack's visions of Neal," Carolyn explains. "He was always battling over social conventions, and frightened a lot. Neal was swift, forceful and spontaneous."

In New York was Diana Hansen, a fashion model and writer who had married her Bernard College English literature professor, and yet now, swept away by Neal at a party, shortly brought him to her midtown apartment (319 East Seventy-fifth Street). *On the Road* portrays Neal as Dean in "a hip-length Chinese silk jacket" that "Inez" had presumably furnished. In 1950 Diana, pregnant, was given a night's stay here by Carolyn, faithful to her high regard for the sexual act: "the most holy thing we have," she insists. Neal ostensibly had gained a Mexican divorce from her so as to marry Diana, legitimizing her child before he returned here to support his West Coast family.

That fall the Cassadys received a letter from Ginsberg with amazing news about a wedding-night party held in Manhattan on November 17 for Kerouac. His second wife, also involved in theatre like Carolyn, was a pretty brunette named Joan Haverty. Neal took

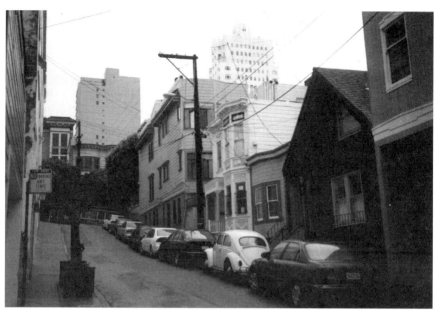

The owner of 29 Russell Street (right) "is always delighted to welcome Jack's fans and ours," says Carolyn. "She is trying to get the house listed as a City Monument — or whatever they call it — like City Lights Bookstore. So far not much luck, since all the residents on the street have to agree."

two weeks to reply to Jack — "in an unusually superficial way," Carolyn states — but soon followed up with the Big Letter, its propulsive style extolled by his friends. To Allen, Neal wrote in March 1951, "All the crazy fallderall you two boys make over my Big Letter just thrills the gurgles out of me, but we still know I'm a whiff and a dream," adding, "So I did work hard at it and managed to burn a little juice out of me and if the fucking thing is worth any money that's great."

The Big Letter's adaptation to film in 1997, as *The Last Time I Committed Suicide*, involved Carolyn in the production — a disaster, sadly, in its neglect of suggestions she made. "They totally botched what could have been an outstanding bit," she says. "Another of my stupid trusting film experiences."

A peak of creativity had come for both men, Kerouac in April 1951 typing out his famed *On the Road* manuscript roll. Then, amid the pain of its rejection by publishers, he left Joan, now also pregnant. Swearing friends to secrecy as to his whereabouts, first he lived with sister Nin in North Carolina.

In November, Jack came here to an attic room Carolyn had set up for his writing needs. Harmony reigned until again he misbehaved with Neal, bringing a prostitute into his room to Carolyn's immense consternation. *Off the Road* shows Jack, chastened, adding a remorseful note to the copy of *The Town and the City* that he had sent earlier. The famed 29 Russell photos were taken just after reconciliation — and not much later began Carolyn's affair with Jack, personal wish balanced against family requirements.

Jack was quietly by himself in the attic. Carolyn settled the children, dialled his "approved" station KJAZ on the radio, sampled the wine to calm her nerves, asked him down to a candle-lit dinner, sustained a flow of reminiscence, walked to a couch kept open as a bed, saw him lie upon it, asked the name of a song to which they had danced upon first meeting in Denver. "Too Close for Comfort": correct.

This marital experiment is thought to prefigure the 1960s. Yet back in the 1920s, my churchgoing grandmother split with her husband in Canada and the two came separately to California. The circumstances of this were veiled, naturally, making them a total enigma to me and posterity.

Upstairs, on a section of plywood Carolyn had painted green, Jack wrote *Visions of Cody*. The long-unpublished work took spontaneity to an extreme, with rambling talk transcribed verbatim from tape. In some of it Carolyn is eerily present, asking how certain people had come together in New York, though none of the tapes themselves are extant.

Carolyn denies awareness of any Beat "movement." As for Kerouac and Cassady prowling North Beach, it was she herself who first ventured into that bohemian quarter, during 1952 as a camera girl in three of its clubs on a six-to-two shift. Asking her to tape-record "the continuing saga of nightlife in the sinful city," they went there only later, for jazz and poetry readings. The family moved to San Jose that August, continued amours producing an unfulfilled wish by Jack to have Carolyn join him in Mexico.

On the Road still hadn't been published. In 1954 Jay Landesman, trying to bring out a novel about the Beats, was told by a publisher that adultery was now so rampant as to disconcert many for

showing "the truth about themselves and the world they live in." Carolyn points to this hypocrisy as a key reason for the delay in bringing out *On the Road*.

Spiritual quest led the Cassadys to their espousal of Edgar Cayce's teaching early in 1954. Kerouac, looking askance at this, went on to find in the San Jose Library a copy of Dwight Goddard's *A Buddhist Bible*, a huge delight. To Allen he wrote keenly that May, offering to send a hundred-page summary of Buddhism, later expanded and posthumously published as *Some of the Dharma*.

Ginsberg, encouraged by such enthusiasm, would go on to take formal Buddhist vows eighteen years later. The Beats made this old religion seem hip, its exoticism challenging old-style church forms of worship across the land. Buddhism shared with Christianity a view of the self as tormented with desires, ever the root of suffering, but led to avoidance of them through techniques of meditation.

In late 1954 at the Cassadys' new Los Gatos bungalow (18231 Bancroft Avenue, demolished in 1997) the threesome re-gathered, though amatory tensions mounted. Kerouac, stung by Neal's insinuation that he was a freeloader, began to cook in his own room as this male bonding dwindled. Jack's link with the family, by mail or telephone, would now occur mainly through Carolyn. "What was beautiful about Jack and Neal was their magnetism, their sense of fun," she recalls. "My job was to get the kids raised, not display brilliance with words."

FILLMORE STREET

I descend to 3119 Fillmore Street, where the Six Gallery then operated (now Silkroute Carpet). The famed October 7, 1955, poetry reading here became a reality after Ginsberg, much attuned to the cultural scene in San Francisco as in New York, got to know handsome poet-playwright Michael McClure. He had begun organizing such an event but couldn't continue because his wife, Joanna, was pregnant. So Ginsberg, recently arrived in town and by now friendly with many locals, took over.

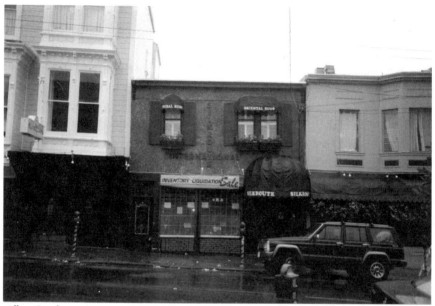

Allen Ginsberg sent out postcards promising "wine, music, dancing girls, serious poetry, free satori" at the Six Gallery, a former auto-repair shop at 3119 Fillmore Street (Silkroute Carpet now on its site). There would be a "remarkable collection of angels on one stage reading their poetry."

East would now meet West, the Beat Generation and California radicalism — the latter embodied in master of ceremonies Kenneth Rexroth, a polymathic poet-activist who annually read the whole *Encyclopaedia Britannica*. Allen, encouraged by him to discard formal versifying, began typing out spontaneous Kerouac-style riffs to describe friends cast in mental turmoil as if through some alien force — and thus gained an opening for *Howl*.

For McClure, among the three speaking first, the event summoned up a "future of harmony seizing the planet." The audience — workers, professors, youth radicals, painters, conscientious objectors, some 150 in all — comprised "an almost secret, semi-outlawed slice of America," he recalled in "Painting Beat by Numbers." Kerouac, then a nonentity, collected for wine "and went out and bought homemade Italian red, eighty-five cents a gallon."

Ginsberg, after an intermission, stepped forward to read *Howl*. He started softly, with outstretched arms, and then hurled himself into his chant, swaying from one foot to the other. Jack began

shouting "Go!" at the end of every line, the crowd following his lead.
Rexroth was weeping before the end and so was Allen, for whom the
poem restored a "prophetic consciousness" to American verse. Mc-
Clure recalled that everyone at once understood *Howl* "because we
were living it, had lived it or knew friends who had."

Scholar-poet Gary Snyder ended the occasion with "A Berry
Feast," about the trickster Coyote. The Human Be-In, a dozen years
later, would be concluded by Snyder with a long note on a conch
shell. This reading having made known that beautiful people were to
be found in this hilly port city, it was inevitably visited by the curi-
ous (myself included, of course).

Using Bill Morgan's excellent guidebook, *The Beat Generation in
San Francisco*, I locate at 2324 Fillmore the flat occupied in 1958–61
by McClure and Joanna. Their doors were ever open to visitors, and
Michael, later reading verse aloud with Doors keyboardist Ray Man-
zarek, forged links also with the realm of rock music. *Life* magazine
would give warning against such countercultural rebels — who, said
McClure, "were more 'dangerous' than *Life*'s fabrications — we were
more outspoken and serious than the magazine made us out to be."

The Fillmore Auditorium, down at Geary Boulevard, was called
the Majestic Hall when Kerouac would hear jazz there. Then, in the
late 1960s, impresario Bill Graham made this a venue for some three
hundred rock "dance/concerts" later staged in the Winterland (for-
merly 1725 Steiner, at Post), where in 1976 Martin Scorsese filmed
The Last Waltz, with performances by The Band summarizing rock's
origins and legacy.

DOWNTOWN

The Quality Inn at 610 Geary, my new Frisco home where Gins-
berg often stayed well into the 1960s, is from another day, with nar-
row wooden stairwells and gilded ceiling beams in the lobby. I fall
asleep reading *Common Ground*, a catalogue of spiritual services:
Lama Trek & Vision Quest ("creative spiritual communities; friend-
ly lamas that carry all of our gear"); Deja Vu Tours and Spiritual

Adventures ("Experience reflections from past lives and receive spiritual counselings and healings"); Blue Dog Shamanic Services & Mystery School ("Soul retrieval/Seance & Ancestor Access"); August Order of the Mystic Rose ("Today, the Stewards of the Ancient Mysteries have opened once again the Portal of Initiation").

Such personalized spirituality points to a big change of outlook. Puritan monotheism, of Jewish background, governed the lives of Protestants settling New England and those of Catholics populating the St. Lawrence. Kerouac, affirming that "God is Ecstasy in His Natural Immanence," led others into these New Age territories.

The next day I walk up Geary to the former Hotel Wentley at 1214 Polk, another Ginsberg hangout. El Super Burrito, at number 1200, supplants the Foster's Cafeteria where, late in 1954, he first met the painter Robert LaVigne — at whose apartment (1403 Gough Street) he saw an oil portrait of Peter Orlovsky. The subject, with whom he had fallen in love, himself then appeared, and spent an embraces-only night with him. Allen moved in with Peter and Robert, a difficult arrangement from which he soon departed.

Throughout January 1955 at the Hotel Young on 106 Fern Street, Allen Ginsberg brooded in a corner room with a vantage point on Foster's Cafeteria (now El Super Burrito), hoping to glimpse Peter Orlovsky on his visits there.

Ginsberg had earlier made a stab at heterosexual life with a young mother, Sheila Boucher, while taking a regular job. Then, telling a psychiatrist what he would really like to do — quit work, live with Orlovsky — he was asked, "Well, why don't you?" That he did, Peter permanently entering his life with an exchange of vows in 1955.

That relationship gave Allen a stability that, says Carolyn, he greatly needed. "So insecure, he had to build this massive ego. Such a need for approval," she says. "For ten years he was so mean to me, then asked me to come to a performance in London, where I was just another pair of hands to applaud."

Cassady in 1955 became involved with the intense red-haired Natalie Jackson, who impersonated Carolyn to withdraw $10,000 from her bank account for what he saw as a surefire win at the race-track. Suicidal over this fiasco, Natalie went to her rooftop (1041 Franklin, demolished) and fell to her demise when an officer attempted rescue but only caught her bathrobe. Neal by then was visiting the family home only at payday, and yet now, unhinged by grief, was magnanimously invited back by Carolyn. Violent death had occurred in the very year of initial triumph by the Beats.

Such human failings undermined what might have been a concerted anti-establishment venture, with talent from both coasts of America. The Beats assailed Cold War repressiveness not with mere protest but with a radical literary program. Thus doubly rebellious, they had the potential for a powerful movement, both artistic and cultural, to which only Ginsberg gave full effort.

Walking south toward Market Street, I come amid a lively crowd that favours headbands and jaunty hats, wraps itself in bath-robes and blankets, is befriended by congenial dogs, shows lots of attitude. A shopping-cart person shouts across the street: "Hey, what's goin' on, big brother?"

"They took me to jail, sixty-three days!"

Continuing down Market to more genteel regions, I aim at glimpsing any here who are "mad to live, mad to talk, mad to be saved, desirous of everything at the same time." Well, at a café I find a photo-buff husband beside his bored wife, a pantsuited woman examining her brochures, a young Japanese man with an iced tea for

his map-study session. Nearly qualifying, I would say, are two girls in front who merrily chat on and on, travel guides unopened.

The touristic epicentre is at Powell and Market, where buskers entertain those awaiting the obligatory cable-car ride. For Ginsberg a 1955 peyote vision made the Powell Street trolleys seem to utter cries unto Moloch, the Canaanite fire-deity receptive of child sacrifice: Allen perceived its eyes in smoke-wreathed upper windows of the Drake Hotel, in the basement of which he wrote "Howl II." These lines, not given in the Six Gallery reading, lent a horror-film note when added later to his poem.

On Grant Street one ascends toward Chinatown and its tantalizing window displays. Lawrence Ferlinghetti in "Note on Poetry in San Francisco" spoke of walking though with "a famous academic poet" who "never saw the whole schools of fish gasping on counters, nor heard what they breathed." That poet is ostensibly Robert Lowell, who did adapt to local verse style by shearing away heavy symbolism (in the T.S. Eliot manner) and attempting more colloquial expression. Ferlinghetti regarded this new poetry to be "using its eyes and ears as they have not been used for a number of years." The academic poet, he felt, had "literally forgotten (taken leave of) his senses."

To the vintage Sam Wo eatery after the Six Gallery reading, Snyder brought a number of elated poets to order off the Chinese menu. He impressed Kerouac with his voice — "deep and resonant and somehow brave, like the voice of oldtime American heroes and orators" — and with his Buddhism, which underpinned the Beat yen for freedom.

Sam Wo's evokes a starkness I felt in 1930s California. One enters by its kitchen, where a broth is on the boil: "Dropped egg soup. Very nutritious. Try." Upstairs, the small and reticent waitress attaches my order to a cord and tosses it into the dumbwaiter — operative since this became an eatery in 1931 — and presently my soup, a meal in itself, is hauled up.

Here a man in a CAUSING EXTRAORDINARY RESULTS T-shirt recalls a Zen master who once sat here, Buddha-like, telling patrons what to order. "Zen waiter in heaven now," adds our server in an update.

City Lights Bookstore

Lawrence Ferlinghetti, co-founder of City Lights Bookstore, served as a U.S. Navy submarine chaser's captain during the Normandy invasions, then was shifted to the Pacific to be in Japan on the first day of occupation. Visiting Nagasaki after it was devastated by an atomic bomb was profoundly shocking: "You'd see hands sticking out of the mud." Ever confrontational, this Sorbonne PhD and successful businessman was listed in an FBI file as "a Beatnik rabble rouser." Recently, he has targeted the massive bureaucratic response to 9/11 as a reshaping of U.S. paranoia.

I'm struck by his comment in the Morgan guidebook that "a time of increasing American materialism, militarism and repression of freedom" has come again, and the land has "need more than ever of the Beat message" given in the book. Yet he frowns on overstressing the Beats, and on a whim I drop off a self-addressed envelope with a note seeking clarification.

Ferlinghetti pioneered locally in verse-accompanied jazz. Five hundred people vied to enter the minuscule Cellar (then at 576 Green Street) in 1956 when he joined with Rexroth to initiate a regular Wednesday "Poetry and Jazz Night." Their Fantasy LP made with the Cellar Jazz Quintet became among the best known of such discs, as readings spread across the country following the Six Gallery event.

Wedding jazz to poetry is a special art, in which Kerouac also triumphed. Here, bandleader Bruce Lippincott "set up as the first rule — listen to each other," writes Peter Davis in Ralph Gleason's *Jam Session, an Anthology of Jazz.* "And second — respond with our instruments as emotionally as possible to the *words* of the poem and also the pre-arranged form."

The Beat Literature section is upstairs. City Lights was conceived as a Parisian café, where patrons might read at little tables, and that I do by a window looking onto a clothesline of laundry. Pilgrims arriving today — the backpack-bearing young, grizzled souls possibly from the first Beat era — behold dozens of titles, the product of a vast Beat renaissance.

Facing what is now Kerouac Lane, City Lights Bookstore (here viewed from Vesuvio Café) is named after the 1931 film by Charlie Chaplin, whose Tramp was much admired as "the little man against the cold cruel world." It has a Poetry Room designated as the store's founding site and is a literary landmark.

The Dharma Bums shows Kerouac's adherence to Snyder (Japhy Ryder in the novel), quite different from Cassady though also keen about sex. He was adept at the Tantric Buddhist "Yab-yum" or "father-mother," whereby a couple would strip to assume the lotus posture of sexual union, denoting enlightenment. Snyder climbed a mountain with Kerouac, also to gain illumination, before going to Japan in May 1956 for Zen Buddhist studies and was seen off by friends in a touching scene at the pier.

I open the City Lights Books edition of *Howl and Other Poems*, some 800,000 volumes of which have been sold. In 1957 Ferlinghetti, having published *Howl*, was booked and fingerprinted on obscenity charges (at the Hall of Justice, then facing Portsmouth Square). This very store became part of a civil-rights battle, long waged by police against the gay community and now focused upon a book.

Ferlinghetti was defended by the American Civil Liberties Union's counsel Al Bendich, who summed it all up later when giving him a civil-liberties award: "If poets reveal the deepest truths of ourselves to us, they also reveal what prevents us from realizing our humanity. And so poets must be free to think and feel and express themselves; and we must be free to hear them."

Prosecuting attorney Ralph McIntosh, to prove that the poem had no merit, called as witnesses an English professor declaring it to belong to a defunct movement called Dadaism and a diction teacher offended by language said to be of the gutter. Judge Clayton Horn took two weeks to read Joyce's *Ulysses* and then to analyze *Howl* in detail before giving his verdict of exoneration.

The poem's first part gave "a picture of a nightmare world," he said, and the second "an indictment of those elements in modern society destructive of the best qualities of human nature." The third portrayed a specific person (Carl Solomon) as a "specific representation" of what those elements produce. And "Footnote to *Howl*," said Horn, "seems to be a declaration that everything in the world is holy, including parts of the body by name. It ends in a plea for holy living."

Here, at City Lights, are several editions of *On the Road*, finally brought out by Viking in 1957. Future rock star Jim Morrison, who read and immediately reread the novel to copy down favourite

passages, on Saturdays would haunt City Lights and once said hello to Ferlinghetti, but fled when he returned the greeting. Much taken with the image of Cassady's raw energy, Morrison imitated his "hee-hee-hee-hee" laugh.

Kerouac received advance copies of *On the Road* when living in Berkeley, he and Memere having come west from North Carolina (where Nin lived) with the thought of settling here. Even before opening one, he witnessed the arrival of Cassady, LuAnne, and Al Hinkle — who in *Jack's Book* recalled that Jack stood there "dumbfounded," whereupon Cassady began reading passages and, on nearby rafters, "chinning himself and swinging from these things and playing monkey." Kerouac stated that all would be angry at him. "But he didn't elaborate on it. And everybody told him, 'That's impossible.'"

LuAnne recounted much the same, his "explanations and apologies" given no heed: "We were reading a line here and a line there and reliving it and laughing and remembering." And Kerouac even then was mentally recording details potentially usable in *The Dharma Bums*, published the next year (though without this episode).

All drove into the city for celebration at a Sixth Street Bar, where LuAnne was rejected for lacking ID (though she was then in her mid-twenties) and Al had to leave early for work. So she imagined that Kerouac felt much as when Cassady had left them on Market Street eight years before — "that he was kind of deserted." Reading the book, she saw how much had been "either left out or added to" while realizing that everyone would have a unique response and thus "had to remember that this was the way Jack was feeling it and seeing it."

Carolyn said of her family's *On the Road* (in black cloth with white lettering now faded to read only E ROAD), "Jack tossed a copy to Neal without signing, since we didn't know then it might matter."

NORTH BEACH

When the cultural scene in North Beach was made known by a 1957 *Life* article, hangers-on came from across the land. The term

beatnik was coined that year by *San Francisco Chronicle* columnist Herb Caen — Russia's *Sputnik* space satellite then being new and "far out" — who was seemingly unaware of the term's derogatory flavour.

"They've made their capital in North Beach — the 'Left Bank' of the West," said the *San Francisco Examiner* in 1958. It reported a lingo largely foreign to the Beats themselves — "I just had a narrow escape, man, I almost found a job" — and in June, the death of a musician from falling off a club's roof; his girlfriend was shortly found strangled. The cultural war over "values" began to accelerate.

In July 1958 the ladies' room of the Co-Existence Bagel Shop (formerly 1398 Grant) was blown up. The next month a hundred regulars mocked local Gray Line ventures into North Beach by penetrating the oglers' own domain on a "Squaresville Tour" of fashionable downtown spots, not at all to their amusement. In September the Alcoholic Beverages Commission, declaring North Beach a "problem area," stopped issuing liquor licences.

Cassady, an obvious target for such criticism, in April 1959 accepted a ride with two undercover policemen and, offering to give "some pot for your trouble," provided three joints. This cost him a 787-day term in San Quentin. A reporter claimed to have learned from police that Neal led a gang smuggling marijuana from Mexico on Southern Pacific trains — though his own went nowhere near Los Angeles — so that later he couldn't regain his old job.

Kerouac sent money, through Allen, for Neal to have a typewriter in jail. And the police didn't initially identify Cassady with Dean Moriarty, Carolyn points out, nor did Neal condemn *On the Road*. Jack didn't correspond with Cassady in prison, she explains, as this was allowed only for women and his godfather, Harlan Fischer — he who had been overjoyed at reunion with Neal during the Cherry Mary episode.

Number 1398 has been converted to video rental but still draws nostalgic visitors, as the cashier explains: "People stop, scratch their heads and ask, 'Hey, how come the Bagel Shop's a video store?'"

Washington Square Park has a statue of Benjamin Franklin, whose work ethic Kerouac followed — albeit drinking himself into a stupor on his final California visit in November 1960. He

The statue of Benjamin Franklin (left foreground), ominously dedicated "to our BOYS and GIRLS who will soon take our places and pass on," looms in front of Saints Peter and Paul Church and over decaying neo-hippies now inhabiting Washington Square Park. One neo-hippie introduced me to his friend as "Katrina, what's left of her."

had a gallon jug of Tokay wine when his poet friend Philip Whalen brought him here to dry out in the sun.

Ferlinghetti had offered Kerouac his cabin in Big Sur's Bixby Canyon, where he might quietly edit *A Book of Dreams*. Carolyn stresses how he loved to get away by himself: "To mountaintops. Taking sensory pleasure in a leaf. Where he didn't know anybody." Where he was less likely to feel unworthy, that is: "He was capable of overwhelming affection. And trying to avoid temptation. Then he would come back and party." Not alcoholic when she first met him, Jack decidedly became so when literary success palled and he said, "I'm going to drink myself to death."

Kerouac made that last San Francisco trip secretly and kept sober while in his train compartment, but spoiled the idyll by rushing directly into City Lights and thus joining old friends. He would have been taken by Ferlinghetti directly to Big Sur to meet Henry Miller, but kept drinking so long at the Vesuvio that he missed his ride. He embarked on a two-day drunk while at the Mars Hotel (192 Fourth Street; demolished), and thus the two never met.

Kerouac did have a three-week campout at Big Sur, returned to San Francisco for an epic binge, was rowdily driven to 18231 Bancroft (offending Carolyn by his state), and visited Cassady, newly released from jail, at the tire-capping job he held after Southern Pacific let him go. Jack, set up with an ex-girlfriend of Neal's, experienced a night of madness at Big Sur from which emerged a revived Buddhist/Christian faith, "simple golden eternity blessing all."

Fast-forward to July 22, 2001, when a four-city marathon reading of *Big Sur* brought the Cassady daughters together to read Chapter 23. It mentions a young Englishman, Ron Blake (Paul Smith), said to be "redhot" for Evelyn (Carolyn Cassady) — obviously so attracted to him that when "little Timmy" (John Cassady) tells his dad, "We shoulda brought Mommy with us, her pants got wet in the beach," Cody (Neal) "matter-of-factly" remarks, "By now they oughta be steamin."

Carolyn went on to do Smith's oil portrait, now hanging in her Bracknell home. "Just one of those chemistry things, just kind of fun," says she of their mutual attraction. Carolyn also recounts her amusement at the talk between Kerouac and poet Lew Welch on

that occasion: "No way to explain how funny it was, I wish I had Jack's ability to remember what they said."

She cites "slapstick shenanigans" by him and friends that made her stomach ache from laughing, while Jack himself omits all this from his account. Now in their very last moments spent together, she was irritated by Jack's "unmistakable soulful looks and suggestive remarks and invitations," and he sensed that "we're all strangers with strange eyes sitting in a midnight livingroom for nothing." Emotional specifics conveyed by her, and by him, a cosmic sense of futility.

The Lost and Found Saloon, at 1353 Grant opposite the Bagel Shop's site, was a beatnik spot called the Coffee Gallery in 1963, offering an "Orgy of Poetry: Beat poets, neo-classic poets, strange poets, jazz poets, white rabbit poets, metaphysical poets." The bartender admits to having been in the area since 1944: "Forty-four, my God, where have the years gone? Man, enjoy it because one day

Janis Joplin, who came to North Beach from Texas after reading On the Road, *sang blues in the Coffee Gallery's backroom (now the Lost and Found Saloon, here viewed from the former site of the Bagel Shop, now a video store). The bartender, asked about Joplin's ghost, replied, "Yep, she's still here!"*

you're thirty, forty, fifty — then it's over." Dolefully, I mull over num-bers well below my own.

Ken Kesey, once a regular here, worked on a North Beach novel, *Zoo*, before participation in government-sponsored tests involving LSD ("acid") gave rise to his 1962 novel *One Flew Over the Cuckoo's Nest*. Neal identified with its protagonist, R.P. McMurphy (R.P.M.), a small-time gambler rebelling against a mechanistic "Combine" rul-ing the mental hospital where he's been placed.

Neal, displaced by Snyder in Kerouac's esteem, in turn attached himself to Kesey and acid-loving confederates known as the Merry Pranksters. Divorced by Carolyn in 1963, he went back on the road the next year as driver of an old school bus taking them east to cele-brate the publication of Kesey's second novel, *Sometimes a Great Notion*, in New York.

The Pranksters in 1965 showed movies of their road trip, ultim-ately at public events where those paying admission would get a cup of LSD-laced punch — "electric Kool-Aid" — and those who made it through the night were said to have "passed the Acid Test." The Grateful Dead would play at these, foreshadowing the mammoth kind of rock concert — a contrast with sessions by jazz musicians who would gather briefly to blow hot notes in some dark venue.

One Lost and Found regular bluffly asks another what's the matter with him lately. A murmured response indicates that his doctor has given him one more year. Gamely, his friend searches for an appropriate response, finally citing a lump in his armpit. "Got one more to go, got one more to go," the man repeats. Death, a central preoccupation of the Beats.

Students in 1965 tried to halt troop trains entering the Oakland Army Base but were opposed for patriotic motives by Hells An-gels, who later met with anti-war organizers and Pranksters in the Oakland home of tough Ralph "Sonny" Barger. As accusations of Prankster involvement in a Communist plot flew, Ginsberg got out his harmonium and began chanting the Prajnaparamita ("Highest Perfect Wisdom") Sutra. A disruptive Angel named Tiny contrib-uted words of his own — "Om, om, zoom, zoom, zoom, om!" — until all participated, in what Ginsberg saw as a historic moment of mantra-chanting for peace. His courage made the Angels decide

that "the queer little kike ought to ride a bike" and to inform the press that they wouldn't lower themselves by attacking such filthy Communists.

Well-publicized trends concerning the Beats had two opposite effects on public opinion: hippiedom perceived as self-indulgently lacking in political involvement, and Ginsberg-style dissent showing

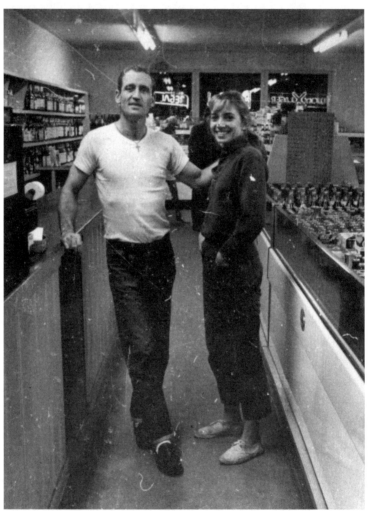

Neal Cassady at several Acid Tests made a raunchy vaudeville duo with girl-friend Anne Murphy (seen here at a shop in San Francisco in 1963), in whom he instilled one main message: "You are created for the experience of joy." Photograph courtesy of the Allen Ginsberg Trust.

too much of it. Wrong, no matter what. A price paid by the Beats for Allen's stance was their breakup, as Kerouac openly disdained his friend's anti-establishment ways.

FISHERMAN'S WHARF AREA

New York Yankee great Joe DiMaggio was known for having a father who toiled on a boat operating from Fisherman's Wharf. Huge fish-factory ships made such trade obsolete, and jet-age travel transformed the wharf into a kind of processing area for tourists. Nearby Longshoremen's Hall has a memorial to the 1934 strike that disrupted my father's employment with Matson Lines and led to our family's exodus.

The Trips Festival was held here by Kesey and the Pranksters on January 21–23, 1966, the Grateful Dead performing amid all-night dancing. Here Kesey wore a silver space suit with bubble helmet, commanding a projector-amplifier control tower while Neal

Now that prosperity supplants the harsh conditions of the Great Depression, the Longshore-men's Hall in the Fisherman's Wharf area of San Francisco is a regular venue for rock concerts, though union members here still remember the divisive 1934 strike.

dangled from a balcony railing above the crowd. Ginsberg reconciled such opiate events with political activism across the Bay, en route to starring at the Human Be-In. Strange new possibilities beckoned.

Kesey, shortly arrested for marijuana possession, faked suicide and fled to Mexico with the Pranksters in futile pursuit. Neal appears as "Sir Speed" Houlihan in Ken's screenplay about this episode, called *Over the Border*, in terms of flight both geographical and inward to the collective unconscious. In October 1966, Kesey, having cleverly re-crossed into the United States, staged a public "Graduation from LSD" aimed at moving the audience onto a new plane, and the next year was briefly jailed (after two hung juries) on a minimal drug charge.

In 1967 Carolyn Cassady and Helen Hinkle attended the final Acid Test, laughing at themselves amid a spectacle dominated by Kesey in Superman attire. That year she reluctantly let Neal take John, then fifteen, to a Grateful Dead concert, and filmed them afterwards playing catch with Kesey. Neal's offspring loved their father's account of bus adventures, but Carolyn cautioned him against narrating "the group's drug or sex capers" in too much detail: "I began to see the writing on the wall."

Widespread now was the term *hippie*, derived from the jazz-appreciative word *hep* and meant to be synonymous with *beatnik* — though coined by "hipsters," ironically, to describe the unhip. Buried beneath all this was the term *beat*. Jack disavowed hippiedom, as did Carolyn in the effort to protect her children. "They were the real horrors, to overthrow convention," she says. "Threw the baby out with the bath water — faith in universal order, that's what they tried to throw out." Yet Ginsberg embraced this as a true legacy of the Beats.

LuAnne tells in *Jack's Book* of being a few times on the Pranksters' bus (called *Further*), noting the desperation with which Neal repeated his sledgehammer-flipping act again and again, and also shared a last moment not long before his 1968 death in Mexico:

> It was really an upsetting visit. Neal and I had seen and said goodbye a thousand times, but that time, we went to a restaurant and had a cup of coffee, and he just took hold of my hand and he said, "Where am I going?" He

said, "I'm so damned tired I don't want to go anywhere."
… Neal always lived like time was short. Time was always too short. From the time I met him he didn't have enough time.

It's time for me also to head out, on Cassady's well-worn path to Mexico. As my bus heads south, low cloud that diffuses sunlight into rays begins to shroud the hills of San Francisco Bay.

Rough and Hard and Extreme

Mexico, 1950s–1960s

5

To Nuevo Laredo

On an overnight Greyhound continuing my trip, the next morning I'm startled to read FUCK THE POLICE on the jacket of the passenger in front. Tenderly, his girlfriend, CRIMINALS, lays her gel-plumed head alongside his: intersecting brooms. Next over are their equally punk companions: KEEP WARM/BURN OUT THE RICH, a pleasant blond kid; and the very pretty FUCK AUTHORITY (USE A CONDOM). Keen affection flows among this foursome, and I wonder what Burroughs would say, having been given the label "godfather of punk."

Heading eastward from Los Angeles through Arizona, I meet Claire, a nurse from England, who looks after women with breast cancer. Graphically, she describes this malady's advance through the lymph nodes, weakening the body so that the pelvis, in time, will snap. Why do some rebound from the pain to go on, while others retreat into self-pity? Similarly with cross-country bus travelling

— why would both of us want to do that, while others stay home? Somehow she got the urge, booked her flight, boarded the bus, headed west, and then attained her basic goal: dipping her toes in the Pacific.

My Greyhound comes into Laredo, Texas, and almost to the Rio Grande bridge, which I cross by foot to Nuevo Laredo. "Welcome Mehico," said the immigration officer to Sal and Dean at the checkpoint in 1950. "Don't worry. Everything fine. Is not hard enjoin

Nuevo Laredo's main street presents children selling bubble gum, big speakers on the pavement blaring music hits, thick plastic Last Suppers, Your Name on a Grain of Sand, redemption voiced by an angry evangelist flaunting his Bible, and posters of Eminem, Jesus Christ, the Virgin of Guadalupe, and the Beatles.

yourself in Mehico." I'm let through unprocessed, however, amid a thick pedestrian stream. It was the men's final big car trip together, Mexican cash of huge spending potential stirring wonderment.

A cab brings me to the Central de Autobuses and a grandiose Guadalupe presiding there: sunburst and crescent moon, festooning beads, robe upheld from below, flowers and candle flames at her feet. The mother of every Mexican, she conveys Catholicism's sensory appeal that Puritanism has long disdained.

My Turistar Ejecutivo coach departs at 3:53 p.m., and for the first time I'm on a bus with music, infectious Latin rhythms. "We had finally found the magic land at the end of the road," Sal declares, "and we never dreamed the extent of the magic."

Northern Mexico

We stop at Loncheria el Pelón Ruben (Bald Ruben's Lunch Spot), enriched by blowups of Marilyn Monroe: *la rubia que todos quieren*, the blonde everyone wants. A patron twirls his moustache beneath a photo of the *Bus Stop* Marilyn, her purse strings descending just like Guadalupe's beads.

In close-up now, Sal and Dean glimpse the "fellaheen" as described by Oswald Spengler. The Beats found in this German thinker's *The Decline of the West* a rhythm of three historical phases: the primitive, the imperial, and finally the fellaheen emergent at the collapse of empires.

Jack's French ancestors, having built their St. Lawrence River colony into a continent-wide empire, suffered defeat yet continued on largely as peasants who, like the Kerouacs, fled to industrial America.

Our coach's route is more direct than the old jungle-and-mountain road through Tamazunchale followed by Jack and Neal (which I also took on a first trip to Mexico with my then-young family). Heavy Spenglerian constructions were placed upon the panhandling fellaheen: atomic-bomb apocalypse having come, Americans were destined to sink as low.

In a 1967 magazine article, Kerouac recounted kinfolks' enjoyment of Christmas ritual observed "much as it is today in Mexico" — a land fervently Catholic as Quebec once was. Yet a Bible-reading passenger, Sergio, was happy to convert from Catholic to Protestant worship through radio evangelism. "Our culture never had a Bible," he says, explaining how his Illinois-based Bible-donation group operates. "Spain conquered Mexico a long time ago, but now there are new ideas, an international network."

Sergio once took over from an ailing relative to run a small company manufacturing truck transmissions. "Workers were used to profits every year, but many drank a lot. They were irresponsible." The sinning of Adam and Eve is responsible for this, he feels: "From then on the whole world was cursed. It became the devil's workshop."

Sergio has no use for Catholic saints. "Why are we so poor, so many injustices?" he asks. "Guadalupe, that's the darkness of ignorance." Here's the Protestant mindset, such as the English brought to Catholic Quebec through conquest. Kerouac, to a large extent, clung to the old beliefs.

After several hours' travel, I awake in darkness to find the bus stopped in wide-open country. Silence. Rich aromas from the earth. A patch of mackerel sky backlit by the moon.

I wander into a cantina, embers glowing beneath pots. "How are you? Where are you going?" the affable brown proprietor calls out. "Mexico City! It's hard. Twenty million people, biggest in the world." I down a tortilla, take another whiff of the fields, and re-enter the bus for the final lap.

MEXICO CITY

Dawn brings a dramatic vision of streetlamp-threaded hills, black against golden clouds: Mexico City. Amid traffic swarms we pass corrugated factories, ramshackle communities outspread on hillsides, Christ colossal in the smog.

At Autobuses Norte, lovely clerks with elaborate hairstyles, earrings, full makeup, gum-chewing allure arrange for my outbound ticket, and then the city is mine.

Outside on the streets, things are more subdued than as shown in *On the Road*, where Dean delights in crazy Indians tooting and cutting across in cars with no exhausts. And Sal, ill with dysentery, is abandoned by him here — a move necessitated in the case of Jack, Carolyn tells me, by Neal's urgent need to keep his railway job. Here are the book's dynamics: one whole-hearted man poised against another who is full of doubts.

I ride the Metro, direction Pantitlán, to its first connection: *la Raza*, the Race. Dirección Universidad: a darkened passageway presents our universe, stars glowing overhead. Pushing onto a packed train, the doors pinching my coat behind, I face *la Raza* — slumbering on its feet: consciousness lost, adrift in the universe.

One more transfer brings me to Sevilla station on Chapultepec, not far from the park of that name. Hereabouts in 1951 lived Burroughs with his family, recently arrived from Texas. Studying ancient Middle American customs at nearby Mexico City College, in May he met a twenty-one-year-old American, Lewis Marker, who accompanied him on a futile South American hunt for the hallucinatory

The direst of all Beat episodes, the shooting of Joan Vollmer Burroughs, occurred in Mexico City close to this aqueduct fashioned by the Aztecs, who practised large-scale human sacrifice.

drug yage, thought to enhance telepathic powers. In early September after his return with Marker, he was very much depressed, and the aftermath of Hurricane Dog made things worse with heavy rain and winds.

Carr and Ginsberg came by automobile for a one-week stay in August, taking Joan on a wild mountain trip. There's a story that she was suicidal, and that she also had an affair with Lucien. The men returned north after leaving her and the children at a bus stop.

On the Internet, James Grauerholz, Bill's long-time companion and secretary, has posted what seems to be a definitive account, "The Death of Joan Vollmer Burroughs: What Really Happened?" A bullet wound killed Joan, that is certain, though mystery surrounds the rest except that Burroughs spent thirteen days in jail, was found guilty of *homicidio*, and was released on bail.

Three blocks down calle Monterrey at calle Durango stood a Cruz Roja (Red Cross) hospital. On September 6, at the family's calle Orizaba home, Burroughs began drinking heavily, and Joan also

At 122 calle Monterrey, William Burroughs would enact routines (charming and seducing the heterosexual Lewis Marker) and under a bad star performed the William Tell shooting that claimed Joan Vollmer's life.

did so. Here, at around 7:30 p.m., a phone call was received, stirring the *comandante* to send an ambulance and pick her up at 122 calle Monterrey. Grauerholz states that "after her death, someone placed a Mexican saint's-relic pendant on her breast, as a blessing for the dead," and there's a photo showing this.

The emergency personnel found the "lady Joan Vollmer Burroughs seated on a little easy chair covered with pink cloth, with a wound in her forehead from which flowed abundant blood," reported *El Universal*. On the dining room table, it said, lay "a .380-caliber Star pistol" and upon the floor "the glass that served as the apple of the modern William Tell."

Also on Monterrey at number 122 stands an apartment block with ground-floor businesses. Left of the entrance in 1951 was found a bar, the Bounty. Burroughs's friend John Healy, its owner, had apartment 10 on the third floor overhead. Here on September 6 were Marker, his friend Eddie Woods, thirty-five-year-old Betty Jones, and perhaps others. Ted Morgan, in *Literary Outlaw: The Life and Times of William S. Burroughs*, shows that Woods saw bad influences on Marker by Burroughs — who, around six o'clock, appeared with Joan while carrying that Star pistol, seemingly to sell it to MCC student Robert Addison, who failed to show up.

"Joan sat in the stuffed chair across from Lewis and I on the sofa," said Woods in 1985, giving the most detailed account. He reported Burroughs saying, "Put that glass on your head, Joanie, let me show the boys what a great shot old Bill is."

This she did, and with a giggle said, "I can't watch this, you know I can't stand the sight of blood." Did she know that this pistol shot low?

"And then it dawned on me, he was actually going to pull the trigger," Woods recalled. The gun went off and there was the glass, "rolling around in concentric circles on the floor." Seeing Joan's head "over to one side," he believed her to be joking: "That's the first thing you think, and then I heard Marker say: 'Bill, I think you hit her.'"

Woods recounted this sequence of events to his sister, June Overgaard. "You know," she said in 1985, "I always took everything with a grain of salt." She herself added word that the Burroughses were planning a move to South America and yet Joan said, "We'll starve to death, if we go up there and — because you won't be able

to shoot, you'd be so shaky." That is what prompted the stunt, said Overgaard: to "prove that he could shoot still."

Marker was also interviewed by Morgan on tapes showing, says Grauerholz, that he "becomes noticeably drunk and slurred." Though he couldn't recall the William Tell routine having been done before, Grauerholz in a 2003 addendum cites a report that Burroughs had earlier been seen shooting a piece of fruit off Joan's head.

Both Woods and Marker shortly "turned into ants," said *La Prensa* — that is, disappeared — as Mexican attorney Bernabe Jurado took on Burroughs's case and eliminated the William Tell story altogether. Grauerholz in 2003 also cited new evidence that "as much as $20,000 may have been paid by Burroughs's family" to Jurado, much of it used for bribes to ballistics experts upholding a view that the gun had fired accidentally.

The press took up a story that Joan had become involved with Healy, prompting violent action by Burroughs, who promptly issued a denial: "I loved my wife and I had no reason to be jealous." And never was doubt cast on Woods's observation that the shooting caused him to go into shock after shouting, "Joan! Joan! Joan!"

Joan was shot of her own volition, said Carr, who believed that she was suicidal. Chase indicated the same. "She wanted to die, and offered Bill a chance to kill somebody," said he to Morgan: the William Tell business was a "sham," and her death "a put-up thing to release Bill, to let him commit 'the ultimate crime'" — he was childish about things like that."

So here we might find that youthful New Vision grotesquely realized. Fulfilling spiritual potential through personal experience: it might seem viable and yet takes a toll.

I continue to the calle Orizaba residence, apartment 5 at number 210. In May 1952, Kerouac arrived here on his second Mexican trip, just having begun the love affair with Carolyn. He had been invited by Burroughs in a letter referring to local pleasures such as bullfights and also applauding Jack's new power of expression.

Kerouac wrote *On the Road* with a benign future lying ahead; *Naked Lunch* emerged from Burroughs's lengthy conflict with "the invader, the Ugly Spirit," which darkened his days after the loss of Joan.

Late in 1952, Jack resumed the affair with Carolyn, and in December was conveyed to Arizona by her family for another bus trip to Mexico City. She was later given a chance of visiting him here; had her conscience permitted that, I wonder what might have been the result. With Bill now departing — a picture of Carr and Ginsberg the last thing tossed into his bag — Jack rented a rooftop adobe cell until he abruptly took a bus back to New York.

On Mexico City's main square, the Zócalo, I take room 206 at the Majestic Hotel, opening a window to admit the sunlight, breeze, and hubbub. Then I head up to the rooftop restaurant for Mexican-style fare and a wider view taking in the cathedral. Here in Aztec times stood the god Quetzalcoatl's cylindrical shrine, skulls piled nearby on racks.

Not far is a large remnant of the Aztecs' volcanic-stone Great Temple, a pyramid dedicated to Huitzilopochli and Tlaloc, controllers of the sun and the rain. On Snake Hill, represented by this very pyramid, Huitzilopochli kills his enemies to gain command before conducting his people to what is now Mexico City. Denied

"Perfect place to write, blast, think, fresh air, sun, moon, stars, the Roof of the City," Jack Kerouac wrote to Carolyn Cassady in December 1952 from 210 calle Orizaba in Mexico City (rooftop cell visible above the white vehicle's hood).

This statue of an eagle grasping a snake, near Mexico City's central square, portrays an image also on Mexico's flag. An enormous flag is raised with elaborate military procedure here each morning.

any proper place to settle, the Aztecs observe an eagle perched on a cactus, and here, lifting mud from swampy ground onto rafts woven of rushes, they create the solid ground on which their holy city rises. It's Mexico's foundation myth, like that of Plymouth Rock for Americans.

Crisis in Burroughs's family — his children dispersed among kinfolk — gave Jack much to consider about his own childhood. On a notebook's first page he wrote, "A novella of children and Evil, the Myth of the Rainy Night" — a title replaced later with "Dr. Sax." The World Snake is ultimately shown being carried off by a giant bird, to imply a union of earthly and heavenly forces.

An evening stroll takes me to calle Chile, abounding in bridal-item stores — entire streets being devoted to one trade as in Aztec

practice — and six blocks show mannequin brides with outstretched arms and fixed stares. Mirrors reflect these ghostly phalanxes: infinite resources of the feminine.

Farther north on calle Oregano were the brothels well known to Kerouac. Virgin and whore: a dichotomy ingrained by his Catholicism. Here he often was in 1952 while writing *Dr. Sax* — long unpublished for being too wildly surrealistic, yet seen now as his major stylistic triumph.

And truly surreal is a burlesque show offered at the Nuevo Teatro Garibaldi, near the touristic plaza of that name. Every stripper is admired for a special element — youthful ginger or mature aplomb, fiery slimness or humid amplitude, erotic potency or awed self-surrender — and all submit to caresses on their runway tour, rebuking any who are not gentle.

It wouldn't be far-fetched to see this devotion imbued with elements of Guadalupe. "In Mexico," says Carlos Fuentes, "the impossible distance between desire and the thing desired has given both yearning and object an incandescent purity."

There's also vaudeville. A bony old man crooning sentimental songs is admired for his defiance of time, his will to express romantic feeling. Comedy would be booed off the stage, one might think — but no, popular as well is an entertainer playing a priest whose talk about Higher Things shrouds perverse motives.

Mexican religion once celebrated divinity in animals. To understand this concept, better than ethnological theory is the ultimate challenge now given by a commanding blonde. As several males venture onstage, she impatiently tears off their clothing — revealing those private parts that make *la Raza* so fertile — but only one individual has the manhood to make the required linkage. She calls for a round of applause as our show ends.

During a 1956 visit, Jack completed *Tristessa*, about the drug use of a prostitute named Esperanza Villanueva, and demonstrating the Buddhist notion that all life is suffering. For a full year he tried celibacy (as told in *The Dharma Bums*) from a feeling "that lust was the direct cause of birth which was the direct cause of suffering and death."

Ginsberg that year arrived with three friends, and in Alameda

Park by a fountain they posed for a photo with Kerouac — fit, weighing only 155 pounds — on his penultimate Mexican visit. Its paths leading diagonally by ornate metal benches and heroes' busts evoke the old-world mood often felt in this land.

Four schoolgirls dart in to ask for help with their homework, and I reply, "Sí." But they need English on their audiotape, and when I supply an exaggerated *yeahhh* they're overjoyed — one girl flails both arms for sheer delight — and even more so when they play back the tape, exploding in mirth. And so on, through twenty-two questions, whereupon I overstatedly kiss their leader's hand before the girls go whooping and hollering to cap their media triumph.

SAN MIGUEL DE ALLENDE

On my return trip to Laredo, lands near Mexico City I had earlier passed in darkness are now visible: many flat fertile areas, cattle, always the outline of distant hills. After three hours, there are signs for turnoffs to San Miguel de Allende, near where Neal Cassady died.

Late in 1967, he had held his newborn first grandson (for the only time) in a San Antonio hospital. That was William, whom Cathy had borne after marrying a newly drafted man. Carolyn says that William, grown up, once made a trek to research his grandfather's fate in Mexico, but mysteriously returned without completing it.

With several traffic warrants against him, Neal managed to cross over into Mexico as if part of a film crew, and proceeded to San Miguel de Allende by train. He then went to a colonial home rented by girlfriend Janice Brown, who was working at the theatre of the Instituto Allende. On February 3, 1968, the two quarreled. Cassady's baggage had gone on to Celaya, forty minutes farther to the south, and he went to the local station to await a train that would let him go there and retrieve it — a "magic bag" holding such personal items as a Bible and letters from Beat friends.

An adobe church adjoined the station. Neal is thought to have been drawn to wedding festivities there and downed quantities of

pulque after having taken Seconals all day. Yet he had "a very delicate stomach," Carolyn informs me, and thus simply did not drink "anything but a few beers" at any time. "Spirits made him very ill, too," she adds. "He would only sip some wine when having a celebration dinner with Jack. Obviously, he was dead set against wine, and after his youth with spirits, he gave them up, too."

Carolyn acknowledges "a few reports from strangers that he did drop in on the wedding reception," and speculates about whether he had been "asked to toast the bride with a glass of wine, even knowing it was dangerous, having just swallowed so many Seconal." Not "all day," however, as "he had just arrived."

She once discussed this with Ken Kesey, who agreed that "Neal would have done that. No way could he say, 'I'm sorry, but I can't.' The pulque would have made him vomit for hours. No way."

Neal began walking toward Celaya along the tracks and, after a quarter-mile, collapsed. Found the next morning in a comatose state by an Indian named Pierre de Latra, he was taken to the home of another friend in town, identified by a scribbled note on his person. In a small local hospital he was pronounced dead of "general congestion."

Janice phoned to inform Carolyn, who quietly told the children what had happened: "We sat in silence for a few moments, of one mind and one prayer."

Varying accounts of Neal's death were given by Janice. Carolyn, doubting suicide, felt that he might have taken a risk or, conversely, acted in a drug haze with little idea of what he was doing. A true autopsy wasn't reported. "There were drugs involved, and he was a foreigner," she tells me. "There has never been any mention of 'over-exposure' except by journalists. The only autopsy report was 'general congestion' or 'all systems congested.' I have that death certificate. We'll never know the truth, but renal failure also shuts down all systems, and that sounds a reasonable scenario for Neal."

Neal's body had to be cremated, she informed Janice, who told of seeing his face rather than her own in a mirror. Finally, the remains were taken on to Mexico City and burned. When I asked Carolyn whether Neal hoped for a quicker release of the soul through cremation, she replied, "There is no 'he hoped.' He and I agree with

the Hindus and higher teachers that fire purifies the cells and speeds the transit onward."

Off the Road portrays "J.B.," this harmonica-playing figure in a poncho, begging for glimpses of Neal's ashes after his demise on the town's outskirts. "She was out of her head," Carolyn tells me, "and thought Neal was still with her, kept talking to her."

Robert Stone's novel *Dog Soldiers* shows Neal (Ray Hicks) as someone for whom there's "absolutely no difference between thought and action." He dies on railway tracks having accepted life as unpredictable, having chosen "the worthiest illusion" among many that existence offers.

Neal after his death was represented by Kesey as the title character of "The Day After Superman Died," whose final words, "Sixty-four thousand nine hundred and ninety-eight," pose a mystery until it is known that he had counted all railway ties to the point of his demise. This is given as an example of hopeful striving: "that faith that saw him through his lapses had become a faith for everybody that knew him, a mighty bridge to see them across their own chasms."

Neal counting railway ties at the end: as if anyone could have known. "Another myth that will always stick," Carolyn reflects.

On my Greyhound adventure's last lap, I meet twenty-something Sarah, well versed in Kerouac. "*On the Road*, that's a classic. It makes everyone want to go," she says. "Also *The Dharma Bums* — that ascent into the mountain, breaking the doldrums and reconnecting with the natural sense of themselves. That book has really stuck with me: out in the wild, flying by the seat of your pants."

Her mother knew Gary Snyder when both were young. "Of course, we're more cynical now," she reflects. "The Beats weren't able to dispel the repression. There wasn't enough to lift it. The police presence makes it harder to connect."

Kerouac, hiking near Tucson, Arizona, one night in 1956, was suddenly hemmed in by police cars illuminating him with their searchlights. Asked where was he going and why wasn't he in a hotel, our man deftly put them off with the reply, "I'm studying hobo." But

in that episode could be discerned the future's shape, especially after the terrorist attacks of September 11, 2001: many now have Spenglerian intuitions, much like the Beats', about an American civilization in decline.

Sarah mentions her *On the Road* poster: "the purple one, of the road and a car — a black car straddling the dotted line." It has an admiring quote from someone, about the book instilling a wish for fresh experience. "That's how I've lived part of my life, rough and hard and extreme."

Not Akin to
Lustful Thoughts

====

Europe and Africa, 1950s–1960s

6

Tangier

From Lawrence Ferlinghetti has arrived my self-addressed envelope, with a card bearing his reply: "Forget the past/Remember the future." Yes: the Beats remembered the future in terms of Depression-era dreams, kept up during years of nuclear one-upmanship. Thanks for the mantra.

Now in September 2005 I'm headed for Tangier, on the Moroccan coast, where William Burroughs lived in 1957 when the other Beats went there to help him complete *Naked Lunch*. They arrived by steamer (individually), whereas I've planned to get there through Europe with stays at well-remembered budget digs along the way.

I approach by rail to Algeciras opposite Gibraltar, the rock bastion long serving the British Empire. Ezra Pound took a cattle ship to Gibraltar at twenty-two and walked all the way from there to Venice, later joining up with fellow American T.S. Eliot to challenge

poetry's status quo in London. Generations later in Venice, Ginsberg would play Bob Dylan records to the aged Pound.

James Joyce concludes *Ulysses* on Gibraltar's flowered slopes, with the scene of Molly Bloom's "Yes" given to her husband-to-be, Leopold. So there's a high-literary aura to the huge rock, which I first saw just under a half-century ago from an Italian ocean liner, the *Augusta*, taking my wife and me on our initial European trip. Teaching high-school English when literary expression was expected to be impersonal in the Eliot manner, I admired Joyce, the self-styled literary priest who transubstantiated fact into Art. So it was before the Beats simply avowed personal feeling, in riffs as spontaneous as jazz.

Easily, I find my way onto a Tangier-bound ferry. It churns water at the stern, leaving Europe as dusk descends, and after a couple of hours our destination emerges in an amber haze. From the quay I have a long walk toward crumbling concrete steps ascending to that surviving "Beat Hotel," El Muniria. Here in 1957 the Beats of Columbia University came together for a penultimate time — and the last in loving harmony.

Part of El Muniria, confusingly, is a "Tanger-Inn" that actually seems to be a bar. I scan several of Ginsberg's annotated photos on its walls and ask for a room. The bartender tells me to buzz myself in, at not the first but the second door farther up rue Magellan. Here, Rabia gives me room 6, adding that Ginsberg stayed next door in room 5, while Kerouac and Burroughs booked rooms 9 and 4 respectively. She can't say how this has been determined.

Anyway, as far as I know, here's the last Beat-frequented hotel still operating. My room, with a shower unit arguably from the 1950s, is lengthy and faces the street. There's action out there. But I enter my bed's clammy sheets forthwith, having had enough adventure for the day.

At 5:15 the next morning there's a loud call to prayer from a nearby mosque. So here I am in Morocco, at the intersection of Beat sensibility and Islam.

On the Yugoslavian freighter *Slovenija* in 1957, Kerouac endured a heavy crossing to arrive at El Muniria early in March. Jack prepared coffee and eggs on an alcohol stove, at night reading the New Testament and about Herman Melville and Walt Whitman.

Tangier's Hotel El Muniria offers a view from a rooftop "patio facing the sea" (mentioned by Kerouac) such as one accesses now through the top-floor rooms 7 and 8.

During the day, with Burroughs he smoked opium, drank Malaga, conversed at sidewalk cafés, and took long walks over green hills behind the native quarter Casbah. In London, Burroughs had had his drug abuse successfully treated through a method using morphine boiled in hydrochloric acid.

Ginsberg was due to arrive with Orlovsky, and Burroughs anxiously used binoculars to check on ships entering the bay until they arrived in late March to complete the reunion. Each of the three writers had produced a literary work soon to become well known: *Howl* already printed, *On the Road* shortly to be so, *Naked Lunch* destined for publication in 1959.

Kerouac wrote to Cassady about his long-gestating road novel, with a hope that he might not be overly recognized in it. Jack proposed giving him $400 for moving Memere and himself to California. No reply came from Neal, who hadn't written to him for some time.

Jack, who suggested the title for *Naked Lunch*, here typed out its entire first section. "I had horrible nightmares in my roof room," says he in *Desolation Angels*, "like of pulling out endless bolognas from

my mouth, from my very entrails, feet of it, pulling and pulling out all the horror of what Bull saw, and wrote." There was also the pleasure of swimming at the beach with the others, and disputing aspects of literature. "The sunny mornings I'd sit on the patio enjoying my

The balcony of room 9 in Hotel El Muniria: shifting wind patterns would occasionally blow manuscript pages of Naked Lunch *outside, augmenting its surrealist aura.*

books, my kief and the Catholic churchbells," he writes. "Even the kids' basketball games I could see by leaning far over and around and — or down straight I'd look to Bull's garden, see his cats, himself mulling a minute in the sun."

Rabia takes me around to show room 9, plausibly that of Burroughs with a balcony above a courtyard normally inaccessible to hotel guests now, being reached by that first doorway up from the Tanger-Inn. I visualize Burroughs typing what was then titled *Word Horde* and tossing down each page into a pile. For visitors, from the floor he might randomly pick up a sheet and read it aloud, with alternating laughter and harangues over mankind's hypocrisy.

On April 3 Kerouac wrote to Gary Snyder about hiking to a Berber village: "little teeny girls of 4 in shawls and robes twinkling along on little bare feet going 'nglambedaha' and 'proo proo proo' — browsing bulls — a Van Gogh, Cezanne, a Kerouac could paint these chalk blue powder blue huts, live here in unutterable mountain peace…."

He could hardly have known that Henri Matisse, painting here in 1912–13, had aimed for spontaneity much as did the Beats. "Rembrandt produced Biblical scenes with cheap goods from a Turkish bazaar, yet they conveyed his emotion," said the artist; heavily researched paintings conversely might appear "untrue and devoid of life." Success came here for him only after he had "forgotten all the little details and, in my pictures, retained only the striking and poetic side."

Kerouac's town-and-city preoccupation comes to mind. Village life in Morocco, as in other Muslim countries, has had an agricultural base ruined by world-market agribusiness, sending its peasantry to vast urban wastelands where idle time breeds resentment. I can well imagine those little girls in maturity giving birth to Islamist suicide bombers. Surprisingly, in *On the Road* there's a late 1949 moment of entry by car to Manhattan when Dean, sweater-wrapped, quips that its passengers were "a band of Arabs coming in to blow up New York."

A cultural milieu had developed in Tangier around the brilliant American composer Paul Bowles, who arrived here in 1947, following a prophetic dream, with his lesbian wife, Jane Auer. Scanning the

manuscript of her novel *Two Serious Ladies*, he was led also to write fiction, *The Sheltering Sky* later being made into a film by Bernardo Bertolucci. The Parade Bar on rue des Vignes, elegiacally cited by Burroughs in old age as having closed, drew Jane into drinking bouts that, combined with too many prescription drugs, led to her early death. Bowles lived until age eighty-eight, having made 250 recordings of Moroccan folk music on journeys totalling some twenty-five thousand miles.

Uptown in the Ville Nouveau I find the New American Bar, with photos of Winston Churchill and front pages of newspapers from that war leader's day. This used to be Dean's Bar, where a piano was played by a lover of the painter Francis Bacon, the wartime Spitfire pilot Peter Lacy. An echo gained here of Rick's Café, in *Casablanca*, is very faint because the clientele now is all Moroccan and male. Tangier's population had become heavily expatriate during 1906–57 when it was an international free port, called Interzone by Burroughs.

"Nothing can be more dreary than 'coolness,'" Kerouac wrote of the Tangier scene, "a kind of sociological coolness soon to become a fad up to the mass of middle class youth." Later in New York he conjectured the end of true Beat adventure — "so unexcited as we sit among all our published books and poems" — unaware that Burroughs in his eighties would be acting in films (*Drugstore Cowboy*, also one of a U2 concert), acting in a Nike ad, writing lyrics for a Tom Waits theatre piece titled "The Black Rider." He had become the quintessence of cool.

Kerouac wished lovingly to depict ordinary people and not poseurs, yet prosperity now allowed those persons to travel abroad and appear cool in cafés (as did I, admittedly, in 1957). Burroughs spoke to a newer generation, and certainly his writing efforts were aided by Jack. So for the Beats, friendship and verbal expression seem to count as the main unifying elements.

In the Petit Socco I patronize Café Central, where Burroughs would nurse a mint tea for hours. Mine comes in a glass, the leaves afloat in the top third like a dishrag. Very sweet.

Naked Lunch includes an irreverent routine, "The Prophet's Hour," featuring a breezy know-it-all saint who dismisses Jesus as a

"cheap ham" and the Buddha as a drug-high swindler. "*Mohammed?* Are you kidding?" sneers this iconoclast. "He was dreamed up by the Mecca Chamber of Commerce."

Radicalism had long been in the air, Burroughs citing a man who called for Israel's destruction. He describes Interzone's political groups — the Liquefaction Party being "entirely comprised of dupes," the Senders feeling dread of any fact — in terms of mind-controlling Mayan techniques he had studied at Harvard.

Taking note of Morocco's soon-to-succeed national independence movement, he eerily foresaw the future: "Nationalist martyrs with grenades up the ass mingle with the assembled conferants and suddenly explode, occasioning heavy casualties." Such deeds are now all too well known. David Cronenberg's film version of *Naked Lunch* gives an even ghastlier image of writers in Tangier typing away at reports on mind-controlling insect agencies, which actually control them.

"Peace is the language of humanity," reflects a man aloud to himself over a Coca-Cola. I try to enter his consciousness, presumably stoned, and to my "*Je suis David*" he answers, "Thank you." This is Ahmed, from Rabat, who adds that the sea and sky are the same colour. Heaven, I reply. He laughs.

"Not Bush," he goes on, adopting a too-mighty presidential voice and stiffening his posture. Then, also portentously: "To be or not to be."

I respond with an old joke. "Plato: 'To be is to do.' Sartre: 'To do is to be.' Frank Sinatra: "Do be do be do.'" This cracks him up.

Naked Lunch presents ludicrous bulletins of the Factualists, who are "Anti-Liquefactionist, Anti-Divisionist, and above all Anti-Sender." Implications of far-in-the-future email hatred seem evident: "The Sender will be defined by negatives. A low pressure area, a sucking emptiness. He will be portentously anonymous, faceless, colorless."

"Mortality," says Ahmed at random, tapping his head. "Free to have everything in your head: maybe a solution for humanity." We touch glasses: he an American drink, me the Moroccan. I assure him that I couldn't agree more.

An hour at the Café Central will yield arresting images, though not in my ken is a live replay of a Naked Lunch vignette: "Black coffin — Arabic inscriptions in filigreed silver — carried by four pallbearers. Procession of mourners singing the funeral song."

PARIS

Another train ride brings me to Paris and a stay at the Hôtel la Louisiane, home to Jean-Paul Sartre and Simone de Beauvoir during the Second World War. It's not far from the Café de Flore, where I take tea as did they while blackening many a page. Their existentialist followers favoured a kit — black turtleneck for men and black dress for women, attitude, stock expressions about the futility of it all — later assumed to be that of the Beats, when beatniks first appeared.

The nearby Bonaparte, above which Sartre afterwards lived with his mother, happens to have been Beat poet Gregory Corso's favourite Paris café. Yet the Beats read hardly anything about existentialism, viewed by Ginsberg as contrastingly cerebral and overly aggressive in its strictly political stance.

Les Deux Magots, opposite, was frequented by Surrealists led by André Breton, their de facto pope. For a 1936 Surrealist show Brion Gysin, later Burroughs's close colleague, contributed a poster, "The execution of Louis XVI," showing a wigged calf's head. Breton, regarding it as too much like his own head, tossed out this work from the show, and also its creator from his tightly run group. He met Burroughs in 1954 at an art exhibition.

The "dream machine" Gysin invented, an ordinary stroboscope that induces out-of-body sensations, epitomizes their view that all consciousness is reducible to a dream. He had grown up in western Canada, at six learning certain mushrooms' psychedelic properties from Native people performing for tourists at the Banff Springs Hotel. Gifted at languages, he was sent by the Canadian military late in the war to learn Japanese but lacked opportunity to use his skills before conflict ended. Off he went next to Tangier, where he opened a restaurant.

Gysin's recipe for marijuana fudge became known to Gertrude Stein's soulmate, Alice B. Toklas, who included it in her cookbook. In John Geiger's new biography of Gysin, *Nothing Is True, Everything Is Permitted*, he is shown being asked by Stein whether this delicacy would take her "for a ride" — and responding, "A trip, darling, a trip."

By the Seine a few blocks away, at 9 rue Git-le-Coeur, a cheap hotel was discovered by Ginsberg in October 1957 — Class 13, lowest of the low — and Burroughs followed along a half-year later. It was operated by Madame Rachou, a lonely woman who befriended occupants also in need of compassion. Gysin, who dubbed this the "Beat Hotel," recalled her as "a funny mixture of peasant shrewdness and hardness along with the most disinterested generosity." During the wartime occupation, she'd had an affair with a German soldier and for that, afterwards, was shorn of her hair by "patriots." Madame Rachou would show guests a photo of herself in that state.

Here Burroughs completed *Naked Lunch*, appropriately about control as an addiction. Treating such themes in the Beat Hotel's creative atmosphere, said Gysin, gave "one enormous intellectual high." And number 9 has become a four-star hotel. No longer a bare

forty-watt bulb in each room. No more hole-in-the-floor lavatories at the landing. No petty thieves or lowest-rung whores among the clientele.

Earlier Ginsberg, just in from Tangier, deposited at the nearby former home of Olympia Press the first *Naked Lunch* manuscript. Publisher Maurice Girodias told how it impressed him: "whatever caught the eye was extraordinary and dazzling."

Girodias offered pornography to tourists in a "Traveler's Companions" series — *Sin for Breakfast, Of Sheep and Girls, Love on a Trampoline* — but held off on doing *Naked Lunch* in this line until 1959. A section of the work published by Chicagoans was then caught in a censorship scuffle, ultimately settled when Judge Julius H. Hoffman ruled its events to be "not akin to lustful thoughts." Girodias, heartened by the notoriety thus gained, gave Burroughs a contract.

The manuscript's edges had supposedly been chewed by rats. Selecting from a thousand pages of material, Beat Hotel regulars scooted parts over to the printer, and *Naked Lunch* was out in two weeks. Such pressure, Burroughs told Ginsberg in July 1959, "welded the whole into a real organic continuity which it never had before."

At the Beat Hotel, Gysin mounted drawings one day when he happened to cut through the boards into newspapers underneath. Setting one slice of newsprint against another produced bizarre verbal results said by Burroughs to be "a project for disastrous success." Thus arose his "cut-up" technique, soon adapted to include tape recorders. As a teacher, I had students in groups do similar experimentation that, as at the Beat Hotel, seized everyone with laughter from time to time.

Samuel Beckett's 1953 play *Waiting for Godot* stirred a confusion matched now by the cut-up method — of which he said to Burroughs on one drunken occasion, "You're using other writers' work!" And often (recalled mutual acquaintance Joseph Barry in 1963) he spoke of this as mere "plumbing." From *Naked Lunch*, Beckett gained a notion that there were no answers — that's what he liked about it. And yet Burroughs, interestingly, felt that answers existed.

Light shows as given at rock concerts "were invented by us in the Beat Hotel," asserted Gysin in 1972. Though Madame Rachou

rationed the electricity, occupants would "hook up two or three rooms" to turn on viewers "with projections and tapes and sound poetry." That's one view of psychedelia's history, and he could be right.

The Nova Mob, superhuman viruses from outer space requiring human hosts, usually gain entry because of addiction to drugs or sex. These powers form a control system akin to what produced the evils of Hiroshima and Auschwitz. The Nova Police are shown opposing them in a trilogy of novels — *The Soft Machine, The Ticket That Exploded, Nova Express* — all drawn from the morass of notes for *Naked Lunch*.

In a 1975 forum, Girodias alluded to the CIA while noting that "an international literary atmosphere, which was a big wet blanket, was created to discredit any literary breakthrough of either the old or the new classics that would have been considered obscene." Burroughs added that *Encounter* magazine, once among his severest critics, was found to have been subsidized partially by the CIA. Words used as weapons: a key element in his worldview stemming largely from Surrealism.

Gregory Corso, a 9 rue Git-le-Coeur regular, contrastingly was a traditional poet, and also more heterosexual than the others. Gysin in "The Beat Hotel, Paris" details his attractiveness to Swedish girls:

> They are the chorus of Muses whose silvery soprano voices one could hear trilling up the slippery stairs, calling: "Gregory! Gregoooory!" whenever Corso was in residence. And then he would yell back some flippant poetic obscenity from his eyrie under the roof at the top of the last flight of steps to immortality. "Fuck off! I'm too busy being immortal but come back later, sweet Poesy."

Kerouac came from Tangier for his first Paris stay ever, and eight years later made the visit told in *Satori in Paris* (*satori* being what the Japanese call a "kick in the eye"). It features a bar on rue St-André-des-Arts, "La Gentilhommiere," where a much-coveted blonde departs "with a handsome young boy and I'm left there hanging on the bar stool pestering everybody with my poor loneliness

which goes unnoticed in the crashing busy night, in the smash of the cash register, the racket of washing glasses."

I go upriver to St-Louis-de-France Church, which bears the name of the one where Kerouac was baptized in Lowell. Here with hat in hand he beheld "guys in red coats blow long trumpets at the altar, to organ upstairs, beautiful Medieval *cansos* or cantatas to make Handel's mouth water." A woman put coins in the hat as if he were a beggar, to teach her children "loving charity": such a Beat moment.

Tourists well know an old English-style bookstore, Shakespeare & Company, by the Seine opposite Notre Dame: little outdoor benches, messages scrawled on a blackboard in its window, no telephone, free lending library, free accommodation upstairs for a deserving few. The store had a literary festival in 2003, called "Lost, Beat and New" after the generations it covered, at which I first met Carolyn. After a reading, she described Neal as "beyond all of us in understanding at a higher level," with a "spiritual nature that he had, that kept me hanging in there" — and yet was not entirely cut out for respectability.

Pause. "Having said that," a woman asked, "why did you marry him?"

"Well, if you knew him, honey, you wouldn't be asking that," she replied with customary ginger and oomph. Never did she not love Neal, though "all the later years were sad."

My question was about a remark she had made to Sissy Spacek, who played Carolyn's role in the film version of *Heart Beat*: "Jack and I both loved Neal too much ever to do anything purposely or even thoughtlessly to hurt him." Didn't Spacek then cry, on realizing the falsity of the film's representation?

"Yes — though she did her damnedest," said Carolyn, recalling also her own chagrin over the film's sensationalism. Beat scholar Barry Gifford chose the title, she indicated, not "heartbeat" but two separate words, "to indicate I was the 'heart' of the Beats — ha ha, no one has ever gotten that."

There in Paris by Notre Dame, Carolyn gave an earth mother image, Our Lady of the Beats — while those tape-experimenting with Burroughs in the 1950s, downstream at the Beat Hotel, seemed from outer space. She was at odds with Burroughs from

Heading back to the Parisian bookstore Shakespeare & Company, Carolyn Cassady was given a kiss by one handsome garçon; she generously spent time with such young admirers, lending insight into her era.

the start — opposites in what I can't help seeing as a movement, the last one there's been in America.

On June 16, "Bloomsday," when Dublin was traversed as told by Joyce in *Ulysses*, the festival concluded with pertinent happenings. Fittingly so, as a U.S. Presbyterian minister's daughter named Sylvia Beach published the work in 1922 at the original Shakespeare & Company. An enormous scandal. The Beats, getting their own books past the censors' control, showed similar impudence.

AMSTERDAM

Not much of a Beat heritage is in Amsterdam, except that Ginsberg loved it. So do I, and especially with lodging at the free-and-easy Hotel Brian, just down from the station on the Singel. The clerk asks me to check whether it's my kind of place — a tactful allusion to my age — and then, learning that I've long been a regular, remarks, "Well, you know the rules; there are no rules."

A breakfast area wall once thick with patrons' postcards is now blank, this yellowed mass having become "too depressing," I'm told. But in my old room, number 7, the initials-carved wooden stool remains as its sole furniture, and still there's no soap or towel. Anyway, I'm here for the big Amsterdam window admitting familiar sounds: hooves of horses on patrol, rattling bicycles, the Westerkerk's quarter-hourly carillon, clanged cutlery on passing tourist boats. This might be the last cheap canal-facing hotel still available in town.

And here in this Beat-style place is someone actually of that era: Brent, an expert in laser technology. His uncle is Andy Clausen, whose poem about Kerouac's death concludes with the felled-tree warning: "Timber!" In Manhattan's East Village this hip relative had a key to the loft of his "good friend Allen, teacher of mine back in college," enabling Brent to visit Ginsberg. "Fucked-up neighbourhood, piss on the stairs, but a really nice room, *big* room," says he of the place. "He kept asking me things about my work — one of the greatest poets of our time saying, 'Man, *lasers*, man!'"

Brent somewhat resembles Herbert Huncke in his lingo, non-smiling demeanour, and powers of recall. Allen's struggle with diabetes: "Poor guy was at the end of his rope." Brent's own creativity was encouraged by Ginsberg: "Seriously, no, seriously, you ought to write poetry, man, poetry is not about rhyming." Orlovsky was there: "I'll tell you one thing — if there was anybody that was loved, it was that guy."

So here at the Brian, unexpectedly I get a vivid account of Ginsberg near the end: frail, but still outgoing and curious about life. What impressed Brent the most was that moment's easygoing quality: "Sit there at the kitchen table bullshitting — regular guy, man. The two of us sitting here now? Same thing. The kind of guy you'd remember, whether he was famous or not. A happy guy to be around."

London

Ginsberg's spirit leads me, in London, to view the Tate Gallery engravings by William Blake. A darkened room holds one of his favourites, *Glad Day*, portraying Albion (England) as a naked youth with arms joyously outspread. "Albion rose from where he labour'd [sic] at the Mill with Slaves," states the original inscription. "Giving himself for the Nations he danc'd the dance of Eternal Death." Once asleep, England might thus spiritually awake.

This work adorns the cover of a 1969 anthology, *Children of Albion: Poetry of the Underground in Britain*, celebrating a new creative force — clubs, magazines, bookstores, poetry readings — heartened by Ginsberg's *Howl* reading. Poet Michael Horovitz added an afterword, citing a *Times Literary Supplement* reference to poets who now "treat the writing and the delivery of a poem as two stages in a single process." Threatened now was a doctrine that verse should be difficult, complex, cerebral, impersonal — the view of T.S. Eliot, another American who had rebelliously affirmed this anti-Romanticism in town forty years earlier.

I continue westward to Royal Albert Hall in Kensington, where all came to a head with the first International Poetry Incarnation

on June 11, 1965. Poets of Communist lands were to have read, but backed off in the wake of Ginsberg's coronation as King of the May by one hundred thousand students in Prague. Cuban poet Pablo Neruda apparently feared that this monarch might strip to the buff, as was now his wont in public. Allen joined with Ferlinghetti and eight other poets, at any rate, to compose an invocation: lines from William Blake's "Jerusalem" prefacing a *Howl*-style exclamation:

> England! awake! awake! awake!
> Jerusalem thy Sister calls!
>
> ... O shameless bandwagon! Self-evident for real naked come the Words! Global synthesis habitual for this Eternity! Nobody's Crazy Immortals Forever!

Ginsberg clashed his finger cymbals in vast Royal Albert Hall and declaimed "Who Be Kind To" as a prayer. The poets "made literary history by a combination of flair, courage and seized opportunities," said the *Times Literary Supplement*, although the hall's manager resolved to forbid any future poetry readings here, being "filth" such as nobody's teenage daughter ought to hear.

Back in 1914 at Royal Albert Hall was a memorial service for Canadians who perished en route to a Salvation Army Congress on the doomed *Empress of Ireland*, both of my paternal grandparents among the victims. "We feel that they have entered into that great world of reality," said the Army's founder, William Booth. "Their temptations are all behind, their tears are wiped away, their Saviour is in the midst." Not quite the International Poetry Incarnation's message, though Blake's Albion has much in common with Jesus of the Sermon on the Mount.

I'm staying near Piccadilly Circus, in cheap rooms above Manzi's fish restaurant. Its aromas lure me into taking dinner here, and Alice, a cordial singer from Liverpool, invites me over to a table where her manager is being treated to a fortieth birthday party. When she mentions the venerable Adelphi Hotel back home, I refer to a 2002 "Aconvention" held there to honour Burroughs wherein a woman named Chloe Poems, in gingham dressing gown and wig,

There was "ecstasy in the hearts of those who had come," said journalist Bruce Cook of the 6,000 attendees at Allen Ginsberg's Royal Albert Hall performance in London in 1965. Cook noted that as Ginsberg read, "one girl rose to her feet and began moving slowly in a weird twisting dance, a marvellous moment." Photograph courtesy of the photographer John "Hoppy" Hopkins and the Allen Ginsberg Trust.

recited "The Queen sucks Nazi Cock" and other verse. Such festive times at the Adelphi, Alice reflects: "The conga lines, the *spirit* of people! No door locked!"

Burroughs during a 1966–74 London stay had many suppers all by himself at an Angus Steak House on the Circus, up from his flat at number 8 on Duke Street. Yet by now, in this "Swinging London" period, he was famous. Asked in a British Broadcasting Corporation interview about his creative methods, he explained, "I am not a dadaist and I don't believe in being obscure," adding that the cut-up method "is a matter of experimentation, not argument."

Bruce Cook in *The Beat Generation* speaks of visiting Burroughs at number 8 and asking, naturally, about the Beat episode (Cassady and Kerouac now dead). "A social movement perhaps," he allowed. "After all, there's no doubt that the Beats ultimately had terrific radical political influence. And in the case of Kerouac, it was almost that he was frightened by what he himself had started."

Burroughs in "Remembering Jack Kerouac" affirmed that many with their names on books are like bullfighters making passes with no bull around: "The writer has been there or he can't write about it. And going there, he risks being gored." The Beats went there — he into drug addiction, Ginsberg into large-scale promotion of individual freedom, Cassady into extremes of poverty and lust, Kerouac into alcoholism. Of Kerouac, Burroughs said that at twenty-one, "already he had written a million words and was completely dedicated to his chosen trade." The Beats thus won a kind of hope, rediscovered in our conservative era so closely paralleling their own.

The Perfect Ecstasy

Lowell, 1920s to Present

7

RIVERS

A literary rite, "Lowell Celebrates Kerouac," annually draws many pilgrims to this Massachusetts mill town of his birth. Its many canals lend a Venetian ambience, the Doubletree Hotel facing one that joins with the Concord River and, farther down, with the Merrimack. Water systems here stirred in Kerouac a poetic response.

My side of the hotel faces a large red-brick building housing the *Lowell Sun*. Jack was writing up sports here at nineteen, with a by-line only once and then with his name spelled "Korouac." An author he deeply admired, Henry David Thoreau, long before in *A Week on the Concord and Merrimack Rivers* had spoken of travelling by boat to this town, already with cotton-spinning factories powered by the Merrimack.

Clues to the city are given in *Kerouac: The Definitive Biography* by Paul Maher who, growing up Catholic here like his subject, recalls

feeling "the same awesome and oppressive mortality bearing down on me whenever Saturday evening discussions, tinted with French Canadian accents, would turn to that day's obituaries: 'Who's this in the paper today, the one who died suddenly? You knew her?'" And now dwindling is the vast Québécois community Kerouac knew, formed initially by immigrants coming from the St. Lawrence's valley to the Merrimack and its textile mills.

A short walk away amid such now-disused mills on Bridge Street stands the Kerouac Commemorative, a mini-Stonehenge of mandala and cross contours suggesting his Buddhist and Catholic beliefs. On dedication day in 1988 it was trumpeted politically as part of a $60 million project for uplift of Lowell's long-decaying downtown.

Yet this is a rarity in America, as explained to me once by local high-school teacher and Kerouac enthusiast Roger Brunelle. "No one has honoured a hometown writer the way we did, with quotations from his works instead of just the name and dates," he said, showing how all face outwards on the stone slabs. "Read them and then stand on the platform in the middle, where all words disappear — you'll hear your echo." The commemorative occupies the site of Leo Kerouac's printshop, Spotlight Print, once at 95 Bridge Street.

Neo-conservative guru Norman Podhoretz in a *New York Post* column used its dedication as a chance to reassert a supposed contempt for decency by the Beats. "Good old Norman Podhoretz," said Ginsberg, viewing him as "a sort of sacred personage" in his life, "someone whose vision is so opposite from mine that it's provocative and interesting." Allen was angry once, however, when this bugbear advocated a gain of literary prestige by getting rid of Beat colleagues such as Jack Kerouac.

Along come friends of mine, Montreal bookseller Richard Gingras and his wife, Helene, who never miss a festival. Atop the platform, spiritedly they sing the 51st Chorus from Kerouac's *Book of Blues*, telling how "the divine wine" gives heart. He was "the son who went away and came back to us," Richard believes, Jack now looming large in Quebec.

"Catholic religion makes us afraid all the time, and this fear has to be blended in with American culture," says Richard Gingras (seen here with his wife, Helene, at Lowell's Kerouac Commemorative), "but that's what Jack was able to do." Not a bad summary of what he achieved.

UNIVERSITY OF MASSACHUSETTS

At the University of Massachusetts's Lowell campus, as always, is a showing of the film *Pull My Daisy* introduced by David Amram, that tireless man with the baggy black suit and travelling-band gear. I savour his Beat-era mannerisms — sudden hand to fevered brow; fingers cupped at one ear; head shaken in mock disbelief — and his exuberant patter, ever positive. "David is never at a loss for words," says Carolyn.

Nor for imagination. One year at a festival event for children, David was telling how Kerouac "took phrases people spoke and used that, was inspired by that," and went on to mention "finger popping" tunes. A kid lying on the floor with both feet up in the air blurted out a correction — "It's called snapping" — on which Amram improvised a jazzy song:

Here we are in Lowell, special kind of day,
Instead of lying down in front of a tee vee.
It's called the Lowell Snap, I think,
Super-cosmic good vibes ...

He now introduces this black-and-white Manhattan-made 1959 "art film," co-directed by Robert Frank and Alfred Leslie, and shot from a script by Kerouac. "I'm just about the only one still alive from when we made *Pull My Daisy*. We thought it would be fun to make a light-hearted, cheerful home movie. To show that we cared about one another." He tells of attacks on Jack's patriotism, French-Canadianness, Roman Catholicism, mother-love, even the Lowell accent — while our hero held true to his origins. "So in America we can be anybody we want to be," he concludes.

The event portrayed is a 1955 visit to the Cassadys by a young Swiss of the Liberal Catholic Church, Bishop Romano, and two middle-aged women. The bishop had tried to meld Jesus' teachings with those of mystics like Sri Aurobindo, whose outlook Carolyn advanced to Kerouac (although today, she "doesn't have time" for his Hindu musings). The Cassadys' religious experimentation included even the televangelism of Oral Roberts. "Neal thought of him as an actor and enjoyed his style, his lack of hellfire and damnation, also his sincerity," she tells me. "He was in a way a kind of joke — an example of that kind of evangelism — and a lot of fun."

David intones, "Our annual showing of *Pull My Daisy* now begins," and onto the screen comes a woman singing: "Pull my daisy/ tip my cup/all my doors are open/Cut my thoughts for coconuts/ all my eggs are broken." It's a ditty co-written by Kerouac and Ginsberg, printed first by Landesman in *Neurotica*, and seemingly about the removal of a stripper's G-string.

Stillness. Then French actress Delphine Seyrig, playing the Carolyn figure, opens the curtains to Jack's famously improvised phrase: "Early morning in the universe."

Enter Pablo, representing the Cassady children (and played by Frank's son). Pan to Ginsberg and Corso, with beer cans: "all bursting with poetry while she's saying, Now, you get your coat, get your little hat and we're going to go off to school." Kerouac adopts a W.C.

Fields voice for the arrival of Milo, the Cassady character. Next, enter the bishop with his two women. Family, art, religion — three forces of Beat life in momentary balance.

Now David, in youth, suddenly appears onscreen as the demented musician Mezz McGillicuddy. Out of eternity comes the survivor amid ghosts: he who composed the film's score. And here at Lowell's festival, this seventy-four-year-old hipster will do French horn tootings much like those recorded in the film: eerie.

Sudden quietness: "The angel of silence hath flown over all their heads." This line, adapted from Anton Chekhov's *The Seagull*, refers to a young artist who, wanting new forms of expression, puts on a play so ill-received that he halts the performance. The phrase, implying loss of creative impulse, is used by Kerouac in a 1957 play, *Beat Generation*, on which this film is based — perhaps applied ironically to himself — and again it pops up here in his semi-subconscious narration.

Pull My Daisy exemplifies "spontaneous cinema," according to avant-garde film critic Jonas Mekas, who in a 1966 lecture called for art expressing "something joyful deep within us." Having believed that the world's suffering would be halted in his lifetime, he then witnessed such horrors in his native Lithuania as to experience later, with other creative souls, a desperate wish to start afresh: "The Beat Generation was the outgrowth, the result of this desperation; the mystical researches came out of this desperation." And for Mekas, *Pull My Daisy* was "the most alive and truthful of films."

Its middle third shows the bishop being urgently questioned about holiness. This echoes the theme of Ginsberg's "Footnote to *Howl*," in which a diversity of things are declared to be holy. "Come on, bishop, tell us," Allen is now shown demanding. "Is your sister holy? What is holy? Holy, holy, holy, holy, holy? And car holy and light holy? Is holy holy?"

Exit the bishop's group, with Carolyn/Seyrig's entreaties to stay. Jack is heard doing scat rhythms to a McGillicuddy tune — "Jamambi, jamambi, jamac, jamac" — and narrating Milo's cowboy lingo: "A fella got off a dusty old roan in southwest Pecos country and stepped up on the sidewalk." Carolyn/Seyrig at the end is represented as crying, whereupon Milo and his friends depart for a night on the town.

"She'll get over it," says Kerouac — a moment now deemed embarrassing, with solemn pronouncements upon Seyrig's tears. Yet uproarious laughter ensued in real life, at Los Gatos, Jack being so convulsed as to roll on the floor in merriment. Another outcome not in the film, but retold in *Off the Road*, is that Neal's departure into San Francisco that night afforded Carolyn and Jack the joys of lovemaking.

So the actual evening was very different. Yet Allen did ply Bishop Romano for answers, learning about sex as "the governing Life Force," used by the "Adam-man" upon rising to the "Christ-man" to create ideas beneficial to mankind. Sex may be destructive when negatively misdirected, the bishop added — eliciting from Carolyn a silent amen — so that tears might indeed be called for in these spiritual terms.

Carolyn disabuses me of rumours about an affair with the bishop. "He taught Sri Aurobindo and 'channelled' from on high — either his higher self or teachers above. Funny, in the end he married a woman the same age as his mother and aunt. I'd have expected gay. Maybe he was. We'd never know."

During a question period, lengthy and animated replies are given by David to whatever is asked. Much impressed is a kid sitting near me who exclaims, "If I had half of the energy that guy has at seventy-four, I'd be dangerous!"

Now I notice a white-bearded man in the audience, Neal's unassuming son, John. Here's somebody else from the movie, in a sense, and I seize the chance to inform the audience of Pablo's presence among us. John then tells David, "Think of the career I might have had if you'd taught me the French horn!" Time takes a strange bend.

John at a 2005 Kerouac festival event played guitar and between sets was interviewed by Steve Edington, a Beat-wise local Unitarian Universalist minister. My heart went out to John as he spoke, in a very quiet voice, about events both hilarious and of painful memory.

John Cassady (middle) rejoices that through his father, Neal — whose photo is displayed at this gig — he met Jerry Garcia, a "guitar hero" whose death inspired him to give a fine website tribute. Steve Edington is on the left, David Amram at right.

DOWNTOWN

Very good pasta dining awaits me at Ricardo's Café Trattoria, 110 Gorham Street, where a strip joint called Nick's Lounge was once operated by Nick Sampas, the brother of Jack Kerouac's last wife, Stella. Every couple of weeks during Jack's late residence in town he would come here, often to spin Bunny Berigan's "I Can't get Started" on the jukebox and play along with an air trumpet.

"You're at the Kerouac festival? He used to sit right there!" says Ricardo to newcomers. "You're at the Kerouac festival? He used to sit right there!"

A spot in the "eating half" is indicated, although, as told by Bruce Cook in *The Beat Generation*, our man preferred the bar. "Interview!" he exclaimed when Cook appeared, putting fingers to mouth for a shrill whistle. "New York is here, America is listening!" Downing

port wine, he denied any consciousness-raising aims: "We were just a bunch of guys who were out trying to get laid."

John Clellon Holmes, attending Kerouac's funeral in 1969, came to this bar with his wife, Ginsberg, and Corso. In the eating section was a long table with abundant food and drink generously laid out — as told in Holmes's memoir *Gone in October: Last Reflections on Jack Kerouac* — and they pondered what floral tribute might serve. Corso sketched "a large red heart resting on a lotus, with spikes of fire shooting out of it, and red thorns with our first names on them." For the central ribbon, they settled on a phrase alluding to Jack's *Mexico City Blues*: "Guard the Heart."

A nickname for Jack was "the Heart," meaning emotional response, which my host happens to have toward him. Ricardo doesn't like Kerouac, the actual person, complaining that his ghost is here. Mentioning that all of his books are in print, I ask whether those who buy them are fools. Long pause; then, "No. He has a following, every writer has a following. Look, it's what he does around here that bothers me. I'll be downstairs in my office and all the lights will go off."

How can we know it's Jack? "How do I know that it's *not* him?" he replies. "Last night, fifty people came in here from the festival and that's when the power went off, I'm serious." Why would he do that? "He knows that I don't like him." But Kerouac was kind and gentle, I reply, adding that he should read what's on the Commemorative downtown. Find peace by learning who the man really was: if only that were possible.

My host's father having been a leading congressman, someone who "knew Jack Kennedy," I ask how he perceives this other Jack. "I thought he was a drunk," he answers, then calls out to a regular at the bar, "What was Jack Kerouac — a Beat drunk?"

"Haven't looked into it," the patron replies: honest and fair. This writer's prose energized the English tongue, but what of that? There's another Kerouac ready at hand to be dismissed. Shame attached to his alcoholism is understandable, though a change of attitude might be expected by now.

Jack would place bets here on his ability to do a hundred push-ups and duly collect, says an anonymous contributor to a slim 1982

volume, *The Kerouac We Knew*. Or con a teenage jock into a half-mile footrace downtown, and win by fifteen metres. In conversation he would offend, "in a friendly way, to break down reserves," writer Robert Boles notes in an account in the same collection; he lacked private life, having "published his privacy in seventeen novels."

Next morning I stroll down Merrimack Street to the companionable Club Diner. George Martin (Leo Kerouac), in *The Town and the City*, is shown leaving a trail of cigar smoke in town and "eating a hearty breakfast in the diner by the railroad tracks": this one, no doubt, "Lowell's historic day & night diner since 1938." Its narrow seats evoke a prewar sense of community, cherished by Jack as bigness became a law of survival. A patron apologizes for not leaving a tip recently and is heckled by another regular, their chitchat bouncing around in the narrow space. "Scream-bled eeeaigs and hay-em!" cries my server.

Opposite stands Jack's beloved Pollard Memorial Library (ART IS THE HANDMAID OF HUMAN GOOD). *Dr. Sax* shows Jack Duluoz (Kerouac) coming here with Nin Duluoz (Kerouac's real-life sister, Nin) — "jumping in the air we dally to the library, fourteen" — to

"I've been coming here since 1960," a truck driver informs me about the Club Diner in Lowell. "There used to be places like this all across the country. Phased out!"

exult in books: "my soul thrills to touch the soft used meaty pages covered with avidities of reading — I see the great curlicued print, the immense candelabra firstletters at the beginnings of chapters…." It had been stocked with more than ten thousand French titles by a cultivated librarian originally from Montreal. Jack Duluoz would return after supper for a "second round" of reading, determined to master all knowledge as told in Goethe's *Faust*, parts I and II — a poem so influential as to lend *Dr. Sax* the subtitle "Faust Part Three." The Beats endorsed Spengler's view that modernity's restless striving represented a distinct "Faustian" stage of insatiable wish for gain.

Sebastian "Sammy" Sampas, who started a "Scribblers' Club" that Jack joined, celebrated his Greek descent by reciting from "The Isles of Greece" by Lord Byron, revered as a fighter for Greek independence. This comes out in the memoir *Visions of Kerouac* by Charles Jarvis (also of Greek blood), who had a local radio talk show, *Dialogues in Great Books*. Kerouac, featured one day in 1962, whimsically applied spontaneous prose concepts to Shakespeare, letting on that *Hamlet* was written in one night and *King Lear* the next. "Once God moves the hand, you go back and revise, it's a sin!" he averred, adding, "My job is to describe Heaven just a little bit."

Now at Lowell High School begins something very much in Kerouac's spirit, a student poetry competition. In the school year of 1967–68, Jarvis recounts in *Visions of Kerouac*, Jack was invited by a substitute teacher to give a class in English after a boozy night. "What is the White Whale?" he asked, and to a student who gave the answer he passed a dollar bill. Solid discussion ensued on *Moby-Dick* for an entire period. Discovery of this grad's inebriation then led to his ouster, and the teacher was never called back to the school: shame on him for welcoming a great author able to bring Melville alive.

As contestants gather, there's a soft cadence of Jack reading to a jazz background on audiotape. Among the judges is Phil Chaput, a rare-book dealer likely to tag a first edition *On the Road* at $10,000. Competitors are told how Jack excelled here as a thick-legged "climax runner," inserted partway through a game when opposing linesmen had begun to weary, and once scored a winning touchdown for the school against its traditional rival, Lawrence High.

A number of Jack Kerouac items are on display at the Mogan Cultural Center in Lowell. John Cassady mentions being taught by Jack, early on, how to pack items: "Remember, Johnny, always keep your socks on top so they stay dry. If your socks get wet, you're screwed."

All the top contenders are girls. I root for one in a striking black-and-white outfit who murmurs, "A blood-smeared reflection is the only one," but she is up against another who begins, "Bear with me because, like, I sing? in my poem." Also there's a black cutie with the line, "I take another nickel from the bank of knowledge." But top honours go to a deep-voiced, dramatic Latino who intones, "Tonight I sleep on the floor in a room that smells of fear." Give that girl some jazz background.

Displayed nearby at the Mogan Cultural Center are a khaki backpack of Kerouac's, donated by Stella, and an Underwood typewriter, "courtesy of F. Edith Kerouac," set amid a sewing kit and mess kit like those he used. Here's the Beats' quest for understanding, across an entire continent, concretely manifested. Too bad there's no connection stated between this Lowellite and surrounding displays on the town's cultural development.

Parked outside is the Beat Museum on Wheels, an Airstream RV with exhibits assembled by John Cassady's friend Jerry Cimino. The two drive cross-country from their Frisco base to various

A wide variety of books — thirty-two Kerouac works are now available — is sold by Jerry Cimino and John Cassady as they take On the Road *"directly to the people" in the Beat Museum on Wheels.*

colleges and towns. "We want to use the story of the Beats," says their exuberant website, "to encourage people to pursue their passions." I like the van exterior's 1965 photos of McClure and Dylan, also the Beat Timeline starting with the *Howl* trial.

The Six Gallery event at which Ginsberg first read *Howl* happens to have been exactly fifty years before today, October 7. Kerouac brought along those jugs of red wine, and I, keen to recreate the ebullience thus aroused, purchase a big one of sangria to present at the Life Alive Urban Oasis & Organic Café, where a "reading event focusing on Kerouac's literary/artistic roots" is held.

I consult Heidi Feinstein, just now quoted on the *Boston Globe*'s front page as having opened the café against naysaying that Lowell is really a drinking town. I would break the law by passing my jug around, she says, but is agreeable to having me make as if to open it, and then be halted by her dramatic intervention. A bit of improvisation.

Kerouac festival president Larry Carradini arrives and, when I outline this scenario, tells how sensitive the alcohol issue is locally. Okay, I drop the gag — taking my wrapped-up bottle outside, perhaps to benefit whatever bums might be about — and, after several readings, am called up to tell about the anniversary, getting a few laughs with explanation of my wine jug's disuse as "cooler heads prevailed."

PAWTUCKETVILLE

Rushing off for Roger's "Ghosts of the Pawtucketville Night" walk, I cross the Moody Street Bridge, where in *Dr. Sax* a man bearing a watermelon abruptly dies of a heart attack as young Kerouac takes it all in. Roger begins, as does Jack in that novel, by noting the "wrinkly tar corner" at University Avenue (formerly Moody Street) and Riverside Street. From typewritten little cards, in slow rhythmic tones with sudden emphasis at the end, our mentor reads the words of Kerouac — whose detailed recall of well-loved moments led Ginsberg to dub him the "Great Rememberer."

Outside a modest home at 16 Phebe Avenue, we're taken back to 1932 when Kerouac, living here, would exchange pulp magazines with friends in the scruffy park opposite. *The Shadow* portrayed that peerless avenger of evil, Lamont Cranston, also on the radio each Thursday night and introduced by Orson Welles above an organ rendition of *Omphale's Spinning Wheel*: "The weed of crime bears bitter fruit! Who knows what evil lurks in the hearts of men? THE SHADOW KNOWS!" On Jack's 1943 stroll with Ginsberg in New York City, the Shadow entered their conversation along with the Shroudy Stranger haunting Allen, who offered help in shaping *Dr. Sax.*

We view the Riverside Street home of a teacher Jack had in 1936, when the Merrimack flooded, inundating this and many other buildings in Lowell. It ruined the printing business set up by Leo, who never again was self-employed and eventually settled the family in New York: town to city.

Hereabouts Jack would play the role of a caped Silver Tin Can, tossing notes in empty cans through open windows and laughing

At these Textile Lunch Tenements at 128 University Avenue in Pawtucketville (left), Jack Kerouac admired Memere's courage in sitting on the precarious top-floor balcony every fine evening, one foot just inside the house. Opposite at number 123 (right) stands the former Pawtucketville Social Club, managed for a while by Leo Kerouac.

the Shadow's laugh. Throughout life he would repeat it — "a strange, shuddering mockery, like a whisper that had come to life." A mockery of Leo's ambition came with the flooding disaster, he then having to rent tenement lodging like that still extant at 128 University Avenue. The family moved seventeen times in seventeen years.

We cross the river to behold one of New England's eeriest sights — outdoor Stations of the Cross in garishly lit glass cubicles. Jarvis has described Jack's recollection, with quivering voice, of how Gerard would lead him here and explain each of the Stations, adding, "And I have followed him ever since because I know he's up there guiding my every step." Jarvis argues that Jack merely observed Cassady's profane side of life, while fixed upon the "one truth" uttered in *Visions of Gerard*: "All is well, practise Kindness, Heaven is Nigh."

There's a Grotto, from which the faithful are expected to climb on their knees to a scene of the Crucifixion: Jesus, supremely beaten down and lifted up. Dr. Sax is here one night in Kerouac's childhood imagination — "I saw him flit from Station to Station, from the backs of 'em, in terrible blasphemy prayer in the dark with everything reverse." The Great World Snake rises from below Snake Hill only to be carried off by the Bird of Paradise, as Sax marvels at a universe able to expel its own evil.

I asked Carolyn how these Stations contributed to Jack's childhood outlook. "Makes you want to throw up," said she, then gave the essence of her take on the Beats: his "will for positive action" as against the radical wish to tear things down. Catholicism expresses a wish both to ascend spiritually and to stamp out evil.

To the Archambault Funeral Home, adjoining these Stations, Kerouac's remains were brought in 1969. Carolyn is glad not to have been present, deploring the spectacle made over Jack in the final dozen years and the ongoing editorial mistreatment: even *The Village Voice* denounced him. An *Esquire* caricature of him as imagined at the end made her weep — for whoever had descended so low as to perpetrate the abuse.

At St. Jean Baptiste Cathedral, where Kerouac had been an altar boy, Father Armand "Spike" Morisette conducted a Requiem High Mass for the dead author. Having closely followed this sinner's

career, he extolled Jack as a "champion of the forgotten and the for-
lorn and the free" and came near to identifying the True Presence
with this man whose example was a reminder, he said, of the two
disciples who met Jesus near Emmaus and happily shared ideas be-
fore parting, whereupon one remarked to the other, "Wasn't it like

*"There's practically no vandalism," Roger Brunelle says of the glass-enclosed Sta-
tions of the Cross (Grotto behind) in Pawtucketville. "They stay lit all night long
except during winter."*

a fire burning in us when He talked to us on the road?" Morisette concluded, "Our hope and our prayer is that Jack has now found complete liberation, sharing the visions of Gerard. Amen. Alleluia."

I return on Merrimack past a tree bearing a cardboard sign: DIS-COTECA EL GRAN PARADISE. Young women of ample form depart on high heels with their dates to drive off in minivans. All speak Spanish, whereas *The Town and the City* shows "French-Canadian millhands cavorting with their women in that stiff-necked, white-collared way workingmen have on holidays," in some "upstairs saloon." Tonight, strobe-lit adolescents are seen dancing — *woo hoo-hoo yah yah, woo hoo-hoo yah yah* — in second-floor windows of a brick factory disco.

A brick wall, revelry among the sexes, Friday night. Kerouac tried to grasp a mystery in such moments by recounting, in *Visions of Cody*, the first hotel visit by Cassady (Cody) with LuAnne (Joanna). At the moment just before lovemaking, visible through the window were flashes of neon on a red-brick wall: "the center of the grief and what Cody now saw and realized from all that time the center of the ecstasy." Ecstasy and grief become one, in a ghost-vision such as all the Beats experienced.

CENTERVILLE

The next day a car tour, again led by Roger, begins at 9 Lupine Road, now with a marker indicating that in the upper tenement, Kerouac was born on March 12, 1922. *Dr. Sax* enigmatically presents the physician as "Young Doctor Simpson who later became tragic tall and gray-haired and unloved." "Simpson" had lost a dearly loved wife and wouldn't remarry, Roger has discovered: "The little bits of information you can still get — but evaporating fast."

At nearby Beaver Brook, says Roger, were swim holes once claimed here by neighbourhood kids. "First, second, third bank — we wore our birthday suits. And two and a half miles up, Kerouac's special bare-ass beach. He called it Pine Brook."

In June 1940 he wrote "We Thronged," about a pre-dawn visit to Beaver Brook with Sebastian — singing "Come ye back to

A car tour led by Roger Brunelle assembles at 9 Lupine Road in Lowell, where Jack Kerouac was born on March 12, 1922. Snake Hill, that dark element of Aztec myth, is represented by Jack as his very birth site — and also as haunted by Dr. Sax, initially a scary figure shown flying to various parts of town. As an ambivalent source of help amid trials, he has been likened to William Burroughs.

Mandalay" — and comic-book fanatic Bill Chandler. The story, effective in its simple declarative tone, was modified for *The Town and the City* to show Chandler newly enlisted, making this a last idyll before both friends died in military service.

A book penned at eleven, *Jack Kerouac Explores the Merrimack*, sprang from what he described as "a beautiful childhood" in the introduction to *Lonesome Traveler*: "roamed fields and riverbanks day and night, wrote little novels in my room…." More beautiful than that of children today, or tomorrow? I imagine so, and yet it's hard to tell: maybe our proto-electronic era will in turn be looked back upon as a growing-up golden age.

We continue to Centerville, where Kerouac grew up amid French-speaking residents, and yet hereabouts now is the sound of Spanish. A resident fills me in: "French Canadians — you'll maybe find ten of them around here, know what I mean? Jean of Baptist church, that's all Spanish. The French moved north, up to Dracut." My informant, a Catholic, is troubled by a fall-off in faith. "The attendance is nothing like what it was ten years ago," he says. "Aw, it's dying out."

Once the Centralville Social Club at 364 West Sixth Street became a festival venue for an "evening of jazz and readings." In a throwback to the Beat era, there were yells of "Go! Go! Go!" as rhythms intensified. Amram, much in his element, at the end announced, "Everything came out naturally, spontaneously, beautifully."

A darker mood pervades 34 Beaulieu Street, where Gerard died from *purpura hemorragica*: bleeding with such force that he suffocated, writhing in pain. "In 1926 a boy turns three, his brother is nine and very sick," says Roger. "He goes away and comes back in a box. Thursday night Jack goes to sleep with the box open in the parlour." Memere thenceforth revered Gerard's memory while placing earthly hope in her surviving son.

Catholicism wasn't all roses, says Roger: "Priests told the women to have one little one every year, so they were all destroyed after a couple of decades." But lying ahead, of course, was an eternal reward. When he refers to any male Catholic's youth here as "really confusing," I request details and out it comes: five priests in succession were abusive. So there was a secret, alongside those

divulged in confession: "I did this thing and you give absolution." More communication happens today, he adds, formerly secret matters now being common coin in the media. So perhaps there's a broader moral framework.

Yet the body, for Catholicism, was seen as the enemy of the soul. In my own Salvationist home, the mere involuntary act of getting an erection in the bath was regarded as sinful, as my father once indignantly let me know upon seeing that pleasant effect produced by the warm water. Carolyn's viewpoint is that both Jack and Neal, as Catholics, had to be penitent for any earthly pleasures en route to rewards after death.

The church adjoins a tall brick Catholic school, École St-Louis, attended by Kerouac in 1928. Roger identifies with his fellow French Canadian, in terms of language: "I didn't know how to speak English until I was five — and Kerouac, not until seven. Dumped into a sea of Anglo-Saxon, a genius — and he's still known as a bum here in Lowell. In the town library he read the French masters as an intellectual exercise, like playing a sport is for teenagers today."

"There were wakes all over the neighbourhood," says tour guide Roger Brunelle at 34 Beaulieu Street in Centerville. "A wreath, purple or black — go in and see a dead person. Thursday, the casket closes and all go to church. And the mother was the one who survived everybody."

On one of Roger's previous tours a visit was arranged with Sister Lucille Mercier, who once taught at École St-Louis. She resides here with other Sisters of the Assumption of the Blessed Virgin: "There used to be forty of us, now there are five." She and Roger together gave the Oath of Allegiance, using the Stars and Stripes, as did both each school day.

The two also talked about Quebec, represented by its fleur-de-lys flag. Sister Lucille in her book *On American Soil*, the story of her religious order's U.S. contribution since 1891, states that "belief in Divine Providence was their unique treasure." Quebec-born Catholics made the new parishes central to daily life: "Allegiance to their adopted country was important but more so was the need to bring up children of strong physical and moral character."

Jack was thus shaped, as a human being, in ways now hard to imagine. He told how one day Gerard, weary after a night of little sleep because of difficult breathing, is allowed to sleep on an arm at his desk, and dreams of being in a white cart drawn by two lambs toward heaven, and "is contemplating the perfect ecstasy when his arm

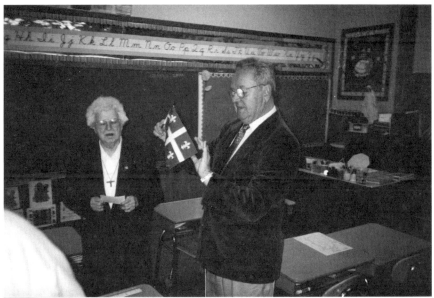

"A hundred and twenty kids and two nuns," says tour guide Roger Brunelle at École St-Louis as Sister Lucille Mercier looks on. "Most of us were wallflowers, so discipline wasn't a big problem. Nuns were brought down from Canada to teach us."

is rudely jolted by Sister Marie and he wakes." Gerard saw his vision as meaning that "we're all in Heaven — but we don't know it!"

Kerouac wrote *Visions of Gerard*, recounting this, when already committed to Buddhism — which tells that from suffering extends the truest road toward wisdom. Gerard's insight gave him the status of a child saint, like the well-publicized Marie Rose Ferron, to whom the Child Jesus is said to have showed his wounds. Kerouac wrote *Visions of Gerard* in this spirit of reverence. Amateur psychoanalysis done by Burroughs showed the fraternal link in another light: his only real memory was of being slapped in the face by this child saint. Yet Jack, often dreaming of Gerard within the coffin, thereafter felt a key imperative. *Écrivez pour l'amour de son mort*: Write in honour of (literally "for love of") his death.

That's a heavy burden, as well I know from having my clan impute flakiness to me and noble Salvationism to my older brother (who didn't die young and still flourishes, praise be). Biographer Gerald Nicosia's remark is right on target: "If in life Gerard was Jackie's best friend, in death he would become Jackie's sternest critic, for his goodness would be remembered as an inhuman absolute."

Memere's influence was paramount in matters both sacred and profane, and Kerouac in his *Lonesome Traveler* introduction told of learning "all about natural story-telling from her stories about Montreal and New Hampshire." He saw his own story-telling as a religious calling, in terms of a favourite movie that showed George Frideric Handel kneeling to pray before composing music. Thenceforth Jack throughout his quest would pray before he wrote, even though his subject might be carnal desire. Paradox abounds in Kerouac, who embraced both concrete reality and mystic possibilities.

SOUTH

In the well-to-do Highland area at 271 Sanders Avenue, on a wooded plot, Jack's brief married life with Stella Sampas became established in 1967. Memere during a short stay in Hyannis the year before had had a stroke, incapacitating her for the rest of her life,

and Stella visited to tend her needs. In November 1966 she married Jack, stolidly providing more of this care.

Carolyn announced Neal's death in a call to number 271 that aroused no reply, and again she dialled only to learn that nobody had told Jack — who then, finally informed, "said all the beautiful things I wanted to hear about Neal." She affirms that Jack would have been a dedicated husband for herself: "He married Edie to get out of jail, Joan on a whim, Stella for aid. Had he married me it would have been an eternal vow."

At 271 Sanders, Kerouac completed a coming-of-age tale, *Vanity of Duluoz* — written for Stella, as *On the Road* had been for Joan. "Dedicated to Stavroula," it begins. "Means 'From the Cross' in Greek, and is also my wife's first name — Stavroula." Its completion, Nicosia states, was boozily celebrated by a mob that ended up at his home around four in the morning. Yet the book was a dismissal of all earthly gain, death looming triumphant.

"Jack's best retrospective of America's Golden Disillusionment," said Ken Kesey of this work in a 1983 *Esquire* article. "It's the final installment in the huge Kerouacian drama, without which none of the rest can be hindsightedly understood. I mean, just look at all these pages, the incredible scope of it all. Faulkner's Yoknapatawpha saga is the only domain remotely close."

Ted Berrigan, interviewing Jack at the Sanders house later for *The Paris Review*, described the results as "like a play by Chekhov," the subject having "totally exposed himself." Berrigan was then sent back for a more conventional question-answer session, "truly hilarious" earlier material then being removed. Many nuggets remain, as when Jack asks about the guy "telling a long tale to a bunch of men in a bar": would he ever go back to make revisions? Noting Cassady's penchant for "first-person, fast, mad confessional, completely serious, detailed" utterance, Kerouac described writing as "a silent meditation, even though you're going a hundred miles an hour."

Calling himself a "loner," Kerouac disavowed support for any non-writing causes. "As Joyce said to Ezra Pound in the 1920s, 'Don't bother me with politics, the only thing that interests me is style,'" he explained. "The country gave my Canadian family a good break, more or less, and we see no reason to demean said country."

A Catholic legacy he also affirmed through the example of Cassady, who "taught me everything I now do believe about anything that there may be to be believed about divinity."

The remains of Kerouac, who died at forty-seven, were conveyed from Florida to Edson Cemetery, now the writer's major pilgrimage site. "The late October breeze stirred in the elms," writes Holmes of the moment. Ginsberg was asked to toss the first handful of dirt upon the coffin, and they flung roses from the flower heart onto it. "I went up and took a white rose and put it over the place where Jack's head lay."

Bob Dylan's four-hour 1978 film *Reynaldo and Clara* shows him with Allen at the grave, strumming guitar, while improvising verse

Here at 271 Sanders Avenue in Lowell's well-to-do Highland area, Jack Kerouac finished Vanity of Duluoz. *All is vanity, Christianity teaches — that is to say illusion,* maya, *in Buddhist terms — and in* Vanity of Duluoz, *Jack views the formulation of his art mockingly. Writing is vanity;* Vanity of Duluoz *itself is vanity. Read the novel in this light and the humour comes through.*

about Kerouac's ascent to the clouds. When Dylan attended university, like the Beats he was drawn toward peripheral types, in whose company he discovered *On the Road* and *Howl*.

Lying nearby are Stella, who composed the gravestone text: "He honored life" — odd, considering Jack's wish to write in honour of Gerard's *death* — and Sebastian Sampas. Joining the Marine Corps as a medic, Sebastian was mortally wounded by shrapnel at Anzio Beach, and so a military funeral laid him to rest. "Sammy looks out from her eyes and speaks from her lips," said Jack.

Then, in 1969, Jack followed Sebastian to this plot. Was there peace in the final years? *The Paris Review* writers found him spontaneous, comical, animated. "God, man," he said, "I rode around this country free as a bee."

I repeat a prayer given in the *Harvard Crimson* for the Great Rememberer upon his death: "God give us strength to be as alive as Kerouac was."

The graves of Sebastian Sampas (left) and Jack and Stella Kerouac (right) are found in Lowell's Edson Cemetery. Devotees have left miniature bottles of Peppermint Schapps and tequila, a paper crane, a small tract giving a portrait of Buddha and a vow to achieve "Ultimate Bliss and Peace."

Golden Ash,
Blissful Emptiness

═══

New England, 1890s–1960s

8

NASHUA, NEW HAMPSHIRE

Steve Edington looks so much like a man of the cloth that he could be an actor representing one. And here's this Unitarian Universalist minister at Nashua, New Hampshire, who acknowledges giving the Christmas Eve service and then, with the rest of his family asleep, putting on a beloved CD of William Burroughs reading his short story, "A Junkie's Christmas." An offbeat tale of Danny the Car Wiper (based on Herbert Huncke), it's deemed instructive by "demonstrating, in his own way, the Spirit of the Season."

So Edington tells it in a new book, *The Beat Face of God.* I identify with Steve, both as an aging vagabond and as an advocate of those crazy Beats as mentors. "They still guide us on our journeys of the spirit," says the blurb. "Learn from these Holy Mis-fits — and come alive!"

In Nashua, Kerouac's immediate ancestors settled from rural

Quebec in 1889. Keenly, Edington researched the facts to produce a book, *Kerouac's Nashua Connection*, and his tours illuminating local sites are not to be missed.

At 16 Pierce Street survives the home built by patriarch Jean-Baptiste for his wife, Clementine, and their nine children. Kerouac admired this vivid personality — "Honest Jack" in local parlance — as told in an early story titled "Father of My Father." He is shown as a fervent Catholic who once reprimanded a whore, yet delivered curses at his Maker during big thunderstorms. There's something of his famed grandson in this closeness to God Himself.

Jean-Baptiste did well enough to arrange private schooling for Leo, the youngest, who was only fifteen when the patriarch thus "died melodramatically." Did his irreverence affect Leo, and Jack in turn? In Lowell's heavily Catholic neighbourhood, Leo would never attend Mass, and is thought to have once snubbed a priest summoned by Memere to induce a little soul-searching.

Yet religion was a solace to French Canadians otherwise torn from their roots. Nearly a million of them provided cheap labour

Immigrant values are expressed in this monument, La Dame de Notre Renaissance Française, *beside the Nashua River. "The Woman of Our French Rebirth" has a cotton spindle in one pocket while tutoring a boy who reads about his native culture. Listed are "contributions to the quality of life in New England" made by Quebeckers.*

for such New England mill towns as this, exchanging near-famine conditions for toil in the 95- to 100-degree temperatures needed for cloth manufacture.

Leo, the youngest child, evaded mill employment by writing and typesetting for a French-language weekly, *L'Impartial*, at 23 Elm Street. Its owner sent him to Lowell to work on an associated paper, *L'Etoile*, and thus he rose to become an independent printer. Back came Leo to find the "neat French Canadian" Gabrielle Lévesque, who lost her mother during infancy and her tavern-keeping father at sixteen. Bereavement having made her the family's sole supporter, she found work locally and was first glimpsed by Leo in a shoe factory. By then she was on her own, boarding at 101 1/2 Ash Street.

At 32 Cross Street lived Joseph Kerouac — the "saddest Duluoz," a grocer, the first male offspring. Jack identified this infirm man as "Uncle Mike" of *Dr. Sax*, who "talked at great length with his melancholy rasping breath about the beauties of the poetry of Victor Hugo." Joseph's son, Armand, who in boyhood played with Kerouac in a cemetery adjoining Edington's church, said that Jack wrote "dirty books."

For Carolyn, too, there's discomfort with the low-life aspect of *On the Road*. Some of that attached to Jack's favourite aunt, Louise, who had an apartment at 100 Main Street. A dressmaker, she is described in *Visions of Gerard* as Aunt Marie, "a talkative, openhearted, teary bleary lovely with red lipstick always and gushy kisses and a black ribbon pendant for her specs." Aunt Marie, on crutches after being struck by a tram, "never married but many boyfriends helped her."

From Armand, a gruff individual, Edington was able to glean few intimate family details, but when asked about her "many boyfriends," Armand smiled and shook his head, then declared, "My Aunt Louise, she was ahead of her time."

St. Louis de Gonzague Church's radically shaped new building replaces that known by Kerouac's ancestors, only one tower of which remains after a 1976 fire. Gabrielle and Leo, whose wedding was here in 1915, contemplated moving to California (as my parents immediately did after their own, a decade later) but came instead to Lowell.

*Nearly all of Jean-Baptiste Kerouac's offspring were married at St. Louis de Gon-
zague Church in Nashua, New Hampshire, including Clara, churched only four
months before bearing his first grandchild, and dying young at the New Hamp-
shire State Hospital, a mental institution: minimal evidence for this clan being
generally crazy.*

Ernest, the normally uncommunicative second-born son of Jean-Baptiste, lived at 27 1/2 Gilman Street. Kerouac is said to have wanted a simple, non-upwardly-mobile existence like his Uncle Ernest's. But clan members fiercely desired higher social status, and many have now risen into the professional class. Edington was amused at Armand's boast on his own family's behalf, saying that it did more visiting than Leo's "because we had a car."

For Leo's interment in 1946, Edington suggested, family members probably gathered at Ernest's home. The magnificent coda to *The Town and the City* portrays mourning by relatives who "arrived in old cars spotted with country mud, with their troops of children, their young mothers, their wise and melancholy old folks, their dark young men dressed in their Sunday best." Along the way to the cemetery, townspeople "paused in their Monday morning affairs to watch, the men removing their hats — briefly — before walking on."

At St. Louis de Gonzague Cemetery (separated by busy Route 3 from the church of that name) rests Leo, along with Gabrielle, Gerard, and "granddaughter Jan Michele." Edington showed the fresher grass where ashes of Kerouac's only known offspring were placed. Before succumbing to kidney disease in 1996, she made a request to be buried with her grandparents, and Edington helped with the interment. "Jan in many ways was abandoned by Jack," he remarks.

Well known is Jan's 1967 Lowell trip with boyfriend John Lash to visit Kerouac for the only time during her maturity. Memere confusedly yelled that these passersby were "foreigners," and shortly they were asked to leave. Kerouac, told of Jan's writing ambitions, said that she could use his name.

"There was no way he could care for a child in the way he insisted it should be done," Carolyn explained to me. Home and family was forever a hope, "but it had to be when he could support one by his writing. Meanwhile he had to be free, and we were his surrogate family — always writing about 'my' kids and 'my' Carolyn."

Steve Edington stands in St. Louis de Gonzague Cemetery in Nashua next to the grave of Jack Kerouac's parents, Leo and Gabrielle. Buried here, too, are Jack's brother, Gerard, and Jack's daughter, Jan. At least Jan's resting place is known, unlike those of Jean-Baptiste, Clementine, and their early-dying offspring. Where Memere's parents lie is also undetermined. Steve observes: "There was a potter's field arrangement here."

BOSTON

Kerouac from adolescence liked to visit Boston and walk around the harbour, viewing ships. In 1941 he would people-gaze on the Common with Sebastian Sampas, shown in *Vanity of Duluoz* jumping up "to make big Leninist speeches at the soapbox area where pigeons hung around watching the argufyings." His theme, "the Brotherhood of Man," sprang from musings in a study group formed in Lowell by the two, called Prometheus after the rebellious Titan of Greek myth.

Listeners here (by the subway entrance) were newly respectful to such Communist-sounding rhetoric, Russia having become England's ally against Hitler. And on each Saturday noon, a cop tells me, such orations are still given: "Cause of the week, same people every time." Democracy in action, I submit. "Gotta love it!" he says.

That fall Kerouac quit Columbia and took a freedom trip to Washington, buying there a copy of Ralph Waldo Emerson's *Essays*, reinforcing his hard quest for self-reliance. Emerson followed a similar path of non-compliance, forgoing ministry in the Unitarian church, and similarly became immersed in Eastern religion. From this arose "Transcendentalist" ideas, crystallized here on the Common in 1834.

Amid "snow puddles, at twilight, under a clouded sky," Emerson became "a transparent eye-ball," ecstatic revelation ensuing: "I see all. The currents of Universal Being circulate through me; I am part or particle of God." It was Romanticism in American form, the imagination lifted above reason as a gift from the gods.

Kerouac in *Big Sur* tells of repeating maxims from Emerson's "Self Reliance." Often he experienced such visions — and in similarly yielding-so-as-to-receive ways — which led to questions about how to live. "Life is an ecstasy," wrote Emerson in *The Conduct of Life*. So why shouldn't we act freely, joyously, spontaneously? Why shouldn't we connect with the heartbeat of all living? This baffled Kerouac as well, raised in a land avowing "life, liberty, and the pursuit of happiness."

In the Boston Public Library, I head upstairs as always to see Edwin Austin Abbey's 1910 mural, *The Quest and Achievement of the Holy Grail*. Commissioned to generalize literature, he decided on the Grail myth as representative of every land, and on Sir Galahad as its central hero. Panel three shows him being led by Joseph of Arimathea toward Round Table knights and given the Seat Perilous — "perilous for good and ill," according to an explanatory handout penned by Henry James.

This grandiose work must have been known by Kerouac, a library aficionado who often thumbed into Boston. Sal Paradise specifies a personal quest, though without vows of chastity: "Somewhere along the line I knew there'd be girls, visions, everything; somewhere along the line the pearl would be handed to me." At no one place or moment in the book is this benison seen occurring, yet the theme is powerfully present.

Kerouac well knew a Québécois heritage and set out also to grasp that of the United States. British scholar James Campbell argues

A panel from Edwin Austin Abbey's The Quest and Achievement of the Holy Grail *in the Boston Public Library depicts figures from the Grail legend. Sir Galahad is shown in another panel surviving passage across the Waste Land to win the Grail. T.S. Eliot, whose poem of that name owed much to Boston wanderings while attending Harvard, assumed a Christianity-tinged stance of impersonality on his spiritual quest. The Beats thrust forward their private selves, contrastingly, upon their own paths to illumination.*

in *This Is the Beat Generation: New York, San Francisco, Paris* that Jack sees Cassady, early on, as possessing "the keys to America" in a mystical quest. One might also point to Sebastian, viewed in *Vanity of Duluoz* as "a great kid, knightlike, i.e., noble, a poet, goodlooking, crazy, sweet, sad, everything a man should want as a friend." *Visions of Cody* also suggests a homosexual pursuit aspect of Sampas: "my Verlaine was killed in a battle of war."

I walk just to the north of Boston's big raw-concrete city hall where, as indicated by an old city map, the National Maritime Union Hall stood in Kerouac's day. He went there for wartime assignment to ships, signing on as a scullion aboard the *Dorchester* in July 1942, after the United States entered the war. It carried construction workers to Greenland on a final round-trip voyage before being torpedoed. And at the docks a final goodbye was said by these comrades, Sampas dying the next year.

But there were "seeds in a new soil," Sampas wrote in his soaring May 26, 1943, letter to Kerouac, and a fresh wind that would energize a freer postwar world as foretold by their favourite novelist, Thomas Wolfe. It was a prophecy, in the tradition of Puritan ministers' Election Day sermons as told in Nathaniel Hawthorne's *The Scarlet Letter*, for the Beats' liberating influence was soon to come.

NEWPORT, RHODE ISLAND

The U.S. Navy in 1943 assigned Kerouac to boot camp after his failure to qualify for officer training (poor mechanical aptitude). This was at the Newport Naval Base in Rhode Island, where he was given the heroic opportunity of becoming a commando — swimming ashore at night as a "frogman" to kill enemy guards and destroy installations — but disavowed being anything other than a "frog" (using the abusive term given to Quebeckers). Also, he lacked the discipline needed by any military unit to gain its targets. Yet he spoke of registering the highest IQ ever attained here.

Following directions to the U.S. Naval Station, I continue to a "Naval Ambulatory Care Center." Two young navy personnel, a man and a woman, guard the vehicle entrance. They can't let me in, but we have a nice chat. He confirms that this is the Second World War unit (replaced by a modern facility); she tells how excited she'll be soon, going to sea as a weapons technician. Neither has heard of Kerouac.

Here he dropped his rifle during drill session, told everyone to go to hell, and went off to the library. Put into a hospital adjoining a drill field where recruits were being reviewed one morning, he ran out naked, shouting "Geronimo!"

The navy placed Kerouac in the psychiatric ward from which he was sent, after being caught with another inmate pocketing butter knives for use in an escape attempt, to a medical center in Bethesda, Maryland, by guards bearing straitjackets for use if new mischief should arise.

On Gerard Duluoz's terms, Kerouac opposed killing anyone, friend or foe. Leo shared strong anti-war sentiment with his pacifist

A key archetype for Jack Kerouac was the title character of Herman Melville's tale "Bartleby, the Scrivener," who submits to the "dry, dusky" task of copying law papers until one day when he has had enough. "Prefer not to," he declares — as did the nonconforming Kerouac here at the former hospital at Newport Naval Base.

generation of French-Canadian males, some of whom in Canada would maim themselves to avoid military service. It threatened political crisis in Canada during both world wars. Kerouac felt conflicted in this, wishing to serve his adopted country as many friends were then doing to defeat a fascist enemy. Probably the key reason for his behaviour was to re-enlist in the U.S. Merchant Marine, which he shortly would do after discharge from the navy.

What I assume to be Kerouac's long-ago hospital, now disused, adjoins an asphalted area where he seems to have given that shout. His contempt for base-camp officers comes out in an utterance Jarvis records: "What I was really saying to them was that I would prefer not to suffer the indignity of having some little monster with a couple of bars on his shoulders clog up my beautiful brain with sawdust from his ugly brain." But he had regrets, Jarvis adds, for a "betrayal of his country in its hour of need."

OLD SAYBROOK, CONNECTICUT

Down by the coast in Old Saybrook, Connecticut, lived John Clellon Holmes at 11 Shepard in a fourteen-room Victorian-style mansion. He is thought to have used an $80,000 inheritance in 1953 to purchase it. Carolyn indicates that Jack, on his first visit here, wrote to say how she would love it, and described every inch — this man thought to prefer being on the road.

He venerated Holmes, says critic John Tytell, as a "bedrock of values, a man whose judgment was dependable because he retained a sure sense of rightness despite the confusions of New York." Holmes's leftist stance was a foil for Jack's, producing a kind of truth out of two extremes.

When Landesman came east to promote the second issue of *Neurotica*, a story in it by Holmes was "the first piece of published fiction that utilized the language of the hipster" — or so he opined in *Rebel Without Applause*, giving its first paragraph with a then-daring reference to marijuana:

> This is a local fable and the boy is Beeker. This guy was a Peko-man, and he blew himself out of the coils of a trumpet every night. He came on for culture, not for loot; so he passed the marijuana to his cohorts when the need was near. This tea-dispensing on the cuff brought in enough for bills, and the lad was living in a new era.

Holmes "would be some far-out looking cat, shifty, probably strung out on the weed," Jay speculated. "Imagine my surprise to meet a quiet, almost shy, tall, thin, professorial type, with a magnificent Bobby Darin wave of blond hair." Landesman was "up to my neck in poets," but receptive to a ditty written by Holmes's friend Ginsberg with Kerouac's help: "It had a nice rhythm and rhyme and a play on words that was very interesting. He called it Pull My Daisy."

Kerouac and Holmes became lifelong friends on first meeting in July 1948. Both were aspiring writers, each supportive of the other. Jack's journal entry for November 9 tells how he visited Holmes that

night, after returning from Poughkeepsie, and then "started to write 'On the Road.'" Just like that: a full nine years before its publication.

"First he tried to write it the way he'd written *The Town and the City*," says Holmes in *Jack's Book*. "*On the Road* started in New York with a rich family, a poor family, all kinds of crazy things. The opening scene was in a penthouse. The mother was based on my mother, whom Jack knew quite well by then. Then there was a whole phalanx of younger children." This scene had humour and yet was rejected, he adds, for being in the earlier book's style.

Holmes, Tom Saybrook in *On the Road* ("sweet, gentle, amenable"), got by on such lowly jobs as ghostwriting (fifty dollars a month) for support while striving for art in serious verbal expression. Much in the Romantic tradition is this attitude toward financial gain — which both men received nonetheless.

Holmes's 1952 first novel, *Go*, presents an alter ego, Paul Hobbes, discerning nascent selfishness in the Beat Generation: "They came to fear emotions, to think of human needs as a sign of weakness, and to view isolation, not as a curse and a blight, but as a protection." Paul is shown as neurotic in contrast to the saner, more open-hearted Gene Pasternak (Kerouac).

It was odd to read a 1982 letter to Carolyn by Holmes that avowed pleasure in rejoining old friends at a Colorado conference on the twenty-fifth anniversary of *On the Road's* publication. "I came back with a new respect for the 'Beat Generation,' something I've heretofore felt so alien to," he wrote. Didn't the man collaborate with Kerouac in coining that very phrase? James Campbell regards Holmes as a virtual inventor of the Beats, in fact — and somewhat more of a note-taker than a hellraiser.

A chapbook Holmes wrote in 1981, "Visitor: Jack Kerouac in Old Saybrook," portrays such moments as when Jack came with Ginsberg and Orlovsky in 1957: "We played football in the snow, and Peter did perfect figure-eights on the ice-covered North Cove." Much changed was Kerouac on a final alcoholic visit in September 1962: "Sweet & tentative when sober, he becomes truculent, paranoiac, garrulous, stiff-jointed, wild-eyed, exhaustless, and amnesiac when drunk. Booze alone can be seen to produce in him the 'ecstasy' he needs to get thru time."

Current owner Leigh Gesick believes that John Clellon Holmes built the chimney at 11 Shepard Street in Old Saybrook, Connecticut, by himself. A home lover, certainly, yet give him credit for the many parties thrown both here and in his Manhattan flat at 681 Lexington Avenue.

Holmes sensed, as did Carolyn, that Jack wished to die. This entailed a "mile-deep puzzle of identity" requiring a quest for the role: "He claimed, in his drink, that he was Christ, Satan, an Indian chieftain, various holy men of half a dozen cultures, the universal genius, and who knows who else, who can remember."

In Old Saybrook, Holmes learned in 1969 of Jack's death from the radio, and reflected first on how much he had wanted his friend to be happy. "Then, all of a sudden, I found myself weeping, because I have always addressed my sentences to him, to his disapproving, canny eye."

Allen phoned with commiseration from his farm in Cherry Valley, New York — "how thoughtful, knowing I would be heartbroken" — and told of a poetry reading he would be giving just then at Yale University in New Haven. Holmes attended, and thus heard "that warm, insinuative tone in the voice, that feeling of an old camaraderie that should be acknowledged despite time & disputes."

A banner had been placed by students on the stage reading IN MEMORIAM: JACK KEROUAC, 1922–1969, and in the line below,

NEAL CASSADY 1926–1968. Allen rose to the occasion, reciting from *Mexico City Blues* the 211th Chorus's last lines, and repeating them twice for emphasis:

> *Poor!* I wish I was free
> of that slaving meat wheel
> and safe in heaven dead.

Then someone asked how Kerouac, of right-wing convictions, might be deemed important. "I knew what he was thinking: How could you sum it up in a few glib words?" Holmes wrote. "How could you bring back the eager Jack, Jack of the tender eyes, the raucous Jack of midnights?"

For fifty seconds Allen leaned on the lectern, silent. The first to "make a new crack in the consciousness," he then declared, was Kerouac, who "broke open a fantastic solidity in America as solid as the Empire State Building — that turned out not to be solid at all." Jack came to know the universe as "golden ash, blissful emptiness, a product of our own grasping speed."

It *Was* Pure, in My Heart

———

New Jersey and New York, 1920s–1990s

9

Paterson, New Jersey

Next stop is the hard-nosed city where Allen Ginsberg was born: Paterson, New Jersey. He aimed early on to become a lawyer, battling for radical causes, though diverted ultimately toward the poetic art. From Good and Truth to Beauty, in Platonic terms; except that he returned full tilt to radicalism — and thereby hangs the entire tale of the Beats.

Louis Ginsberg, Allen's father, certainly was devoted to Beauty. Challenged by a high-school English teacher to write a poem imitating Milton's "L'Allegro," he did so to general amazement. Louis went on also to teach high-school English and won modest fame for his own verse.

Louis's fiancée, Naomi Levy, also taught, at a school for the educationally disadvantaged, and suffered there a nervous breakdown, giving his parents qualms about their marriage plans.

These went ahead, and to Paterson, New Jersey, the couple moved from Newark after the First World War.

Allen was born in 1926, his home for a while at 83 Fair Street (demolished) by a crossing of the Erie Railroad, where an embankment was used by children for play, and an adjacent silk-thread factory made loud noises night and day. At 155 Haledon Avenue, better lodging was rented by the Ginsbergs when Allen was eight. Louis walked the floors reciting great verse from memory: "part of the household," he recalled, the way others sing at work.

Allen spent two summers at an upstate New York camp run by the Communist Party, for which Naomi served as the local chapter's secretary. Louis devoted himself to socialism at the cost of religious ties — not attending synagogue, though observing sacred days and seasons — as did his son, in a similarly eclectic embrace of the Jewish heritage.

Naomi practised nudism, which led Allen to include in *Kaddish* the line "beard around the vagina." Afflicted by paranoid

Allen Ginsberg's parents would venture from their bourgeois milieu at 155 Haledon Avenue in Paterson, New Jersey, into Greenwich Village for poetry readings. Naomi, Allen's mother, played the mandolin to accompany favourite songs.

schizophrenia, she began a year's treatment of insulin-shock and electroshock therapy in 1936 at the Greystone Psychiatric Hospital. On her return — the family now briefly in another apartment down the street at number 72 — she was much transformed for the worse.

At number 288 on what is now Rosa Parks Boulevard stands another apartment building where Ginsberg lived until his college days. Throughout, there were radio programs such as *The Eddie Cantor Show*, concluded each week with the comedian's song that would sadden him: "I love to spend this hour with you, as friend to friend. I'm sorry it's through."

From infancy Allen feared the bogeyman, named a "Shroudy Stranger of the Night" in his early verse. Still opposite number 288 is a church once bordered by thick hedges, causing him to wonder about infinity — particularly after taking in a movie at the Fabian Theatre — and behind these was the Shroudy Stranger. He pondered whether a wall might be at the very end, and he would

Naomi Ginsberg's malady returned while the family lived at what is now 288 Rosa Parks Boulevard (right foreground) in Paterson, Allen holding ever-diminished hope for a cure. In 1939 on a brief return to home she had told him: "Don't be afraid of me because I'm just coming back home from the mental hospital. I'm your mother."

go into a faint over his loneliness amid the universe. I had similar agoraphobic experiences early on, causing shame along with horror.

At Bennington College, Carolyn Cassady had lectures by the noted Erich Fromm, who regarded sanity as dependent on satisfaction of human need for "relatedness, transcendence, rootedness," gained primarily in collective art such as folk dance and community singing. Quaint. Naomi's Communist camps, with singalongs in praise of the worker, were deemed sane societies and yet could hardly stave off mental illness.

A short walk leads to Eastside High School, attended by Allen. "'Professor' is the philosopher and genius of the class," his 1943 yearbook entry states: "hopes to study law ... Talent Club President, Criterion Big Brother, Senior Mirror ... fiend for Beethoven and Charlie Chaplin ... hates dull teachers and Republicans." Though popular, and president also of the debating and dramatic societies, he later viewed himself then as decidedly cut off from reality.

At the Paterson Public Library, 250 Broadway, Ginsberg shelved books in adolescence and surreptitiously looked into Richard

Photographing a sign identifying Eastside High School as the "Home of the Ghosts" — "Shroudy Strangers" on the loose — I'm chided by two guards on the possibility that I'm a terrorist stalking out targets. Madly, I protest such madness until they order me off the grounds.

Freiherr von Krafft-Ebing's *Psychopathia Sexualis*, studying whether or not he was homosexual. It was a crush on a quiet boy named Paul Roth, who went on to Columbia, that prompted his own choice of that university.

Over at 416 East Thirty-fourth Street, Louis lived out his final years. Allen often visited, in 1948 bringing Kerouac here for a Passover Seder. In the garden, annual "Ginsberg cookouts" were given by Louis, who in a 1969 article, "My Son the Poet," folksily told of having room there to "chat and ruminate." Three years earlier Allen, informing a Paterson poetry-reading session that he had "smoked a joint" just before, had induced Mayor Frank Graves to give a warrant (later voided) for his arrest. This "Famous Poet" ventured to demystify drug experience that year in a major *Atlantic Monthly* article, "The Great Marijuana Hoax: First Manifesto to End the Bringdown." Laws against its use were founded upon misconceptions, he said, its harmlessness having been proven as far back as the 1890s.

Allen in turn indicted America for its materialistic values. Theodore Roszak in his 1969 study *The Making of a Counter Culture* likened him to the Hebrew prophets, instruments of a higher power. Yet he and the other Beats seek a mysticism of this world, savouring "ecstasies that have been buried and forgotten beneath the nitty-gritty scatological and sexual rubbish of existence."

Morris Plains, New Jersey

A drive westward on I-80 leads to U.S. 202 and Morris Plains, where the Greystone Psychiatric Hospital survives as an endangered historic site. For the Ginsbergs, bus trips required two or three hours each way, past small towns contributing a melancholy of their own. Here is the wholesomeness of woods and rolling meadows — restorative powers for the mentally ill, it was hoped.

Greystone, where in 1961 Bob Dylan visited the ailing Woody Guthrie in a non-psychiatric section, is now largely given over to vandalism. Patients could once be seen though the fence playing

basketball or checkers, though a siren would warn of any escapes requiring local residents to lock their doors. For Ginsberg the place was a nightmare of bad smells and crazed behaviour.

Deinstitutionalizing began when drugs provided better treatment, also in the wake of conjecture like that of Thomas Szasz, for whom "mental illness" was a lie conceived to serve doctors and the public.

Mental hospitals such as this briefly held my mother — who recovered, fortuitously — and visits required a long trip with my father and brother uttering the usual lies: "She's improved, hasn't she? ... I think Mom's getting better ... She'll be home soon, just like before."

Yet a desert would spread in the soul, as told in *Kaddish* — "I went alone sometimes looking for the lost Naomi, taking Shock" — in which Ginsberg struggles to understand human destiny: "Done with yourself at last — Pure — Back to the Babe dark before your Father, before us all — before the world...."

Allen Ginsberg's mother, Naomi, was confined here at Greystone Psychiatric Hospital in Morris Plains, New Jersey. The mental institution in Ken Kesey's One Flew Over the Cuckoo's Nest *is viewed as "a little world Inside that is a made-to-scale prototype of the big world Outside," where any kind of protest is cause for shock therapy, or even lobotomy, and the dissenting Chief Bromden serves as a kind of mad prophet.*

Manhattan

In Manhattan again I visit the West Twenties, closely linked with both *Howl* and *On the Road*. An apartment once at 125 West Twenty-first Street was the scene of parties, in 1950, recalled by Ginsberg in *Howl*: "danced on broken wineglasses barefoot smashed phonograph records of nostalgic European 1930s German jazz finished the whiskey and threw up groaning into the bloody toilet."

The loft was rented by Bill Cannastra, a hellraising Harvard Law School grad. In 1950, several days after talking lengthily in the San Remo coffee house with Ginsberg about death, he boarded a subway train but humorously made as if to return to Greenwich Village for more drinks. Getting stuck partway out of a window as the train accelerated, he fractured his head against a pillar and died. His ostensible madness struck a mood for the composition of *Howl*, largely about friends in the early Cold War era with psychic conflicts of their own.

Telepathy, a major Beat concern, was extended to a kind of communication with the dead in *Howl*, Ginsberg experiencing the madness of those gone into the Land of the Dead. Homer speaks similarly, in the *Odyssey*, of Trojan War heroes consigned to the Underworld. Burroughs loved Sal Paradise's talk of his own existence as that of a ghost, and cited Charles Baudelaire's view of poetry as putting images in the reader's mind by means of incantation.

Cannastra had lived at number 125 with Joan Haverty, a drama enthusiast from Albany, New York. Efforts in high school and a downtown acting circle had drawn her to Cliff Pryatt, an older man who enticed her to a Provincetown theatrical hotel. Shunning his amorous intent, she departed for New York. After Bill's death, she maintained the flat as a shrine, and once invited Kerouac in to share some hot chocolate — thus gaining a domestic quality, it seems — and was asked the next day to marry him. So here in late 1950 Jack sang, "Them wedding bells is breaking apart that old gang of mine" with Carr — who, living nearby at number 149, was often visited by him.

This abrupt initiative baffled Carolyn and Neal, in terms of Kerouac's attitudes toward women and Catholic doctrine. Joan tried

living with Jack in Memere's new residence in Queens (94–21 134th Street). This tight son-mother-wife arrangement didn't work out, understandably, and Joan in February 1951 took a loft at 454 West Twentieth, where Kerouac decided to join her.

Joan committed her views on Jack to copious notes posthumously assembled in a memoir, *Nobody's Wife: The Smart Aleck and the King of the Beats*. Scholars find it excessively biased against her ex-husband, but it's fascinating nonetheless.

In early April, Joan was learning the ropes at a high-end waitressing job. "Jack seemed to have been locked in some struggle with *On the Road* through my whole training period," she writes. Noticing that he neither wrote nor talked, she asked "what really happened" on the road: "Questions about Neal, about traveling, cities, trains, New York, Mexico, cars, roads, friends, Neal, Neal, Neal, and Neal."

He answered by typing the manuscript-roll version of *On the Road*. Usually called the "scroll," it was hung by a coat hanger over

"It was ironic that I acted as his muse," Joan Haverty, Jack Kerouac's second wife, reflected, "when his writing had always seemed so unimportant, even unreadable, to me." Haverty lived with Jack here at 454 West Twentieth Street (right) in Manhattan in 1951.

the typewriter keys. The contraption worked like a word processor in freeing him from changing paper, yet was dissimilar in lacking cut-and-paste functions (detrimental to full spontaneity, he might have thought). Serving the aim of zero-revision creativity, the device would now become for him a regular means of expression.

The New Vision was about to be realized in full. Seventeen years later on the *Firing Line* television show, Kerouac would speak of the Beat movement as "pure" — meaning unalloyed with dull matter, presumably — and now would come its moment of purest creation and spontaneity.

He consumed coffee and pea soup Joan prepared and, wishing her to be close by, dragged their bed near the desk and put a screen around it to reduce the light. The 86,000-word account was clearly written for Joan — whom he encouraged, also, to record life experiences. No paragon, of course, but wanting to do the right thing while fashioning this bold new form of expression he precisely described (much in Joan's terms) to *The Paris Review*:

> You think out what actually happened, you tell
> friends long stories about it, you mull it over in
> your mind, you connect it together at leisure, then
> when the time comes to pay the rent again, you
> force yourself to sit at the typewriter, or at the
> writing notebook, and get it over with as fast as
> you can ... and there's no harm in that, because
> you've got the whole story lined up.

On May 5, Joan asked Jack to leave. Some put the blame on his petulance and other character flaws, though much remains a mystery. Did Kerouac grow cold toward her? Probably not, his "sex list" showing that they made love 150 times. He took his belongings to Carr's loft, returning one night to find her in bed with a Puerto Rican man from work. When Joan told Jack about her pregnancy in early June, he figured the father was the Puerto Rican.

The couple conferred on number 149's roof, seeking a solution. Kerouac, without a publisher for his new novel and thus unable to support a child by writing, also couldn't abide forty-hour weeks of

menial toil. Against Catholic doctrine he demanded an abortion, which she refused. Then came what appears to be a mutual wish to go separate ways.

Holmes, in an April 27 journal entry published in the periodical *Moody Street Irregulars*, speaks of being allowed to read the manuscript even before Kerouac did so. When he took it back to tell his response, the two went to a waterfront bar and spent a few minutes "out on a cluster of pilings at the end of a pier." (No such place is evident today, unfortunately.) The work "has scenes of unusual power that dredged me dry, and has straightforward clean American writing and a new recognition of the depth of the American experience that should set the critics squabbling," said Holmes. "The sections in Mexico are faultless, lovely, sad. There is much, much else." *Sad*: Carolyn was long unable to bring herself to read *On the Road*, for the memories it evoked from 1947–50.

Kerouac visited the office of Harcourt Brace, where *The Town and the City* was published (383 Madison Avenue), and exultantly unrolled the work for supportive editor-in-chief Robert Giroux, who is thought to have compared it to Dostoevsky. But on a manuscript of such irksome shape, how to make revisions? It ended up at Viking and remained unpublished for six years, meaning near-poverty for Jack but also the benefit of writing out of the limelight on his own terms. Holmes, by contrast, would shortly get a lucrative contract for his unremarkable novel *Go*.

Ginsberg, also seeing the manuscript, told Neal that it needed a kind of prophecy at the end. Kerouac had a different idea, based on a late-1950 limo ride he'd had from Henri Cru's apartment to a Duke Ellington concert when Neal, inconveniently asking for a lift to Penn Station, had to be left in the cold. It was that detail Jack wanted, for its implications of friendship eroded by time. "Last part," he wrote to Cassady on May 22, "dealing with your last trip to N.Y. and how I saw you cutting [*sic*] around corner of 7th Ave. last time."

Kerouac had leaped ahead stylistically on the stimulus of Neal's ultra-spontaneous Big Letter. He now told of completing a "full-length novel averaging 6 thous. a day" during April 2–22, adding that "your development from young jailkid of early days to later

(present) W.C. Fields saintliness" is the plot. "I've told all the road now," he said. "Went fast because road is fast."

The book's famed concluding vision, from a Hudson River pier, is of America stretching far westward at the onset of "complete night that blesses the earth, darkens all rivers, cups the peaks and folds the final shore in." The two friends' Grail quest seemingly ended, Sal views ahead only "the forlorn rags of growing old." I find no such misery in agedness, and yet, asking Carolyn what's wrong with a lengthy life, was told, "Plenty!"

The fabled San Remo once flourished at 93 MacDougal Street on Greenwich Village's main corner at Bleecker. Martinis, strong espresso, and fifteen-cent beers once drew many here — addicts, homosexuals (Thursday nights primarily), Living Theatre people — into the small hours. "After the San Remo closed there was always someone's pad we'd go to to finish the conversation," recalled Landesman. "Talk was the main activity; dead air was a hanging offence." His wife, Fran, would be welcomed here, she "an easy laugher, a great asset to a table full of men."

My last time at the café (by then renamed Carpo's), the server clasped her hands in glee to have an actual customer aside from those on bus tours. Ginsberg was introduced to the San Remo in 1948 by Carl Solomon, who later became a fellow patient at the Columbia Presbyterian Psychiatric Institute. Allen was put there upon pleading insanity to a charge of harbouring stolen goods, and Solomon asked for committal upon identifying with the nihilist Kirilov in Dostoevsky's *The Possessed*. At the "PI" Carl had hammered on a piano and yelled as if indeed possessed, this producing a memorable image in *Howl* (his actual madhouse reconfigured as Rockland).

Here gathered what Ginsberg called the "subterraneans," used as a book title by Kerouac, who credited it to him and endorsed his view that they were both hip and Christlike. Jack was just outside the "San Remorse" (so called for its existentialist mood) in 1953 when he first saw, perched on a car fender, the lovely Cherokee-black woman with whom he had an affair, Alene Lee — Mardou Fox in *The Subterraneans*.

Gore Vidal, often seen here at the bar with one foot on the rail, in *Jack's Book* disparagingly tells all about going to bed with him

at the Chelsea Hotel. Strike one: Kerouac wouldn't "really describe" that night in *The Subterraneans*. Strike two: this meant that he was "basically timid." Strike three: Kerouac was "not above using" his bisexuality to further a writing career. Then Vidal dropped a bombshell, recalling when Memere got Ginsberg to acknowledge his homosexuality: "She said, 'That's so interesting, because, you know, I always thought Jack's father was.'"

The popular Kettle of Fish was then at 114 MacDougal. Before a neon sign on the doorway's left side reading BAR, Kerouac was photographed in 1958 not wearing the usual lumberjack shirt — and thus presented a rugged image to which Gap later bought the rights for a khaki campaign. The sharp dresser: a guy who didn't even know his collar size.

Girlfriend Joyce Johnson stands alongside in the photo but was airbrushed out. After first meeting Jack as a blind date at a Howard Johnson's (416 Sixth Avenue), they had descended to the subway and she had noted an airline ad slogan: FLY NOW. PAY LATER. Her comment that it would make a good title for a novel led around to her own writing: "He was going to look at my work and show me that what you wrote first was always best." The mind's true impetus: no airbrushing.

Long gone also is the Gas Light Café from the basement of 116 MacDougal, opposite, where the first Village poetry readings occurred, and Mike Wallace did interviews with Beats in 1960. Wallace had written a *New York Post* article on Kerouac early in 1958, describing him as "a tattered, forlorn young man with the chronic exhaustion of one who eats and sleeps infrequently." Jack recklessly recounted visions gained from drugs, leading Wallace to identify a "new kind of mystic" using "the strange modern techniques of jive, junk, and high speed to achieve his special ecstasy."

The Figaro at 186 Bleecker (relocated from number 195) is just about the only Beat-era coffee house remaining — and lacking, I'd say, in Beat-style intensity. David Amram in his memoir *Offbeat: Collaborating with Jack Kerouac* tells of going with Jack in 1959 to the Figaro and finding women in black — sweaters, skirts, fishnet stockings — and men in black berets who tapped bongo drums. "It's like Catholic school, everyone in uniform," said Kerouac. "We're like tourists in a museum about ourselves."

In November 30, 1959, *Life* magazine printed staff writer Paul O'Neil's crude falsification of Beat Generation values, "The Only Rebellion Around." He sneered that Kerouac was "the only avant-garde writer ever hatched by the athletic department at Columbia University," that Burroughs had "rubbed shoulders with the dregs of a half dozen races," that Ginsberg made free "with perverse allusion in a fashion calculated to make the squares run for the cops."

Eisenhower-era Time-Life nonsense, mistaken for truth by anyone striking responsible poses in, say, an Ontario high school. Not for a dozen years did I teach anything by the Beats, so stigmatized they had become. Yet their writings are ideal for the classroom (even the "dirty" parts) in terms of adolescent hopes and fears about experience.

In the Village, generations notably intersect. Kerouac would sit doing "scat talk," verbal jazz, in nearby Minetta Lane where the Cafe Wha? stands beside it at 115 MacDougal. A kid from Duluth entered it in 1961 to announce, "Just got here from the West. Name's Bob Dylan. I'd like to do a few songs. Can I?" *On the Road* had inspired him, like so many other rockers, to take such footloose paths.

A "party room" is now available at the Figaro Café on Bleecker Street in Greenwich Village, long after all-night partying went on at this street corner. Where have all the bohemians gone?

The first Manhattan home of Ginsberg and Orlovsky, back in 1958–61 after their San Francisco stay, was an East Village tenement flat at 170 East Second Street. This wasn't far from where Ginsberg's grandfather, Mendel Levy, having sold Singer sewing machines in the Russian village of Nevel, first settled his wife, Judith, and their four children. Allen described the Orchard Street candy store he operated: "first home-made sodas of the century, hand-churned ice cream in backroom on musty brown floor boards."

Early in 1959, Norman Podhoretz was invited here, despite his anti-Beat stance, and there was amicability though certainly no meeting of minds with Ginsberg and Kerouac. "What they had in common was a fierce hatred of America," said he in a 1999 memoir, *Ex-Friends*, dismissive of their works while posturing as the true champion of U.S. values.

In his 1958 article "The Know-Nothing Barbarians," Podhoretz had conjectured a Beat cry for violence: "Kill the intellectuals who can talk coherently, kill the people who can sit still for two minutes at a time, kill those incomprehensible people who are capable of getting seriously involved with a woman, a job, a cause." This falsely defamatory rant was repeated word for word in 1995 by Michael Gerson, who became a speechwriter for George W. Bush — elected to the U.S. presidency as a foil to the easygoing (and thus Beat-like) Bill Clinton.

So the Beat legacy lives on, seemingly decisive in elections. Hillary Rodham Clinton, with presidential ambitions herself, must account to hard-line voters for such youthful advocacy as that given in her 1969 commencement address at Wellesley College for "a more immediate, ecstatic and penetrating mode of living." How dare she?

During Ginsberg's youth, many felt threatened by his vision of a more sympathetic world gained through drug use. In 1960, drawn to Harvard by Timothy Leary's experiments with the mushroom-based hallucinogen psilocybin and hearing the music of Richard Wagner after receiving thirty-six milligrams of the drug, he zoomed high enough to grasp finally how John Milton, in *Paradise Lost*, appeared to side with the rebel Lucifer. Allen aspired to phone such world leaders as President Eisenhower and Mao Tse-Tung to invite them to the campus and transform the world's consciousness.

Jack Kerouac, taking a psilocybin trip here at 170 East Second Street in the East Village in 1961, used a loaf of bread to play football with Timothy Leary in the street afterwards. Kerouac left those neural doors unopened, famously averring that "walking on water wasn't made in a day."

In January 1959, *Pull My Daisy* had been chaotically put together in Alfred Leslie's East Village loft at 108 Fourth Avenue (since rebuilt). Free-form capers recurred amid rehearsals, so that customarily there were three takes of each scene. To demonstrate poets' brotherliness in a society ignoring its prophets, Ginsberg dropped his pants upon entering one shot and was drenched by Gregory Corso in a mixture of ketchup and french fries.

Well, they would have to "remain more faithful to Jack's initial ideas," said Leslie, the director (as recalled by Amram in *Offbeat*). "Still, I like the spirit Gregory, Allen, and Peter are bringing to all this." Corso then jumped through an open window onto the fire escape, brandishing a Raggedy Ann doll as he ran through the traffic shouting insults.

In Lowell, David was asked how spontaneous the filming had been. "Kerouac said that one take of the narration was enough, because he was touched by the hand of God," said he. Then he added, to some laughter, "A very modest person." I can well construe this trait from John Cohen's photo (see the cover of this book) of him listening to the radio at that time, leaning toward it in a kind of intense rapture. Kerouac's own words were being broadcast, says John, who's not sure what this rare media moment actually was.

The film's completion was celebrated with a cast party (at the Artist's Club, 73 Fourth Street) memorably retold by David. "I congratulate all of you for making a film that brings us all together, and documents some precious moments of everyday life," Abstract Expressionist painter Franz Kline said. Then he toasted the participants along with others — Jackson Pollock, Charlie Parker — who had gone to the spirit world: "We're all sinners, so put in a word for us so we can join you upstairs when our time comes. Here's to life!"

As the loft shook with carousings, David felt that all were sensing a demolition of that "underground network of friends" by changing times. As the 1950s ended, the "company store" had bought all their ideas for repackaging — into "an image so specious that we realized we were no longer welcome unless we wanted to join the charade." When I told David of being startled by the term *charade*, in embarrassment he spoke of editors missing a flaw in what was otherwise upbeat: baffling.

Bohemians and the bourgeoisie, then in conflict, are described by columnist David Brooks as blending into "bobos." He argues in *Bobos in Paradise* that a form of bohemianism won out by 1970, only to become "a mass movement" with soaring rates of divorce, crime, and drug use. All of this was a social catastrophe, neo-conservatives assert, needing to be reversed through what amounts to a cultural war. Its terms, Brooks's opinion notwithstanding, still appear to be those of pleasure versus the work ethic, Dionysus against Apollo.

Soldiering on that cultural battleground were Kerouac and Ginsberg — on opposite sides, unfortunately, as was plainly evident by the time Jack died. One year earlier, on September 3, 1968, he came down from Lowell to appear on the *Firing Line* show in New York, there to meet with his Columbia University proto-Beat friends for the last time.

This was at the Delmonico Hotel in Lower Manhattan, where he was put up. Burroughs had a room there and Ginsberg also showed up, these two urging Kerouac to decline being on the show. Why? Richard Nixon was then running for the presidency on a claim to represent true Americans — disgusted, that is, with the rise of outlooks traceable to the Beats — and Kerouac would likely show his own rightist view. He went, anyway, with that very result and afterwards was hugged by Allen in a lamentable farewell: "Goodbye, drunken ghost."

Cinemas at 189 Second Avenue were called the Entermedia Theater in 1978 when, with Burroughs back in New York, a "Nova Convention" went on here to celebrate his ideas. A sellout crowd arrived to see Keith Richards jam with punk rocker Patti Smith, only to learn that a heroin bust in Toronto had made it unwise for him thus to be linked with the notorious Burroughs. Philip Glass, playing in his stead, only aroused boos. Brion Gysin did better by reading variations on "Junk is no good, baby" to slide-show accompaniment — shades of the Beat Hotel — and Frank Zappa was conscripted to read the "Talking Asshole" scene from *Naked Lunch*.

Patti, unwillingly persuaded to follow Zappa, came onstage in a fur coat. "Keith ain't here," said she. "He asked me to tell you all that if

anybody wants their money back they can come and get it right now." Running a fever and unable to sing, she performed on the clarinet, and Burroughs himself came out to warm applause for a reading. To Lawrence, Kansas, he would go in 1981, avowing Buddhism as the Beats' journey to understanding became widely known.

Burroughs in popular esteem had eclipsed Ginsberg, *Howl* having becoming a museum piece that he would enliven by mockery of those "best minds" once agonized over. "Burroughs stole the show," says Morris Dickstein in *Gates of Eden*, "for his was a completely imagined world, in a unique and unmistakable style, diabolically self-sufficient in its solipsism."

To 404 East Fourteenth Street, above a McDonald's, Ginsberg had just moved in 1997 upon learning that he had a terminal case of liver cancer. Orlovsky told of coming home from the hospital with Allen, who slowly went to the record player to put on a blues disc. He now had final conversations by phone with a multitude of friends. John Cassady telephoned him, and Bill Morgan answered the phone to say, "Oh, yes, John, he'll certainly want to speak to you. Alas, he has just slipped into a coma, but when he awakes, I'll tell him."

Allen never awoke, dying in his bed on April 5. "He'd always invite John to the banquets at his hotel and give him the expensive books of poetry," says Carolyn. "We have been so sad ever since." Ginsberg's death came a full half-century after they first met, she at that time contemplating a life devoted to the study of Dante — and many regard *Howl* as the *Inferno* of our age.

Then, in 1999 at a "Beat Week" in Sotheby's, celebrity readings of Allen's verse climaxed in an auction of personal items. Gone to the highest bidder were such curiosities as his harmonium ($15,000) and a wallet with listings of every Salvation Army store in town, for his meagre purchases.

Kerouac's *On the Road* manuscript roll was auctioned in 2001, capping an immense surge of interest in the Beats. At the Lower Manhattan studio of an artist friend, Ed Adler, I get filled in on that tragicomic event at Christie's, 20 Rockefeller Plaza. Who would bid for Lot 307? Ed sat around there with Beat kingpin John Sampas without seeing anybody they knew.

Then along came a man in pinstripes, "big lapels and big tie, looked like a gangster": James Irsay, owner of the Indianapolis Colts football team. Often he wielded white paddle number 479 as higher and higher went the bids — sold, for $2.4 million! The overflow crowd cheered explosively, and the auctioneer announced this as a new world-record price for any auctioned literary manuscript. "It was football got Jack out of Lowell/and it was football saved his holy scroll," rhymed *Village Voice* columnist Brian Hassett.

Joyce Johnson said that Jack "would find it ironic that a manuscript that nobody wanted for six years" commanded such a price. After writing it, "he was a homeless man for about seven years and could hardly afford to eat. Most of the attention he got in his own life was abusive and humiliating."

Carolyn was quoted as opposing the sale for putting the manuscript at risk, although she's now pleased at how well it's been treated, after first being displayed in Indiana University's Lilly Library. Kerouac annotated the 120-foot roll — heavy tracing paper, it turns out — in minute handwriting for punctuation, paragraphing, deletions, and name changes.

"From a stewardship standpoint I really felt good about saying 'hey I can help' or I can be a curator for this kind of thing," said Irsay. "The uniqueness of the scroll and the spontaneity with which he wrote it is a form of writing that I'm a big fan of."

Flushing, New York

Exit 24 off the Long Island Expressway leads to Queens College, a City University of New York branch where in 1970 English instructor John Tytell contributed to its "Last Lecture" series: academics making what would be seen as a final stab at meaningful expression to mollify radical students. A hundred of these had lain upon the thruway's asphalt in opposition to the Vietnam War.

Tytell focused on the Beats, their origin and significance, in his talk. Published three years later in *The American Scholar* as "The Beat Generation and the Continuing American Revolution," it showed

Exit 24 on the Long Island Expressway was the scene of antiwar protest by students at Queens College, where they were lectured by John Tytell: more interest would accrue to the Beat Generation than to the Lost Generation, said he, "because it was more coherent and had more clearly defined spiritual imperatives."

them as prophets: "Rejecting the glut of post-war materialism and an obsessive national conformism, the Beats proposed a creed of individuality and a commitment to the life of the spirit with a passion that recalls the struggles of the American Transcendentalists." This lecture became the basis for Tytell's *Naked Angels* (1973), the first thorough study of Beat writing. *On the Road* was completely misunderstood by reviewers as a nihilist work, he argued, Dean Moriarty showing positive force — "a man whose incredible energy makes a mockery of the false idol of security."

Five years later, authors Barry Gifford and Lawrence Lee brought out *Jack's Book*. Their method of oral history, innovative then, was appropriate to the task of gathering reminiscences from Kerouac's friends — many being still alive, as he had died so young. It's lucky that in 1982, when *On the Road's* twenty-fifth anniversary celebration drew Beat personages together, Tytell and filmmaker John Antonelli captured their views in a documentary entitled

Kerouac. Over a hundred other general treatments of the Beats' legacy have since appeared, Ann Charters's collections of Kerouac's correspondence being invaluable.

Yet to arrive at the pristine truth now, we're really stuck with the Beats' writing and whatever is found in such rarities as *Jack's Book.* Carolyn sees this as "all gossip," however, and Gifford, introducing a new edition in 1994 after Lee's death, disclosed a remark by Ginsberg on reading the galleys: "My god, it's just like *Rashomon* — everybody lies and the truth comes out!"

Northport, New York

To Northport, farther east on Long Island, Kerouac had come in 1958 with Memere — finally settling down after disorientation that began with the war. At the Chalet Motel a pleasant Chinese-American clerk, Al, mentions being with the 101st Airborne in Europe during 1944–45: "one combat jump, in Holland." Sixteen million Americans did military service then, he points out: "That's a lot of people. Now it's a different world." The postwar shift in consciousness is what the Beats recorded — kicks of war trauma, then kicks of pleasures pursued.

I head downtown to Gunther's Bar, where the suburb-dwelling Kerouac matched drinks with local clammers and fishermen. There's a reading here every August, I'm told, at which aspiring writers ardently dedicate their works to him. On the jukebox I select a couple of Van Morrison songs, although someone has punched in numerous Black Sabbath cuts, and I depart before my own come up.

The first of three comfortable Northport homes provided for Memere stands at 34 Gilbert Street. In this quiet, long-settled community reminiscent of New England, Kerouac could finally realize the promise to Leo with the publication of *On the Road.* Here now lives former librarian Joan Roberts, her cat and small dog settled on her lap, who invites me to chat about him on the front porch: "A very interesting man. Not really attached to the practical world. Terribly mixed up. Kids would pick him up for rides."

Librarian Joan Roberts now lives at 34 Gilbert Street in Northport, a former home of Jack Kerouac's. Joan discounts Jack's dread over "the haunted sideboard" that would unexpectedly swing open for him, indicating spirits inside. "This house," she says, laughing, "there's not a level spot in it!"

He had no car but could easily walk up to the Long Island Railroad depot for rides into New York. Allen would come down and stay over in a backroom, now used mostly for sewing: "When my sister stays there, she'll say, 'Now I'm in the Ginsberg Room!'" I'm surprised by that, Memere being thought to have generally forbidden entry to him, considering him a bad influence. And Joyce Johnson, who had suggested Northport to Jack as a haven, was denied the right to extramarital sex here with him, this being his mother's Catholic household.

In *Minor Characters*, Joyce tells how on September 5, 1957, from her Sixty-eighth Street apartment, the couple had walked to a newsstand at Broadway for the Sunday *New York Times*, opening it in the Donnelly Bar on Columbus Avenue to read its assessment of *On the Road*. They found Gilbert Millstein, actually a part-time reviewer, pronouncing it a "major novel."

That night Kerouac "lay down obscure for the last time in his life," she writes. "The ringing phone woke him the next morning and he was famous." A Byronic moment. The first of numerous reporters then arrived, with minimal grasp of the review, to ask, "Is America going to go Beat? Are you telling us to now turn our backs on our families and our country and look for kicks?"

There it was: either pursue ecstasies or mind the store. For months Kerouac went though this with reporters, impatient with subtlety: "People wanted the quick thing, language reduced to slogans, ideas flashed like advertisements, never quite sinking in before the next one came along."

What this represents became clear to me from appearing on the PBS documentary *Lost Liners* to narrate my clan's shipwreck tragedy. Five binders of factual material I gave to its producers, who instead wanted a display of emotion: all the complexities regarding my fiery Salvationist grandfather reduced to the one item of his last letter home for me to read on-camera: pathos, please.

I got to know Joyce at a 2003 reading in Lowell of her play *Door Wide Open*. She told how Jack encouraged her to find a writing voice, lent radiance to what might otherwise be ordinary. The West End Bar, she said, was "where all the interesting kids in trouble hung out." John Ventimiglia of *The Sopranos*, taking Kerouac's role in her

play, so flawlessly captured the Lowell accent that Carolyn, hearing this once, shivered with remembrance of Jack.

Joyce passed on Kerouac's fast-living credo to her son, Daniel Pinchbeck, who in a 1999 discussion between the two, "Talkin' 'Bout Our Generations," lauded the Beats' "experiential approach." Pinchbeck saw contemporary white middle-class authors' lives as "a little embalmed by comparison, and that lack of experience is reflected in their fiction."

Back then, such was the animus against *On the Road* that John Updike "resented its apparent instruction to cut loose," without even reading the book. He made this admission in his 1995 introduction to *Rabbit Angstrom: A Tetralogy*, explaining that his novel *Rabbit, Run* "was meant to be a demonstration of what happens when a young American family man goes on the road: the people behind get hurt."

For Kerouac personal abuse was soon to appear, as when a *Village Voice* reporter asked about his plans. "Always go back to my mother,"

In Lowell in 2003, Joyce Johnson stages a reading of Door Wide Open, *her play about Jack Kerouac. John Ventimiglia (left), an actor in* The Sopranos, *plays Jack. At ten years old Ventimiglia saw Kerouac's photo in a book* (The Fabulous Century), *and later upon hearing the writer's voice on the car radio, intuitively exclaimed, "That's Kerouac!"*

he unwisely blurted out. Aha, he was hung up on Memere — not admirably loyal to her or considerate or tender, but mentally sick.

Evidence for this charge is meagre. Painter Dody Muller, another girlfriend, made candle-wax sculptures that Memere saw as a means of placing "Gypsy hexes" on Kerouac, and called Dody *la sauvage* for her long hair and habit of going barefoot. Dody, likening mother-and-son tiffs to lovers' quarrels, suspected incest — and additionally, there is the story of Jack once agitatedly telling artist Victor Wong that Memere had tried to seduce him.

Downtown at the Historical Society is a 1960s display referring to Jack's local reputation "both as a hard-drinker and as a man who was capable when the spirit moved him to establish local friendships." His conviviality comes out in an October 1958 television interview with playwright Ben Hecht — someone from his own writing background who remarked, after a mention by Jack of starving often on the road, that "authors never get fed, they have to beg and plead." Hecht, who had actually read his works beforehand, asked about "the great Dracula figure" as told in *The Town and the City*. Who was this devil?

"A character says that," replied Kerouac, waffling. Hecht persisted, asking whether a devil actually ran the world. "The devil is defeated," he was told. By the Beats? "No, no, by God," Jack explained. But with the devil's defeat, Hecht went on, how can there be politicians such as Eisenhower and his Cold War fanatics? "There's no reason to criticize anybody, actually. We're all gonna go to heaven," he replied, stirring consternation. "You too, and your cigar," he added. And so on, the best of all Kerouac interviews.

For a "Beat and Its Beginnings" symposium at the Hunter College Playhouse in November 1958, Kerouac was asked by the event's Brandeis University organizers to contribute a twenty-minute talk. The Beat Generation "goes back to when grapefruits were thrown at crooners and harvesters at bar-rails slapped burlesque queens on the rump," he told the gathering:

> To train whistles of steam engines out above the moony pines. To Maw and Paw in the Model A

clanking on to get a job in California selling used
cars making a whole lotta money. To the glee of
America, the honesty of America, the honesty of
oldtime grafters in straw hats as well as the honesty
of oldtime waiters in line at the Brooklyn Bridge in
Winterset, the funny spitelessness of old bigfisted
America like Big Boy Williams saying "Hoo? Hee?
Huh?" in a movie about Mack Trucks and sliding-
door lunchcarts. To Clark Gable, his certain smile,
his confident leer. Like my grandfather this America
was invested with wild selfbelieving individuality
and this had begun to disappear around the end
of World War II with so many great guys dead (I
can think of a half a dozen from my own boyhood
groups) when suddenly it began to emerge again,
the hipsters began to appear gliding around saying,
"Crazy, man."

Cheers often came from the generally young attendees. Jack,
who had unfairly been told early on that his "five minutes" were up,
forged ahead to curse the faithless: those trusting the atom bomb,
those discounting "the unbelievable sweetness of sex love."

This talk, printed as "*Beatific*: The Origins of the Beat
Generation," has only recently been anthologized among other great
American orations. It catalogues items in the manner of *The Town
and the City*, though now in the colloquial rhythms of Kerouac's
mature style. Delight in America and purity of heart become one in
this rhapsodic prose poem.

Although clothes shopping was a struggle, Kerouac did purchase in
a Northport shop the sports jacket worn for his January 1959 stint
on *The Steve Allen Plymouth Show* (and also for his funeral). That
same month, in an interview with British television personality
Kenneth Alsop, he spoke of Americans living in "a kind of sinister
luxury," and of his bid to "make them less afraid of one another,
more joyful." The Beat Generation, he said, "was about a bunch
of real crazy hipsters who rushed around shouting Yes! Yes! to

everything that was happening to them. That's how you gotta be. Ecstatic. Dig me?"

Joyce lamented Jack's failure to protect a "deep visionary part of himself," and amid deepening media intrusion this neglect took a toll. "I am mentally exhausted," he wrote to Ginsberg that June, "and spiritually discouraged by this shit of being of having [*sic*] to do what everybody wants me to do instead of just my old private life of poesies & novelies as of yore." A key requirement, shared with Carolyn: *not to let anyone else tell you how to think and feel.*

I'm keen to hear the Northport Library's own 1964 Kerouac interview, part of an audiotaped local history series. He was "well oiled" for this taping done amid friends, says Barbara Johnson, a reference librarian overseeing the library's Kerouac Collection. Hearing the sustained utterance of this celebrity, someone clearly crying out for attention, for a moment I'm dismayed.

Jack then starts talking about Dody Muller's assistance in painting a likeness of Pope Paul VI, and the charm comes through: "Hung it up with nails [tongue-on-palate knocking sounds], had my girl stretch the canvas, was in my shorts, took a big pot of paint [gusto], took some charcoal first — and *drew* him [wonderment, relish]."

Barbara understands his genius. We share a few anecdotes, including Gerald Nicosia's account of Kerouac "storming" a local reassembled European castle with four teenage confederates. "Well, work with that one!" she says, laughing. Barbara explains that a mix-up caused the first half-hour of interviewing, soberly informative, not to be recorded — a loss, though I like the jocular give-and-take in what remains.

It's odd to hear events told in *Big Sur*, so dire for Jack, being treated lightly by his cronies. When he cites failure to hitch a ride from Bixby Canyon in grubby clothes, finally aspiring only to be in a station wagon's back platform — "no, alas, here is ten thousand racks of dry-cleaned and perfectly pressed suits and dresses of all kinds for the family to look like millionaires every time they stop at a roadside dive for bacon and eggs" — David Roberts, Joan's husband, is heard declaring that he sure as hell wouldn't have picked him up.

"I wouldn't, either," another Northporter laughs. "I'd run him over!"

To 7 Judyann Court, above the old part of town, came Kerouac and Memere in 1962 after one of several stays in Florida. Joan Roberts told how once he asked her to bring some books on Harpo Marx, "and answered the door with a flashlight, he'd been pestered so by fans." Having been deep into Shakespeare, he merrily recited verses to her. "Such a memory — on and on. So gifted, so talented. He lost a career of being a stage actor, for heaven's sake!"

The next year in July, along came Cassady — "as sweet and gentle and polite and intelligent and interesting as ever," said Kerouac — and in 1964 again, newly divorced, conducting him to the Park Avenue apartment where the Merry Pranksters' bus sat (at Eighty-sixth Street). It was the last occasion on which they met.

Future novelist Robert Stone was also briefly on the bus. "Kerouac was eloquent on what jerkabouts we were," said he in a 1997 *New York Times* article, likening *On the Road*'s "promise of life more abundant" to that of Ernest Hemingway's *The Sun Also Rises* — a wiser book, he feels, "because Hemingway was tougher

Jack Kerouac couldn't gain privacy here at 7 Judyann Court in Northport, New York, despite putting up a basket-weave fence, and spoke of keeping guard "with homemade tomahawk in hand in darkness, waiting."

and meaner and more realistic about people than Kerouac." Surely, Kerouac was a realist author, with a project of recording his entire Jack Duluoz world, yet Stone has a point.

Millbrook, New York

Timothy Leary in *High Priest* tells of dismissal from Harvard after having "started planning the psychedelic revolution," and his later founding of the Castalia Institute near Millbrook, New York, to study drug benefits and lead others to speak of "manifesting their divinities." Asking whether anyone might remember his time here, I'm directed to Cathy at the Bank of Millbrook. "He put us on the map, I'm telling you," she says, telling of her bid with a girlfriend to spy on those at the institute's large estate. "We sneaked into the Big House, and there they were, sitting in a circle on the floor! Then we were asked to leave. We didn't see him, but there were some painted horses — psychedelic!"

Visible from the main street is part of the institute's former 3,200-acre estate, initially shaped by a Bavarian millionaire. In 1964 when Kesey and the Pranksters arrived here, there was no joyful mingling because those here, unforewarned, were coming down from an LSD trip regarded as especially meaningful, and took little notice. Leary, intent on research, saw the visitors' motive as merely to say "hi."

Neal's chosen fate as the Pranksters' driver was endorsed by the Grateful Dead's rhythm guitarist, Bob Weir (as told by music writer Parke Puterbaugh in *The Rolling Stone Book of the Beats*): Jack "only caught the budding Neal Cassady but never caught him in full bloom. He amounted to a whole lot more than Kerouac was ever around to document." Carolyn wouldn't subscribe to that — nor does she to Tom Wolfe's portrayal of Neal's repetitive hammer-tossing, though she's favourable toward Kesey. Her copy of *One Flew over the Cuckoo's Nest* has an especially warm dedication by him: "For Carolyn and the Cassady kids and other nest egg letts of the future: it has always been a pleasure. Love, Ken Kesey."

Ginsberg in a postscript to *Visions of Cody* described the

An imposing stone gateway guards the grounds of Timothy Leary's former Castalia Institute in Millbrook, New York. After the institute was finished, Leary remained keen about fungi, flowers, and chemicals that allowed trance revelations: the "Holy Confusion" coveted by many Native people. Like William Burroughs, Leary urged human advance into uncharted realms.

Pranksters as "cynically expectant & starry eyed worshiping" upon meeting Jack — and, alluding both to their optimism and to the Beat sense of wandering spirits, called this event "the Hope Show of Ghost Wisdoms." Kerouac, when a U.S. flag was draped on his shoulders, removed and carefully folded it.

Kerouac somehow kept the purity of his Wolfean vision. And to *Boston Globe* writer Gregory MacDonald in 1968, he gave a historical judgment — dark, Spenglerian, bitter — reflecting his migrant-Quebecker background with startling ambivalence: "America was an idea that was proposed and began to deteriorate at the turn of the century when people came in waving flags. And now their grandchildren dance on the flag. Damn them."

Albany, New York

In Albany at suburban 7 Borthwick Avenue, Joan Haverty grew up with her mother, Violet, who split with husband, John, when he served during the Second World War in the South Pacific as a military officer. When Violet's department store held a book-signing party for the handsome young author of *The Town and the City*, Joan's brother, Dave, took him drinking to local roadhouses, and their father (then in the billboard trade) threw a gala wedding reception at his new home in Washington, D.C. Then, in 1951, that quickie marriage on the rocks, she returned to bear Jan here on February 16.

Joan had a tumultuous later life, as portrayed in Jim Jones's *Use My Name*. To Columbia, Missouri, she went with six-year-old Jan and an art student, John Aly, whom she had just married after becoming pregnant with what turned out to be twins. Jan surmised in an "autobiographical novel," *Baby Driver*, that her mother had fled big-city poverty and gained respectability by settling here — but only until boredom set in, impelling her back to Manhattan with the children. Here is real existence as the Beats addressed it, decidedly messy — and especially so as the pursuit of happiness went into high gear after the war.

Jan went to Mexico with her boyfriend, hoping to enjoy a simple life as Kerouac had done, but there the trauma of a miscarriage led her to seek out her mother in San Francisco. In *Nobody's Wife*, Joan observed that Jan must learn her own view of the world: "And if I raised her to think for herself and to value learning and to ask questions and be honest, maybe she'd take the Kerouac legacy one step further: maybe she would write the truth."

Nobody's Wife presents chauvinist males as a basic feature of her era, and marriage as a means of keeping them at bay. Carolyn told me how unfair it seemed that "Jack gets all the blame for Jan's disintegration." Her mother, to whom she had been close, only rarely is blamed for what happened. Joan was urged by Jan to meet Carolyn but declined, saying, "Not that blonde who stole my husband."

When *Heart Beat* was filmed in 1979, Jan happened to show up on the set as an extra. "It's just like seeing a ghost," said Carolyn upon first glimpsing Jan, whom she invited to stay at Los Gatos.

Joan Haverty grew up here at suburban 7 Borthwick Avenue in Albany, New York. Having had twins and also a son by another man, she ended up as a community activist in Eugene, Oregon, dying there of cancer in 1990 after being taken up, in Kerouac family chronicler Jim Jones's words, "as a kind of folk hero by the local lesbian community."

Having attended Hunter College's top-level high school in New York, she seems not to have lacked advantages. Nor was there any grudge against her father. A Rhino box set released in 1990, *The Jack Kerouac Collection*, has an introduction by Jan — whose "devotion to her father was very touching," recalls its producer, James Austin, "and the collection seemed to rejuvenate her" in that late phase of her short life.

One easily finds blame for Jan's marginalization. The imperatives of writing? Memere's domination? Jack's own moral turpitude? Biographer Tom Clark records a remark made by one of *The Paris Review* interviewers, gleaned from Kerouac's wounded response to questions about her: "He knew it was his daughter, but he thought it was not his fate to make and have a family." Did fate require sacrifice of such hopes on the altar of Art?

Cherry Valley, New York

Charles Plymell, classified among "latter-day Beats," lives quietly in Cherry Valley, New York. Of part-Cherokee stock, he owns up to a turbulent youth. At Wichita State University he and his poetry-writing, Benny-popping, jazz-crazy friends (akin to the Beats at Columbia a decade before) became what he calls "mystic visionaries." Somewhere in the attic is the Royal typewriter belonging to his footloose sister, Betty, on which he composed a cult classic, *The Last of the Moccasins*.

Charlie is no follower of Jack, seeing him as a "square." And he won't accept the Beat label. "Neither did Burroughs, or Huncke — that's a gimmick, 'Beat,'" he says. "Sold a lot of copies of *Moccasins*, though, got me some recognition." With his daughter, Elizabeth, and his wife, Pamela Beach Plymell (related to Sylvia Beach, who brought out *Ulysses*), he has published various Beat volumes under the Cherry Valley Editions imprint.

On land near Cherry Valley, Allen once practised subsistence-level farming (which Kerouac's kinfolk avoided by emigration). Pamela gives directions to the ninety-acre East Hill property he

owned: down Sideroad 50, then the second right on Wilson Road, to a green metal gate on Committee Road.

This odd name has to do with a 1966 Manhattan march led by Diane di Prima "to protest government limitations on freedom of the arts." Committees advancing that freedom arose, Allen announcing the "Committee on Poetry" which, assisting poets "who lacked personal finance," would help in "altering the consciousness of the Nation toward a more humane spirit of Adhesiveness prophesied by Whitman." Revenue from Ginsberg's extensive readings was thus diverted from federal taxation essential to the Vietnam War.

I proceed on foot to the Committee on Poetry farm, its ramshackle farmhouse now rimmed by overgrown fields. In the brambles I can't locate foundations for the barn, which burned down years ago. Talk about ghosts: this was a full-fledged mixed farm, with a horse, chickens, fruit tree, organically grown vegetables,

Allen Ginsberg, shortly before moving here to the Committee on Poetry farmhouse in Cherry Valley, New York, learned from Carolyn Cassady of Neal's death. In wrong-headed tribute, he brought college students of Appleton, Wisconsin, to the burial plot of Joseph McCarthy, a native son, for exorcism of "illusion" from the senator's spirit. Perhaps Ginsberg's protest at the 1968 Democratic Convention had made him overwrought.

Bessie the cow for milk. Allen spoke of this being a "refuge" for Jack, but it mainly gave sanctuary from Manhattan's drug culture for Peter Orlovsky, who nonetheless hid supplies of Methedrine on the property. It became a commune such as then proliferated, with often-bruised emotions as when Gregory Corso would chew out Orlovsky.

Old maples stand next to the farmhouse. During 1969 in their shade, Ginsberg worked on musical notations of William Blake's *Songs of Innocence*, which he would pick out on his old pump organ (acquired at a barn sale) so as "to articulate the significance of each holy and magic syllable of his poems, as if each syllable had intention." Earnestly, he would recount how in 1948 he heard Blake's voice reciting "Ah, Sunflower — thus grasping life's then-and-thereness on the basis that this is all we have" — until late in life, to radio reviewer Jack Foley he remarked, "I cooked it up, somehow." Quite a confession, leading me to wonder what else he had fabricated.

Once resident here was poet Ray Bremser. In 1959, fresh out of a six-year reformatory term for armed robbery, he was heard at a reading by future wife, Bonnie — who then, going to bed with him on what he anticipated as a chaste get-acquainted night, aroused more fire than expected: "Jesus! You're naked!" In solitary confinement later, after re-arrest on suspicion of the same crime, Ray scribbled on toilet paper a poetic tribute to her, "Angel." In 1961 he skipped bail, and the couple fled to Mexico, later returning to take over the farmhouse's large attic for a while. Ray last read his verse at a local arts festival in 1998 and died that year, though Bonnie lives on nearby.

At Ginsberg's gone-to-ruin farm a cold wind arises to scatter leaves. Nostalgia for the simpler life of an agrarian America was felt by the Beats, who also ventured the pleasure principle — experiencing kicks, going for broke — prevalent amid urban prosperity.

It was from here in 1968 that Allen went to New York in his bid to keep Kerouac off the *Firing Line* show. With this event Douglas Brinkley begins a perceptive article, "The American Journey of Jack Kerouac," telling how Ginsberg would give a biased retelling of the episode: "that alcohol had ravaged Kerouac's once poetic mind, and insinuating that his conservatism was actually a side effect of this."

Not so — Jack's upbringing having sufficed to make him conservative-minded from early on. The Right criticized him for

bohemianism, of course, yet "Kerouac didn't even try to bridge the cultural schism but remained an island unto himself." To literary art, and that alone, he was entirely committed. The talk show's host, William F. Buckley, Jr., had been a close friend in college days, the two having "gotten together for champagne at the Plaza and double dates in Times Square," and this now-famous personality genuinely sought his old chum's take on the chaotic late 1960s era.

The show's key moment came as Kerouac called hippiedom (in Spenglerian terms) "some kind of Dionysian movement in late civilization." Stating that "we started this and the kids took it up," he asserted that "hoods, hoodlums and communists jumped on our backs, well, my back, not *his*." Startlingly, he then gestured at Ginsberg in the studio audience.

There it was, ammunition for stern assault on this man of radical roots — flawed, but keen to fight injustice while also advancing the careers of friends (Kerouac included). His detractor then spoke of "pleasure in life and tenderness" felt by the Beat Generation:

> Kerouac: [T]hey called it in the papers the "Beat Mutiny," the "Beat Insurrection," words I never used, being a Catholic. I believe in order, tenderness, and pity.

> Buckley: Well, then your point was that a movement which you conceived as relatively pure has become ideologized, misanthropic, and generally objectionable.

> Kerouac: A movement that was … a movement that was considered what?

> Buckley: Pure.

> Kerouac: Yes, it *was* pure, in my heart.

Well it might have been. Carolyn Cassady has tried to convey this for years. *Give us joy in life*, she said. *There has to be beauty!*

Canada Was My Bosom of God

Quebec, 1950s–1960s and Early Years

MONTREAL

10

In December 2005, I go on a probe of Kerouac's Quebec roots, hoping to view at its wintriest the village of Saint-Hubert where Jack's father, Leo, was baptized in 1889. Kerouac had an image of its "wind whipped country crossing Catholic Church," yet seems never to have beheld the place. Down the St. Lawrence River on Highway 401 I go, passing from a traditionally English nation to one where fleur-de-lys flags proclaim the monarchy once ruling Quebec.

During Montreal's Expo year of 1967, Kerouac memorably appeared on French-language television. If he were twenty again, interviewer Fernand Séguin inquired, would he do it all over? "I have done it all over — and I'm fed up with myself," he replied, the studio audience's laughter making him grin. Asked what he thought of Jack Kerouac, again he said, "I'm fed up with myself" (more laughter; no grin).

Were they laughing with, or at, the famous writer? The latter, affirms Victor-Lévy Beaulieu, who in *Jack Kerouac: A Chicken-Essay* portrays him as a "rotted old Canuck" ever returning to Memere as the embodiment of a saint-revering, sin-confessing, superstitious Quebec. In this Beaulieu sees a kind of clan fatalism, typified by his approval of St. Paul's weighty adages: "Let him become a fool, that he may become wise." Also, Jack's diction was "not American and not Québécois, exotic, only exotic."

Asked by Séguin about Memere, Kerouac burst into one of her old songs: "It's such ... sitting ... sitting ... sitting with my little dog, it's such a shame." What had drawn him back to Lowell? "Well, I know all the police there!" he replied. Jack loved old customs such as when Quebec kinfolk annually came down, he said, "in dog sleighs in the snow, to celebrate." Was that a joke, the story-spinner in action?

"I know I'm a good writer, a great writer," said Jack. "I'm not a courageous man. But one thing I can do is write stories." He and brother-in-law Nick Sampas then spent the night visiting a dozen or so jazz dives.

In 1951 Kerouac applied for a Guggenheim Foundation grant to write an epic entitled *The Vanity of St. Louis*. This "French-Canadian novel" would have followed *On the Road* as the first of several volumes "that eventually will be my life work, a structure of types of people and destinies belonging to this generation and referable to one another in one immense circle of acquaintances." But the funds didn't materialize, and that grand voyage never happened.

To Neal in December 1950 he had written about using the money to go off with Joan "for 3 wonderful lazy years perhaps in provincial Mexico (cheaper than Mexcity)." The next day he wrote to Neal again, explaining an odd delusion resulting from his brother's death: "We would all go away to Canada with Gerard and be in the bosom of things as I knew them to be; for I'd always heard, 'Things aren't like they were in good old Canada, let's all go back to Canada.' Canada brooded in the air and haunted me. Canada was my bosom of God."

At a Dunkin' Donuts at rue Ste-Catherine and boulevard St-Laurent, I come in from the intense cold. In a January 1953 letter to

Carolyn and Neal, Jack told how he liked "winter weather, storms, snow, long walks in snowshoes, will go and live in French Canada eventually with Ma and really make it for the storms and health there." He wished to remove Memere from dependency on Nin, and clearly had fantasy of pleasant living up north.

Carolyn cites his wish for work on the Canadian Pacific Railway. Yet his affair with her had just begun, so why head north instead of to sunny California and her arms? He was drawn by a strong wish to explore family origins and an abiding respect for the Catholicism pervading his ancestral land. Quebec licence plates still bear the motto *Je me souviens*: I remember.

And here's the very corner where that March, Kerouac imbibed *le sang du caribou* — an antifreeze blend of red wine and raw alcohol — and briefly felt to be among his true brethren at last. Personal identity: he was "Ti Jean" to doting Memere, "John" as author of *The Town and the City*, "Jean-Louis" for a story when on the lam from Joan, "Jack Duluoz" as his life-story's protagonist.

Also in 1953 he found rapport with looser women of "Northern Gloomtown," such as now inhabit the doughnut shop with their cleavage and complaints — "He used to be one of my regulars no problem … draggin' me down the street last night" — surely not far from where he passed out in a rue Ste-Catherine bordello, with bad dreams that made him forgo his fantasy of settling in "Montreal, Russia."

Châteauguay

Amid scenic riverside territory at Châteauguay, I find a retreat house, the Manoir d'Youville, once the home of the Sisters of Charity. This order was set up in 1737 by the widowed Marguerite d'Youville, whose husband had traded liquor for furs with Natives. Such trade was thought to continue behind the cover of good works, so d'Youville's followers were dubbed the Grey Nuns — *Les Soeurs Grises*, slang for "tipsy nuns" — though presumably not really guzzling the mood-lifter on cold dark nights.

It was here in 1884–85 that extensive farm properties were managed by Jean-Baptiste Kerouac, Jack's grandfather. He did drink, indeed — vodka made from potato peels — and with good cause. A decade earlier he had brought his family some four hundred kilometres upriver from Rivière-du-Loup (at first to the town of Varennes) in vain hope for a better life. It well knew poverty, as did most Quebeckers in those times.

Circumstances made Jean-Baptiste shout at God to strike him with lightning, as family lore indicates. And here's a prominent cross, erected on a hillock to ward off an 1832 cholera epidemic, that was brought down by a severe storm. Its replacement was felled by a thunderbolt; another was also toppled by storm and finally replaced by the wrought-iron cross spared thus far. Nature is cruel.

At Châteauguay was born the second of Clementine Kerouac's children, Caroline, who chose her calling here and served at Sisters of Charity missions in South Dakota, Washington, Montana, and Idaho. The devotion of such women, travelling afar to spread goodness, is dramatized by a burial ground on a plateau, where those tightly disciplined sisters rest beneath hundreds of identical markers like those in military cemeteries. On this Quebec venture I'm guided by Steve Edington's volume giving background on the province, *Kerouac's Nashua Connection*, which includes verse by Jack's Aunt Caroline on the death of saintly Gerard:

> He has come to harvest him, this
> flower of morning light, before
> the impure breath of the world
> could tarnish his whiteness.

I showed this to my ex-student Karen Holmes, who became a faith-development facilitator with the Congregation of the Sisters of St. Joseph. "It is beautiful — lovely expression, written out of deep sorrow, trying to find consolation — but here's the idea that this world, if you can avoid it, *avoid* it. I have a lot of trouble with that — that is *Jansenism*," she said, her tone implying something like devil worship. "People cocooning themselves to pass through life unscathed — like a doll of my mother's that she never took out

of the box. Kerouac, my goodness, such an oppressive thing to live with."

My own Puritan upbringing endorsed such attitudes, and my stake in this part of the world is much like Kerouac's — both of my parents born in the Maritime provinces, then immigrating to America with rural outlooks steeped in Christianity. Widespread until recently were the religious tensions Kerouac felt and wished to resolve.

Carolyn, naturally, sees Christian indoctrination as a curse for Jack and Neal: "Get them that young, and you'll produce the idea that we're all miserable, unworthy worms and sinners. Always a sense of guilt. Do this, confess, I'll punish you. It was one of the hardest things for me to accept."

Nine elderly nuns remain here. One, Florence, came recently from Rhode Island to translate for the Pentecostals and other charismatic groups who now assemble here, mostly on weekends. Such is the eclipse of Roman Catholicism.

The Sisters of Charity Cemetery and their former lands in Châteauguay lie under snow. Farmlands that until 1960 produced milk for a Montreal orphanage have been turned into a wildlife centre, the Refuge Faunique Marguerite d'Youville — care for the environment having become a newer form of religion perhaps.

From 1850 to 1900 in Quebec the number of priests quadrupled, and the increase in nuns was tenfold. These were drawn from, and served, large families like that of the Kerouacs. And practising Catholics filled Quebec until the 1960s when their number abruptly dropped from 65 to 38 percent; now it is down to 14. So it is throughout the West, where cities once under a tight Catholic leash — Dublin, Madrid, Prague — now draw partygoers such as the Beats once decidedly were.

During the eighteenth century, the Iroquois fled upstate New York to settle in Kahnawake, not far from Châteauguay. Wonderful names abound here: "Thunder's Child" and "Swift Eagle"; "Boom-Boom's Variety" and "Jo-Jo's Nursery"; "Digital Dreamcatchers." Here are Mohawks who, having initially fought the French, came to prefer their company to that of the land-hungry English. Another ancestral strand: Memere's grandmother was half-Iroquois. So Kerouac, portraying his family at supper in *Visions of Gerard*, remarks on its "semi-Iroquoian French-Canadian accent." Seeing westerns on television, he would always cheer for the Natives.

Kerouac can hardly be trusted on the facts, though, considering his embrace of lies told by one Paul Bourgeois, self-proclaimed "Chief of the Four Nations of the Iroquois" — two of which, he said, represented Jack's maternal and paternal ancestors. Memere sang "Indian songs" for Bourgeois, yet finally dismissed him as "a juvenile delinquent from Lowell."

Family origins were less of a concern to Ginsberg and Burroughs. Allen's paternal grandfather, Pinkus, brought his family from a town between Kiev and Warsaw, and his maternal grandfather, Mendel Levy, emigrated from Russia to avoid being drafted into the tsar's army. Burroughs, whose paternal grandfather and namesake invented the adding machine, and whose maternal grandfather became a high-ranking Methodist Episcopalian churchman, had a cynicism about human impulse that presumably kept him from studying family roots.

QUEBEC CITY

At Quebec City, one of the first permanent European settlements established in North America, British invaders in 1759 decisively triumphed over Old France (Kerouac fancying that a forebear had been among the combatants). Americans later marched upon Quebec as a revolutionary force that easily took Montreal, then angered British and French alike by hampering trade. Continental free trade is now an issue, and in 2001, coming here to witness heavy protest against it, I was amused by a pretty demonstrator's sign, which in English read MAKE LOVE NOT GLOBALIZATION.

Quebeckers were so stung by defeat in 1759, it seems, as to take the anti-militarist stance that endures to this day. Ginsberg asserts in the 1989 documentary *Jack Kerouac's Road* by Quebec filmmaker Herménégilde Chiasson that military-industrial concerns had usurped America, and hence, "everything that as a Canuck peasant Kerouac hated had taken over — the mechanization, the money-grubbing, the disrespect for a person, that had all taken over; and vast wars, the *attack* on the provincial in the wars. So I would say America broke his heart." Yet wouldn't Jack have disavowed so political a stance?

In 1987 a four-day rethinking of Kerouac's North American ties, the Gathering, was held here at Laval University. "We can help shed light on Kerouac's past," said its organizer, geography professor Eric Waddell, "but he is helping us to see into the future." Very interesting is the collection of texts from that conference, entitled *Un Homme Grand: Jack Kerouac at the Crossroads of Many Cultures.*

Lots of heated argument went on, some Quebeckers of the opinion that America illustrates the condition of exile, Example A of that being Kerouac. Whereas multitudes went to New England, more families moved to the United States from elsewhere in Canada — my parents feeling like exiles upon departing from there, and me upon losing American roots when the family went back north.

Carolyn in an illuminating talk focused on family-style intimacy. Bonds of "unconditional love" were extended by Neal to Jack as a "best friend," she said, and such strong linkages in that era "remained

so throughout life, even if he or she were led into different or distant paths." She saw dilemmas arising for Neal from "efforts to make everyone happy" — in the collectivist mood, perhaps, of Catholic families such as his own and Kerouac's.

Protesters demonstrate during a continental free trade conference in Quebec City in 2001. Jack Kerouac, keen both about family custom and the wider world, interests Quebeckers coping with global forces that challenge their identity.

Francophones of Quebec are unique for retaining a culture different from the English-based one otherwise pervading North America. Did any Québécois writer influence Kerouac? Cited as a possible model for the Duluoz Legend series of interrelated books is Roger Lemelin's Plouffe family chronicle, set on the northern side of Quebec City's Lower Town. Negligibly Beat is its account of the sensitive Ovide who, aroused by sexy Rita Toulouse, briefly retreats to a monastery before marrying her.

When Kerouac told *Paris Review* interviewers of knowing "who the great poets are," he gave only one reference: "William Bissett of Vancouver." That's a name better recognized in lowercase spelling as bill bissett, known for distinctively spare verse. Kerouac admired the expansive vision of Walt Whitman and Thomas Wolfe, but wrote haiku after haiku which, for *The Dharma Bums*, were reshaped into paragraphs of immense concentrated power.

Kerouac fully engaged with America, even so far as transforming its expression. So despite the flaws lamented by Victor-Lévy Beaulieu, he is seized upon by young Quebeckers as the one most perceptive of America's reality. But finding the man himself isn't easy, as Yves Le Pellec pointed out: "As soon as we say one thing about Kerouac, someone jumps up to say the opposite."

ROUTE 20 IN QUEBEC

Along the river's shore leads Route 20, amid many towns named after saints. Jean-Baptiste and his own grandfather were born at Saint-Jean-Port-Joli, notable for its wood-carvers. Most Quebec *habitants* were from western France, where life focused on village and family: Kerouac's preoccupation right alongside the thrills of America. Communities of Quebec formed true democracies in which all were equal — a fact often overlooked when New France is seen as a feudal state — and such collectivities remain an enigma to anglophones, viewing equality largely as a matter of individual rights.

In Saint-Pacôme, Josephine Jean Lévesque (or L'Évesque) gave birth in 1895 to Kerouac's mother. But how can that be, Gabrielle's

own mother having been married in New Hampshire in 1894? Presumably, Josephine returned to complete her term of pregnancy among family members and friends, unfortunately dying only a year later in her new homeland. Edington's book has a photo of the house where Memere was born, which I show to numerous people with explanation of her link to the writer Jack Kerouac. But nobody recognizes the place.

The upside to all this searching is that I meet a succession of Québécois women and marvel at their vibrancy and charm. Memere had plenty of both, though Ginsberg never knew the buoyant younger person. At the municipal building I'm shown books listing the local Lévesques, and many there are — so many marriages, so many big families. The largest room here has a sign reading WELCOME TO ALL CITIZENS. There's a piano in one corner. This bitter cold afternoon I think of the dancing and fun and exuberance that help Quebeckers to get through the long winters.

Catholicism was upheld by Memere even though once, failing to apologize to nuns for an offensive remark, she had to show penitence by kneeling on raw rice. But Saint-Pacôme's fine church is locked. That's been the case throughout Quebec for more than a decade, I'm told, vandalism being rife. Also, no longer are there enough priests for all of them. Kerouac, who enjoyed lighting candles in churches happened upon in his wanderings, would be appalled. Here in Quebec!

I hear lots of *joual*, the lilting French so called from back-country pronunciation of *cheval*, horse. *Joual* was the only language spoken by Kerouac until age seven. Mentally, I hear his voice and that of his mother as given in *Dr. Sax*: "I say, from under my little black warm sweater, '*Moi's shfues fini mes race dans ma chambre*' ('Me I's got to finish my races in my room') — '*Amuse toi*' ('amuse yourself') — she calls back."

Carolyn, who would exchange notes with Memere at the end of Jack's letters, dismisses the common view of him as a mama's boy. "My take is that although he was constantly aware of the vow to Leo — a very significant vow — it was rather easy for him to rationalize," she tells me. "With Memere as with no one else, not even us, *he could be completely himself*. They both drank, they both used foul

language, so they were wide open to express anything without fear of condemnation." Carolyn also observes that "no one seems to look at how often he left her — he was hardly ever there!"

The village of Saint-Pascal boasts a church spire rising from a parapet where I remember having seen trumpet-blowing angels. An earthquake toppled one of these, I'm told, so now they're all inside. Here in 1869 Jean-Baptiste married Clementine Bernier, he twenty and she only nineteen, with all that child-rearing ahead of them.

A guiding aim of Quebeckers was *la survivance*. Even those in Lowell and other New England towns who formed tight-knit and withdrawn communities often suspected others in ways that bred racism. Today Quebeckers are crazy for winter vacations down south, seasonally poring over copies of *Florida Motel* and *Florida Guide-Vacances*.

At Kamouraska, once a thriving port community, I take in a dramatic view of the St. Lawrence. It was a sacred river for early settlers, named for St-Laurent's feast day and regarded as akin to the Jordan, where Jesus was baptized by St. John. Before icebreakers, river traffic would be halted for half the year from November to April, requiring communities to pull together until springtime as cheerily as possible.

The mid-December sun sets at four, so it's dark when I get to Rivière-du-Loup. In 1967 Kerouac came north with a Lowell buddy, Joe Chaput, to probe clan history at the town archives here. Their hopeful start on a route up through New Hampshire led into numerous bars. Every night, said mutual friend Charles Jarvis, "became a one-act play with Kerouac as the protagonist and the rest of the customers the supporting cast." They finally got to Rivière-du-Loup, but never to the archives on that chaotic ten-day excursion.

On the St. Lawrence River at Kamouraska, the winter image is of ice, danger, remoteness. Jean-Baptiste Kerouac's branch of his clan stuck it out for 160 years — and later one of them, in America, had the audacity to give a name to his generation.

SAINT-HUBERT

In the morning I take Route 291 to Saint-Hubert, with fresh gleaming snow all around. It surrealistically drapes over a big field of cars, whether wrecked or new I can't say. First sunlight on snow: a week before Christmas, the land of Kerouac's people made luminous. Thrilling views of distant hills recur, evoking a Rimbaud quotation he pinned up while at Columbia: "When shall we arrive at the final shores and mountains to salute birth of the new task and new wisdom, the flight of darkness, the end of superstition — Christmas on Earth?"

More saints: the villages of Saint-Arsene and Saint-Epiphane, each boasting its traditionally tall church steeple; but Saint-François-Xavier-de-Viger, next along, has a squat church recently built. I'm wondering whether Saint-Hubert retains its original one, but the next vista shows its traditional spire. The corner just now is

not windswept but calm, except when a grille-wreathed truck with its big load of logs roars through.

Here's a genuine country store, its narrow aisles crammed most-ly with essentials. There's a needle-and-thread part, another with many small cellophane bags holding soup and sauce powders, over there the tools, soaps in the back. It's a supermarket compressed to tiny dimensions, with lots of customers.

Their *joual* rattles along. Kerouac in a 1950 letter to Yvonne Le Maître, who had favourably reviewed *The Town and the City*, wrote: "All my knowledge rests in my 'French Canadianness' and nowhere else. The English language is a tool lately found." Handling of Eng-lish words was easy, he added, "because it is not my own language. I refashion it to fit French images."

Up front are many versions of the *hebdo*, weekly: *Hebdo Police* and the most popular of crime tabloids, *Allo Police*, with grisly pho-tos no daily would print. *Vedettes*, "media stars," are trumpeted in *Ve-dettes internationales*, *Echos Vedettes*, *Allo Vedettes*; every Friday there

This Roman Catholic church in Saint-Hubert hadn't been built yet when Leo Kerouac was baptized in August 1889. He was given the first sacrament at the Parish House, extant alongside. Nearby signs read ATTENTION: CHUTE DE NEIGE *("Watch Out: Snow Falls from Roof").*

is a rush on the new issues, particularly those with stories about cancer. And Leo Kerouac brought out a kind of *vedette* called *Spotlight Print*, about theatre and cinema events around the Boston area.

Perhaps it was in Saint-Hubert that Jean-Baptiste learned the manufacture of vodka from potato peels. To my new friends I trot out a French term, *les pommes de terre*, "earth-apples," to ask whether potato-growing still goes on. "Cow," I'm told. Dairy farming now prevails. Already this town enters my heart. I would come here in any season, Kerouacs or no Kerouacs, just for the real life it contains.

Considerable fuss is made over a little boy, François, about the age Leo must have been when his family joined those million other Quebeckers flocking to the New England textile mill towns. From the start they had practised an early-marriage, large-family lifestyle, yielding numbers too large even for subsistence farming. The Conquest had aroused a revenge-of-the-cradle mentality yielding the highest Caucasian birthrate ever recorded which, when the pope's

This Saint-Hubert store, like all in Quebec, has a big display of Vachon cakes — Jos. Louis, May West, Passion Flake, Ah Caramel!, Miami, Doigts de Dame. Jack Kerouac, who didn't shy away from using the word lamby, *sometimes put in a little too much sweetness.*

1964 anti-contraception ruling was ignored, plummeted to the lowest in Canada.

Townspeople, shown a photo of Leo's birthplace, tell that this now-modernized house stands a kilometre to the west. Here in 1876, says a front-lawn cairn, Father Bernier sang the first Mass celebrated in the parish. Potato-growing: subsistence farming by peasants apt to view life soberly. Kerouac said in a letter to John Clellon Holmes on October 12, 1952, that he had a "strong Quebec Plain Peasant feeling and general weird Catholic mysticism — & a streak of truly Celtic superstitiousness." This he set apart, for the moment, from Neal's "franticness & silly sexfiend ideas."

Jean-Baptiste apparently brought his family to Saint-Hubert because one of his brothers, Eusèbe, farmed here. During a half-decade stay, four offspring were added to the eight already born; three more would come along in America, none living beyond a few months. Vigorous was the eleventh child, baptized in August 1889 as Joseph Alcide Léon Kirouach — one of the fellaheen (Arabic for

Jack Kerouac's father, Leo, was born in this Saint-Hubert home. Leo, who became an ebullient man rubbing shoulders with vaudeville stars, was also heard by Jack to say that life wasn't worth living. Did this paternal mood make Jack retreat into a life of the imagination?

"peasant"), living a poor feudal village existence before the future leap to urban life.

For the big move of 1889, the Kerouacs must have sold excess property at auction and put the rest, along with their surviving nine offspring, aged one to nineteen, on wagons for the trip to Rivière-du-Loup. From there they took the train to New Hampshire, Eusèbe accompanying them all the way before returning to Saint-Hubert. Why they chose the town of Nashua is unknown.

The Bar St-Hubert has a little *casse-croûte* ("crust-breaker") where a steaming *grand'mère* bowl of coffee accompanies my break-fast of French toast — here melodiously called *pain doré*, "golden bread." A man in a shirt with a body-builder logo loads sugar into his coffee and lights up, as does everyone else here. Quebeckers buy 20 percent more cigarettes than the average Canadian, and 35 percent more lottery tickets.

People come and go. The *madame* abruptly smiles upon the approach of a man with a bag of pickerel, extracted from below the ice of some frozen lake. They converse about his catch, which she places in the freezer.

Jean-Baptiste, a descendent of Breton seamen and farmers, took skills developed here to Nashua and became a carpenter — man's work, seemingly unlike what Jack chose to do. And Leo, who considered writers "sissies," aimed at U.S.–style material success as generally pursued by immigrant families. Kerouac, in Beat fashion, placed a higher value on ecstasy.

Down into
the Darks

Southern United States, 1940s–1960s

Bethesda, Maryland

11

In May 2006, I drive into the U.S. South where Kerouac often visited sister Nin, herself a tragic figure, and where both died, along with Memere.

After the Newport parade ground escapade, Kerouac was brought in 1943 to what is now the National Naval Medical Center in Bethesda, Maryland. Negotiating its immense car park around and around with many lengthy halts, I report at the Command Office desk. An officer speaks inspiringly nearby to people in their navy whites. I inquire how things were when the writer Jack Kerouac was a patient during the Second World War. The word passes along. Then I'm given a map of the centre and dispatched to the Public Affairs Office, where the man I'm supposed to meet has stepped out.

My presence baffles a couple of petty officers, who huddle briefly and offer a photocopied history of the centre. Psychiatric cases are

now treated elsewhere, I learn. And it's no use to go on about Kerouac, how he was sent here from a U.S. Navy boot camp to go amid mental patients who howled like coyotes. That's beyond their parameter. So is the 1940s context of his stay: nobody around here has any kind of historical sense. Slipping away with some embarrassment, I'm told, "I hope you ... find what you're looking for."

What motivated Jack here to request execution by a firing squad and tell his psychiatrist that he was Samuel Johnson? Portions of his medical history, newly released by the National Archives, show for May 27 that "he had been writing a novel in the style of James Joyce about his own hometown, and was averaging approximately sixteen hours daily in an effort to get it down." Observation: "There seems to be an artistic factor in his thinking when discussing his theories of writing and philosophy." Jack was released after June 2 when "strong schizoid trends that have bordered upon but have not yet reached the level of psychosis" were diagnosed. Rendered thereby "unfit for service," he was "not considered to be a menace to himself or to others and is not likely to become a public charge."

To take all this at face value would be wrong, in light of Kerouac's letter to Lowell friend Cornelius "Connie" Murphy. During an interview, he had started "pouring it on thick" to the young staff psychiatrist, who with a "poker face" gave a "superb performance." This individual proceeded helpfully to diagnose dementia praecox, which was the preference for Kerouac, well versed in psychiatry through association with Burroughs.

Jack thus engineered a shift from boot camp to active service, sailing next month on the bomb-loaded *George Weems* — albeit with a new sense of resignation about death. Around this moment in 1943 the "story pivots," he wrote in *Vanity of Duluoz*. In a complex scenario, leaving Bethesda represented his "lost dream of being a real American man," the chance to learn a trade had been squandered, and authorship was now seen as a "stupid 'literary' deadend."

Yet he had an honourable discharge, and shortly a better outlook on authorship. To Murphy he spoke of "dedicating my actions to experience in order to write about them, sacrificing myself on the altar of Art." An essay written here, "The Wound of Living," shows neither egotism nor desire for fame, but an intent to share his

outlook with humanity. On returning to Columbia, he met Edie, and then with Carr began conceiving the New Vision.

ROCKY MOUNT, NORTH CAROLINA

In 1948 Kerouac was in Rocky Mount, North Carolina, with his family. Nin and her second husband, former air force pilot Paul Blake — by whom she had a child also named Paul — had a home at 1328 Tarboro Street. On Christmas Day along came Neal from the west in the Hudson, his entourage cold from travelling without a heater and weak from having recently eaten only some rotten potatoes. All were invited in to share the turkey.

In 1952, while *On the Road* went unpublished, Kerouac worked in Rocky Mount briefly in a textile mill, such menial toil being

In 1948, Jack Kerouac stayed with his sister, Caroline, and her husband, Paul Blake, in their home at 1328 Tarboro Street in Rocky Mount, North Carolina. So, too, did Neal Cassady. Neal's "frantic tragic destiny" had victimized those with him, said Jack in Visions of Cody; *yet he charmed Memere by transporting a load of furniture and then herself to Ozone Park in round trips of a thousand miles each.*

then typical for him. "John, do you think I'm a self-made martyr?" he asked John Clellon Holmes that fall. "I go 3,000 motherfucking miles, sleep on railroad porches, in Salvation flops, eat out of cans."

Holmes's *Gone in October* portrays a Kerouac then known only by an exchange of letters, his friend from afar lending encouragement "because there was simply no distrusting a man who burned as purely as he was burning then." It was ironic that Jack "came into full and unique voice precisely during this half-decade of anonymity," producing an average of two books (unpublished) each year:

> The letters kept arriving — tortured, angry, pensive, triumphant, bitter with complaints, insistently creative; letters from west coast Mexico, from L.A. slums, from rusty tankers and Washington State lumber towns; letters that traced (for me) the progress of a man gradually sinking out of sight, down into the darks of life and self, below "literature," beyond the range of its timid firelight.

I cross once-busy Route 301 in downtown Rocky Mount — "Testament" in *On the Road* — now with a "Pace Setting Barber Shop" and "New York Hi Fashions" — to the neighbouring hamlet of West Mount, where the family next had a home at number 8230. Blake developed a television business in which Memere placed her life savings, on the condition that Kerouac would be able to have room and board with the family. Jack on visits would bed down on its porch in his sleeping bag.

In 1953 Kerouac had devised a "theory of breath as measure," the writer's phrasing likened to that of a jazz saxophonist, and Buddhism suggested that all sounds belonged to "the One Transcendent Unbroken Sound."

The British Columbia academic Warren Tallman in a 1959 study, "Kerouac's Sound," noted that in *The Town and the City*, the New England scene is "orchestrated with slow violins." In *On the Road*, where some moments "rock and sock with Moriarty's frenzy" while others are "curiously quiescent, calm," the unifying melody

"is the holiness of life, because this for Kerouac is the meaning of words, the inside of his sound."

The Dharma Bums shows Ray Smith (Kerouac) tramping across a cotton field after each night's writing to a meditation spot with various dogs, treating them as intellectual equals (as does Charlie Plymell). Convinced that dogs love God and are wiser than their masters, Ray tells that to them and they lick his face, keenly attentive. He also philosophizes with "Little nephew Lou" (Paul Blake, Jr.), both taking joy in this.

Nightly for over two weeks in 1956, Kerouac wrote *Visions of Gerard* in pencil in Nin's kitchen. John Dorfner in a 1993 article, "One Writer's Refuge," indicates that he would "sit and stare at something like he was really thinking about it for long periods of time," recalls family friend Helen Bone. "And all of a sudden he'd put down a cat and pick up a notebook, write something down, then put down the notebook and pick up the cat and start petting it."

In the 1950s, Jack Kerouac often visited sister Caroline and Paul Blake here at their home in West Mount, North Carolina. Ray Smith, in The Dharma Bums, *tells little nephew Lou that things are ghosts inasmuch as they lack solid physical qualities. Ray's "mother and sister" want him to forswear such Buddhist flights and stick with his own religion. Paul Blake, avowing Christian fundamentalism, would have felt the same.*

A resident remembers two brothers, George and John Langley, who long owned two general stores at this crossroads (now the West Mount Grill and a CITGO station). Ray, in *The Dharma Bums*, is shown reflecting that men seen there, chatting amid molasses barrels, would go through the motions of real work to fulfill their wives' images of them. One lounger, on being informed of Ray's meditations in the woods, however, said he might follow his example if there was enough time.

"Let there be blowing-out and bliss forevermore," he would pray. One bitter night, almost hearing a voice saying that "everything is all right forever and forever and forever," Ray made an outcry that made the dogs seem to exult. Another night, he made up a song to go with rain pattering on his cape: "Raindrops are ecstasy, raindrops are not different from ecstasy, neither is ecstasy different from raindrops, yea, ecstasy is raindrops, rain on, O cloud!"

Kerouac finally packed his rucksack, donned boots reinforced by Memere with new rubber-and-cleat soles, and set out westward — to see Snyder off to Japan, then do fire-tower duty on Desolation Peak up in Washington. It was the last year before *On the Road*'s publication transformed his life.

To Orlando, Florida

I take a motel room on I-95 just into Florida and, getting a pre-dawn start the next day, play my CD of Gustav Mahler's Fourth Symphony. During the final movement, all becomes slower and quieter as a woman sings verses from a German folk song, "Das himmlische Leben." In the dark, on the path of Kerouac's last journey, speeding along as the music's tempo decreases, I'm deeply moved by this woman's voice.

She sings as if from heaven: "On earth there is no music/To be compared with ours." St. Cecilia and her relatives are court musicians there; St. Ursula laughs as her eleven thousand maidens begin to dance.

The angelic voices
Lift up the spirits
So that everything awakens in joy.

By now I've been following Kerouac's life so long, such a trou-
bling story, that pure emotion begins to take over. This man who
loved women, many women, looked forward to higher forms of love
in heaven. Final rhythms are pronounced on the English horn, and
Mahler's Fourth echoes in the mind.

In the first rays of sunlight at a rest stop, I see a young family
returning to their car: the mother in denim shorts, her caring glance
down toward two little daughters skipping about. And their hand-
some father — why couldn't Kerouac have had joys such as his?

The crunch had come, says Carolyn, with dissolution of the
late-1940s dream that Beat friends might live communally, with
their families. Jack then returned to his roots — those in Lowell,
and in Canada — until (as stated in her Quebec City talk) it was
"too late to reclaim his peace of mind or his pride." I find this dis-
tinctly possible.

A reason for his Florida stays was to flee animosity in Northport
over court scenes regarding his paternity of Jan. Blood tests taken in
January 1961 were inconclusive, though he was then required to pay
monthly sums for her support. *Baby Driver* shows Jan afterwards
with both parents in her East Village neighbourhood, she proudly
walking past friends with her real father to an East Tenth Street
liquor store for the purchase of a bottle of Harvey's Bristol Cream
Sherry. He "seemed shy, like a boy on his first date." After his depar-
ture, Jan would occasionally "take out my one souvenir of his visit
— the cork from the bottle of sherry — and stare at it."

In Orlando, a westward drive from Route 4's Princeton Street exit
and then along College Park and southward on Edgewater Drive
leads to 1219 Yates Street. Here the Blakes became re-established
amid boom times, Memere among them when Kerouac came for
another Christmas in 1956.

The next year, after his European trip, Jack planned on settling
Memere in California. This scheme didn't work out, and furniture

already shipped had to be brought back here. Carolyn was "very hurt" that she was never brought to Los Gatos in "an episode never unravelled between Jack and me, and years later I was further dismayed to read in *Desolation Angels* that I had been mad at him and 'refused' to see his mother."

So Memere went to the first of two Orlando homes occupied by Kerouac, off Yates at 1419 1/2 Clouser Street, a corner bungalow she regarded as "cute." He found it hard to work on its tin-roofed back porch in midsummer heat, and drew stares whenever he wanted to read or sunbathe outside after *On the Road* made him famous. Yet here in November he was able to write *The Dharma Bums* on teletype roll.

Government defence contracts now determined many lives, including that of Paul Blake, who prospered from installing weapon systems across the land (thus undermining his marriage). Yet he now borrowed $5,500 from his brother-in-law, successful at last — and repaid only $1,500. This irritated Kerouac, often living hand-to-mouth and therefore frugal.

On Smith Street I visit Chapters Café & Bookshop, operated by Jan and Marty Cummins, who led a project to buy and restore the Clouser Street cottage as a retreat for writers, and thus "raise the profile of literature in Orlando." Then, at the nearby Edgewater Library, I ask for a file on Kerouac. "Who?" the fill-in reference librarian asks.

"The author who lived over on Clouser and also Alfred Drive," I reply, "the man who wrote *On the Road.*"

There's no file. "Material about locals and their experiences that you'd expect, it doesn't exist anymore. No storage space," she says. "Unless the historical society has some. But don't waste a minute there — a lovely building, an expensive building, but you'll go there and say, 'Now what did I just see?' It's really sad."

After the 1958–61 stay in Northport, back came Kerouac and Memere to settle at 1309 Alfred. Why such drastic shifts of location? Everything had "blown up" in Florida, said she, with word that Blake had found another woman on the West Coast. Nin's 1959 divorce drew the family back here, largely out of anxiety about her and Paul Junior. Kerouac's concern as an uncle grew, and he gave the boy instruction in football and track.

Here he wrote *Big Sur* in October 1961, pleased to have completed another Duluoz Legend volume after four years of thwarted creativity. Yet the book was dark, telling how a creek's babble seemed to give a call toward death and how he wished that Memere would pray for him. Calling upon God for personal salvation, he awakened to all the world's horror.

That month Carolyn wrote one of her sweetest letters (not in *Off the Road*, strangely) touching on the love affair: "in ages to come it will just be people in a story as life is anyway if we didn't get our tender egos and emotions tangled in it. But we've known some real wonder and beauty which would be exceedingly difficult to get across with words and have them interpreted in the way it felt." There were also the frustrations of "having known the unearthly, extra beautiful and gentle values of you and Neal, and seeing no one interested or aware of any side but the self-indulgent one."

Kerouac didn't answer until January 1962, and then to say that *Big Sur* had been his reply: "You know, that old idea about you and me meeting in Nirvana later at which time Neal will be perfect etc. you remember. Anyway, pretty romantic." Quite a contrast of attitudes: hers essentially this-worldly and Jack's about the beyond.

Reviews for *Big Sur* made him question whether to write anymore. "He seemed secure as a perpetual adolescent — free of thought, full of feeling, blessedly zooming back and forth across the country," begins the one by *Time*, which cruelly misrepresents his emotional crisis: "A child's first touch of cold mortality — even when it occurs in a man of 41 — may seem ridiculous, and is certainly pathetic."

St. Petersburg, Florida

The September 1964 path of Jack and Memere leads off Route 275 (Exit 24) to 5155 Tenth Avenue North, a location he tried to keep secret from abusive visitors. Nin now lived in an Orlando apartment, doing maintenance in exchange for rent. Distressed by her second marriage's collapse, she developed high blood pressure.

On September 19, Blake made a long-distance phone call that highly alarmed her, triggering a fatal coronary occlusion.

Kerouac, always committed to his family, took Nin's death hard. Jim Jones's *Use My Name*, a study of Jack's family links, gives young Paul's viewpoint: "When my mom died he gave up. He didn't want to live." Paul might have exaggerated, yet it is known that Kerouac wept over her death for many weeks.

Sometimes he walked to Paul's high school near the end of the last period to wait for this boy, now almost a surrogate son. Paul implored his father, after Nin's death, to let him stay with his uncle and grandmother, but Blake vetoed this plan and threatened to ask for police help to get his son aboard the westbound plane.

Nin, when delivering Paul prematurely by emergency caesarean section, had barely escaped with her life. Ultimately, she was laid to rest in Orlando's Greenwood Cemetery, and Kerouac scholar Bob Kealing, in a *Dharma Beat* article, tells of going to pay his respects at her gravestone. There isn't one. Her husband (whose ashes now rest in the same plot) didn't carry out his intentions to erect a marker until it was too late.

Nin died just after *Visions of Gerard* came out. Recently auctioned at Sotheby's in New York was a copy Jack had inscribed, in French, to Memere. Pressed between its pages was a flower taken from the grave of his sister, another Kerouac who had died in pain.

Young Paul much resembled Gerard, Memere said, and he, too, was destined for misfortune. His home of late has been a pickup truck in Sacramento: licence plate 4E9 3262, Joe Radden's junkyard. Jack's closest living relative has entered a sad decline.

University of Southern Florida students in October 1965 began a habit of hurling rocks at Jack's door after their drinking bouts. The next year brought the move to Lowell, and then, late in 1968, Joe Chaput brought Kerouac (on his final road trip) to a concrete-block home next door at 5169 Tenth Avenue North in St. Petersburg. This time there was Stella, by now perceived as another woman telling him what to do. But she liked coming to Florida — though not so her husband, who spoke of not having the fun he had enjoyed in Lowell. Kids were seen to be longer playing hopscotch or made-up baseball games.

Kerouac is well known to have supported the Vietnam War, but he was appalled by the loss of life. Anti-war protesters angered him less than those condemning America outright. Though of Quebec descent, he felt deep-seated in the land. What he could hardly abide was the respectable neatness of prosperity in an America changing beyond recognition.

Alcoholism has its horrors, but did happiness entirely elude Jack in later years? His last article, "After Me, the Deluge," was run in the local *Times* along with a profile by reporter Jack McClintock, who in 1970 wrote a revealing *Esquire* article, "This Is How the Ride Ends." A tender view emerges of Kerouac, now with red-rimmed eyes and a large belly but also a youthful aspect: "Like a little boy, an eternal innocent, he had no defences."

McClintock found Kerouac by a television set emitting no sound, but with Handel's *Messiah* coming from speakers in another room. Yet a severe beating received in a ghetto bar had made him fearful. "You can't do what I did anymore," he said. The world described in *On the Road* no longer existed. Though acknowledging that Cassady was dead, he would mutter, "I don't want to believe it."

At St. Anthony's Hospital, Jack Kerouac was given twenty-six blood transfusions, all rejected by his system as he cried out in pain, and in fear of death.

Always on a table next to his rocker were books, usually classics. "Wheer the divil are me glawsses?" Kerouac would say, and then read something "with broad, wild gestures of self-parody, grinning and mugging and dipping into a cornucopia of foreign accents." It was as if he had "burrowed farther and farther back into his own personality."

Kerouac would skip around anything boring, said McClintock, so as to uncover new topics. "He was the perfect drinking buddy: uninhibited, creative in conversation, inventive in mimicry, erudite in the range of his knowledge. Some of what he said was trash, but some was the fruit of his erratic genius."

His literary standing having reached a new low, Kerouac's earnings for the first half of 1969 were only $1,770. Stella would walk to Forty-ninth Street and take a bus to Webb City for sewing-machine work at two dollars an hour to keep the family afloat. When that opportunity dried up, they had only Memere's Social Security to live on. He well knew that literary taste had swung toward the more ironic expression later known as "post-modern" — non-Wolfeans ascendant, you might say — and felt that some twenty-five years would be needed for his popularity to return.

Seven months before the end, during one of Jack's drunken telephone monologues, Carolyn reluctantly hung up and he never called again. Then, on October 17, 1969, he was upset to witness the removal of a large Georgia pine standing before a neighbour's house. Though a smaller tree grew near his own front door, no longer would the wind's voice speak to him through the taller one's branches.

On October 20, Kerouac rose at four in the morning, having earlier read to Stella from an old letter of Leo's. His bank account then showed a balance of sixty-two dollars. In the night's waning hours, on a cot purchased with S & H green stamps collected by Stella, he lay outside looking at the stars.

"Who knows, my God, but that the universe is not one vast sea of compassion actually, the veritable holy honey, beneath all this show of personality and cruelty," he mused in "Beatific: The Origins of the Beat Generation," regarding with awe a huge potential "that can ray forth anything it wants from its pure store, that blazing bliss, *Mattivajrakaruna* the Transcendent Diamond Compassion!"

In mid-morning he suddenly began hemorrhaging. "I'm hurting, I'm bleeding," he called to Stella. "Help me." His liver had backed up at last, veins in his gullet burst to let blood issue forth, so that he drowned in it.

St. Anthony's Hospital, at 1200 Seventh Avenue North, was the scene of his excruciatingly lengthy death. The end came at six on the evening of October 20. Its cause, said the death certificate, was "gastrointestinal hemorrhage, due to bleeding gastric varix from cirrhosis of liver due to excessive ethanol intake."

Both of Carolyn's men died far from her presence, despite her having been "closer to those two than anyone I'd known." Her epitaph is from Jesus, but evokes William Blake and Thomas Jefferson, as well: "Let the dead bury the dead; our concern is with the living."

Later in Rhodes Funeral Home, at 635 Fourth Street North, McClintock heard Memere murmuring beside the casket, "O my little boy.... Isn't he pretty? ... What will I do now?" Stella stood there gripping the handles of her wheelchair. The Sampas family would attend to Memere's needs until she also died in the city four years later.

On McClintock's last visit, Kerouac "leaned back in the rocking chair and sang, 'I'm romantic,/And strictly frantic,/I love those old-fashioned times." He answered his own question as to who the greatest American writer might have been: "Wolfe! Thomas Wolfe. After me, of course."

Everything
Is Ecstasy

———

Central United States, 1940s–1990s

12

TO NEW ORLEANS

Still alive in the pages of *On the Road* are Neal and Jack, nowhere more so than as seen (in their personas) driving westward with Al Hinkle and LuAnne in January 1949. There's a moment when Sal wakes Dean to let him take over the wheel and all get out to become suddenly aware of being in the South with its aromas of manure and green grass.

Shortly, they were excited by proximity to Florida on arrival in Flomaton, Alabama. I've retained from that era a Shell "Official Road Map of United States" (offered for free) showing Flomaton prominently on U.S. Highway 31, then the fastest route diagonally toward New Orleans. Interstate 65 has since been built alongside Highway 31, its turnoffs drawing chain operations and thinning local enterprise along that old route.

It's late afternoon when I enter New Orleans, recently a victim

Flomaton, Alabama, is now a ghost of itself, even several of its billboards vacant, such Dracula-like feats by the interstate system being widespread across America.

of Hurricane Katrina. The 1949 travellers, savouring the sweet air, went on the Canal Street ferry to visit Burroughs's family, then living at 509 Wagner Street in Algiers. We have a glimpse of the doomed Joan, Jane Lee in *On the Road*, standing at the screen door and mighty high on Benzedrine. Regulars of apartment 419, in New York just a year earlier, were meeting once more.

With the Burroughses was Helen Hinkle, who had found her "honeymoon" trip so uncomfortable as to opt out and follow Al's suggestion of using his rail pass to come here for a stay with these total strangers. Each day she went into New Orleans to stay out of her hosts' hair, on each visit picking up one Benzedrine inhaler for Joan.

This was to clear up nasal congestion, supposedly, though she would extract the cotton to ingest for a high — eight inhalers per day minimum, says Carolyn: "A quarter-inch strip torn from the wad inside makes you high for eight hours, followed by an equally long drag. Joan, of course, avoided that by taking more. I'd say one inhaler would provide six to eight hits, so eight a day — whew."

Off the Road gives Helen's account of reunion with Al, with the

detail of LuAnne asking to watch these newlyweds-on-delay finally making love. It also shows LuAnne being receptive to blows delivered by Neal. Kerouac's book gives mention of neither event, yet is viewed by some as too forthright: strange.

Bull Lee (Burroughs), shown asking Dean to sit quiet long enough to explain why they're going cross-country, gets no clear reply either from him or Sal, who acknowledge knowing nothing about themselves. Bull's own life is clearly full of chaos, naturally, his daily heroin hit being well known to all.

Here together, in the novel, are three major Beats, each highly individualistic while sharing deep curiosity about the afterlife. Sal, gambling with Bull, notices a horse called Big Pop and, recalling his own deceased horse-playing father, enters a brief trance. Big Pop, on whom they don't bet, triumphs and pays fifty to one — Sal's father having spoken from the beyond, Bull conjectures, averring that a mutation in the brain at death permits this.

In real life Al and Helen decided to stay on in New Orleans.

A marker (nearly unique for Beat residences) mentions the verandah — which Kerouac described as sagging — at 509 Wagner Street in the Algiers section of New Orleans. Here On the Road's Marylou joins Sal in Southern aristocracy miming, he with genteel praise of her loveliness and she burbling words of appreciation.

So Kerouac and Cassady, with LuAnne in between, headed toward San Francisco. Shortly, they disrobed for cooler driving and, among remote Native ruins, had fun when an elderly couple approached by car. Cassady mounted a platform to strike a classic pose, says LuAnne in *Jack's Book*, and the three later howled over their dupes' likely reaction of awe at the statue's well-preserved state. The world in Beat terms: a mad delight.

LuAnne became a successful nightclub owner but also a heroin addict, Carolyn tells me, thereby losing her husband and nearly also her daughter and mother: "She quit after a while and got the mother and daughter back. The daughter was her greatest love. In the 1970s she was still friendly with Al and me and interviewers, but drew away year by year."

EAST ST. LOUIS

My downtown hotel in St. Louis, the WS, has an angled glass-block counter lit by candles — "for effect," says Diane as she books me in. At small cost I get oversized accommodation — two big bedrooms, three TVs — and return to ask whether there's been a mistake. "We wanted the very best for you!" she says, beaming. Then she adds that I ought to be around when St. Louis sports idols are "announced," and descend from such condos to mingle at the bar with ordinary mortals. "They'll autograph your jersey!"

Next day I take the Metrolink across the Mississippi to East St. Louis — a great industrial centre in the Second World War but now enfeebled by globalization, a wasteland of vast extent. Here during 1959 Kerouac took in jazz and burlesque shows. "Through the bars of East St. Louis lies the dead frontier, riverboat days," writes Burroughs in *Naked Lunch*.

St. Louis was long among far-flung outposts of France's "empire of the St. Lawrence," like other places with French-sounding names such as Detroit and Terre Haute. The 1803–06 Lewis and Clark expedition began a process of bringing most of these into America's embrace.

Burroughs grew close to Carr in a truly Beat manner, as told in a *Jack's Book* anecdote. Wishing to visit East St. Louis, he borrowed Burroughs's Ford, and on its dirt roads the car's front suddenly exploded. Carr thought about it for a week, then called Burroughs. "Hey, Bill, you know your car," he began. "I think I blew the head off it, anyway it all came flying out the hood and … it's over there and I don't think it's worth goin' over to pick up."

"All right," Burroughs replied. Then he added, when Carr said he thought he had better explain, "Fine." It turned out he was pleased by the lack of any attempt to apologize, and that's what made the pair close friends.

Burroughs, Carr, and Kammerer were all from St. Louis, yet in *Vanity of Duluoz* they are presented as members of a New Orleans clique — "the most evil and intelligent buncha bastards and shits in America." Kerouac lacked their dryness yet had a "saving grace" at Columbia: "the materialistic Canuck taciturn cold skepticism all the picked-up Idealism in the world of books couldnt [*sic*] hide."

Two elderly black men on my returning train converse about old tunes and violent acts.

"'Soldier Boy,' remember that one?"

"'Down in Mexico.'"

"Yeah, the Temptations."

"Warren died from alcohol."

"The movie showed he died in a car."

"Got hit with a hammer, died with a blood clot in the brain."

"They *deed* show it in the movie."

"*Coh*-caine, that's what keeled him."

Kerouac's praise of "happy, ecstatic" black people he'd met in Denver riled Norman Podhoretz, for whom such an attitude paralleled that of Southern plantation owners. Burroughs was closer to this issue, his mother being a Southerner descended from Robert E. Lee, and he loved to skewer gentility myths of the Deep South, as when *Naked Lunch* presents a court house in "Pigeon Hole," with local concerns shown by a patch of Southern Belle/Redneck dialogue:

> "Roy, that ol' nigger is looking at me so nasty. Land's sake
> I feel just dirty all over."

"Now, Sweet Thing, don't you fret yourself. Me an' the boys will burn him."

"Do it slow, Honey Face. Do it slow. He give me a sick headache."

St. Louis

Uptown in St. Louis, I visit what remains of a once-vibrant corner called Gaslight Square. In 1951 Jay Landesman returned with wife Fran from his Manhattan stint promoting *Neurotica* to reshape an old bar into the Crystal Palace (so named for its chandeliers). In 1958 this was re-established westward to 42–44 Olive Street at the heart of Gaslight Square, becoming the centrepiece of an internationally known mecca for the hip. The next year in this "cross between a church and a movie palace, without the reverence," *The Nervous Set* scored an immediate success.

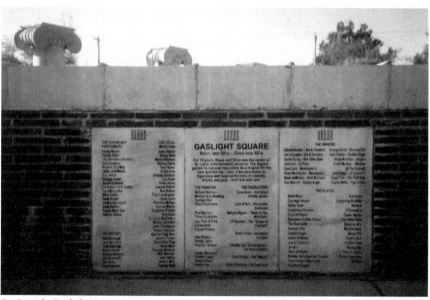

St. Louis's Gaslight Square in its entertainment prime was praised by Time *for combining "a sort of Disneyland quaintness with the gaiety of Copenhagen's Tivoli Gardens and the innocent naughtiness of Gay Nineties beerhalls."*

Nothing of that remains, although a kind of tombstone arrangement now marks the corner of Olive Street and Boyle Avenue. "Jay, Fran and Fred Landesman/Crystal Palace" is the listing, under "Pioneers." Brother Fred helped bring here the best of a new kind of performer: Lenny Bruce, Woody Allen, a teenage Barbra Streisand. Fran, delighted by jazz musicians who talked about being "hung up," asked their young pianist, Tommy Wolf, about the T.S. Eliot line describing April as the cruellest month: in hip lingo might that be "Spring can really hang you up the most?" Wolf, swift to embellish a line, stopped playing and asked her to repeat it, then suggested that she write a lyric with this title. Later she shyly slipped her lyric into his pocket, and he set it to music "almost as quickly as she had written it."

Phoning Jay at a number Carolyn provided, I report my St. Louis findings with lamentation for the neglect accorded him. "You can say that again, kid!" he replies. And why should this be so? "I've been eclipsed by the nirvana-seeking boys."

Yet *The Nervous Set* ran on Broadway in 1959. Kerouac, portrayed by future *Dallas* star Larry Hagman, was almost barred from its opening for being drunk. Jack soon fell sound asleep, Jay recalls, but awoke to hear his name in the first act's final song and said, "Hey, that's pretty good, man." Amusing, though Carolyn suspects he made that up.

Gaslight Square, victimized by white flight to the suburbs, was shortly left prey to urban blight that induced the couple to settle in London, soon after the first murder occurred here in 1964. Jay has no doubt that *The Nervous Set*, having been once revived in St. Louis, will run again on Broadway.

A sidewalk plaque nearby at 2635 Locust Street marks the birthplace of Eliot, who became London's arbiter of taste. Mega Sun now has its offices here, and owner Ron Poe well knows the Eliot connection: "Edgar Allan's my drinking uncle. He was adopted so he doesn't count."

Burroughs grew up near Forest Park, often exploring its ponds to capture frogs. Writings of naturalist Ernest Thompson Seton — long settled in Toronto, where I've traced his haunts — held great

appeal and contributed to the persona of teenager Audrey Carsons, recruited by gleefully depraved youthful tribes described in *The Wild Boys*, who were "learning the old magic of wind and rain, the control of snakes and dogs and birds." These boy scouts, clearly gay, are alien from the conservative milieu Burroughs knew here (and found fault in his manner and appearance).

In *The Cat Inside*, Burroughs recounts walking in Forest Park at age four behind his brother and seeing "a little green reindeer about the size of a cat." This he conjectured to have been a totem-animal vision, "clear and precise in the late afternoon sunlight as if seen through a telescope." Yet the medium of such revelations now thins out: "As the forests fall to make way for motels and Hiltons and McDonald's, the whole magic universe is dying." Over 90 percent of the continental United States remains open land, actually, though he may be right about our vision of it. Burroughs dreamed of living in the wild before our era of instant communications in which, he feels, control systems of war and commerce prevail.

A 1964 essay for *The Nation* by Marshall McLuhan (who taught university English in St. Louis) states that "an engineer's report on the new electronic environment's risky terrain and compulsive processes" was given by Burroughs's cut-up novels. "Today men's nerves surround us; they have gone outside as electrical environment." A reasonable spin on what Burroughs proclaims, I'd say.

Pershing Avenue is still tree-lined as when Burroughs grew up in the sizable but unpretentious red brick home at number 4664. His father, Mortimer, had a small plate-glass company and was later viewed by Ginsberg as "a wise distinguished version of Bill tho not so fiery as his son."

Bill was introduced to guns at eight by Mortimer. "I used to go out duck shooting with the old man and the president of the First National City Bank and the owner of the *St. Louis Post Dispatch*," he told biographer Barry Miles. "As the ducks came in, all these fat old businessmen would stand up and blast away at them. We had retriever dogs to collect the ducks. I used to really enjoy it!"

In number 4664's garden, a knack for flower-arranging was shown by his mother, Laura. Though upset in 1931 to learn of his sexual preference for males, to Ted Morgan she said, "He's just the

For Playboy in 1964, William Burroughs wrote impressions of his old neighbour-hood walks, and while "trying to take 1920s photographs, alleys and whatnot," produced one here in the Forest Park area of St. Louis at 4664 Pershing Avenue, appearing "ghostly" as "seen back through forty-five years."

funniest person I know." And she once declared to her son, "I worship the ground you walk on."

She and Mort later moved to Palm Beach, Florida, and operated a gift and antiques shop, Cobble Stone Gardens, from whose profits Bill received $200 a month when he couldn't make a living from his pen, and this, he said, "really made it possible for me to go on writing." Young Willie, after his mother's death, was taken by Burroughs's parents to live with them, and Julie by Joan's to their upstate New York home.

Mystery surrounds a beloved Welsh nanny who with a veterinarian boyfriend took Burroughs, at age four, to a woods where molestation seems to have occurred. In a letter written at age forty-four, after psychoanalysis, he wrote, "I witnessed a miscarriage, by Mary the evil governess, and the results were burned in the furnace. That is the 'murder.'"

The River des Peres, once running behind number 4664, he recalled as "a vast open sewer that meandered through the city," wherein he could see human waste being deposited from vents along its route, and enjoy the smell. In *The Western Lands*, Burroughs tells of a "frozen sewer" lying between oneself and those territories once thought by the Egyptians to be the righteous soul's destination: "You have to be in Hell to see Heaven. Glimpses from the Land of the Dead, flashes of serene timeless joy, a joy as old as suffering and despair."

Locked gates inhibit entry to a high-toned region immediately west. *The Wild Boys*, coincidentally, shows civilization reduced to an elite maintaining a police state within walled enclosures. Statuary portraying *Mercure s'amuse* — the winged god with an eagle — shows cultivated St. Louis. Burroughs followed the expected path of obtaining an Ivy League BA, yet discarding that educated facade was necessitated by the writing of *Naked Lunch*, parodying the control systems of middle-class ways he found repressive.

At Bellefontaine Cemetery, Block 37, lot 3938 is dominated by a monument to William Seward Burroughs, his namesake grandfather, who founded the Burroughs Corporation upon his improved adding machine (its patent now held by UNISYS). This didn't translate into vast wealth, the businessman Joseph Boyer in the

WILLIAM S. BURROUGHS
JAN. 28, 1857
SEP. 14, 1898
❀
ERECTED
BY HIS ASSOCIATES
AS A TRIBUTE TO HIS
GENIUS

URROUGHS

The grave of William Burroughs's namesake and grandfather is located in St. Louis's Bellefontaine Cemetery. The inventor's grandson, buried near this solemn stone, was equipped by admirers with a joint and a gun, slipped into his casket for kicks on the journey ahead.

1920s having bought nearly all the company shares with only 485 going to Bill's parents.

To this family plot in 1997 a five-hour motorcade brought Burroughs's remains in a white hearse from his final home in Lawrence, Kansas. At the funeral Patti Smith sang, "Oh Dear What Can the Matter Be (Johnny's So Long at the Fair)." Proceedings were delayed because she insisted on walking to the gravesite from the cemetery's entrance.

Growing up in tiny Pitman, New Jersey, Patti had read Arthur Rimbaud and contemplated suicide before reflecting, "There's a new Stones album coming out and if I was dead I'd miss it." In 1979 Burroughs gave Patti her last interview before she "retired" from music at her popularity's height and moved to Detroit. "Basically, I just wanted to inspire kids, get 'em off their ass, get 'em thinking, get 'em pissed off, as pissed off as I was," she disclosed. "You know, interject a little extra joy and pain into their lives."

LAWRENCE, KANSAS

To Lawrence, Kansas, native son James Grauerholz brought Burroughs from New York in 1981, back to his Midwestern roots. Once-notorious Bill spent his final quarter-century hereabouts, at first renting the two-storey "Stone House" and its adjoining properties upon a ridge outside town. Where, exactly? A drive south on 59 and east on County Road 458 to Shank Hill will do the trick, says James on the telephone. And soon I'm at number 1490 on that road, at which the Stone House adjoins a limestone barn where Bill used his guns.

In 1992 Burroughs undertook to cleanse his guilt through a Navajo ritual he commissioned to be held here. Black plastic stretched over a twig framework comprised a sweat lodge, which all entered. After prayers of thanks given to the grandfather spirit and the elements, Navajo shaman Melvin Betsellie blew on a bone flute amid thick smoke. From the fire he took coals and placed them in his throat, eerily lighting it up. He swallowed an ember purported to be

At this limestone barn on County Road 458 outside Lawrence, Kansas, part of the "Stone House" property, William Burroughs was able to shoot handguns regularly and stack firewood as background for target practice.

that of the very "Ugly Spirit" Burroughs blamed for his crime, and retched it up several times.

The shaman described to Bill an eyeless white skull with rudimentary wings that had finally been tamed. Ginsberg, naked amid the smoke, reflected on the voices and spirits Burroughs himself could summon up, and his courageous realism.

Back in Lawrence on Learnard — "Learn Hard Avenue" to Burroughs — I visit his small final residence at number 1927, its parts ordered from a Sears, Roebuck catalogue for assembly some fifty years ago. Frank Dorsey and his cat Bigby, living here now, make me welcome. Burroughs's care for his own felines brought out a sentimental side movingly evident in *The Cat Inside*, illustrated by Brion Gysin.

Ginsberg's death occurred only four months before that of Burroughs, who at the end had a vision of his friend in the leaves. Back in 1981 at Columbia, Allen during an otherwise triumphant reading of *Howl* had read newer poems expressing failure. "I have not yet stopped the armies of entire mankind on their way to World War III," he confessed. "I never got to heaven, nirvana, x, whatchamacallit. I never learned to die."

Before his actual demise, however, Ginsberg admirably phoned his friends to give farewell, one by one. Far-right diatribes against him came, anyway, columnist George Will's attack prompting Burroughs to write a letter to the *Lawrence Journal World*: "Mr. Will pointedly ignores the calm and dignity with which Allen met his death. I wonder if, when his time comes, will George perform as well."

Frank kindly shows me around number 1927's interior. In an introduction to *Last Words*, Grauerholz says that on a typical day Burroughs would feed his cats, receive visitors, read books, and look through *Field and Stream*; do a stroll or some knife-throwing in the garden; enjoy some vodka and Coke, smoke a joint, make journal entries until the arrival of dinner guests, and — at an increasingly early hour — retire. Still in the yard is Burroughs's Datsun, behind the rear bumper of which he saw his favourite cat, Fletch, lying dead. Each upon dying would be buried in the garden, the last being Fletch.

A few blocks away, William Burroughs Communications operates in the modern house owned by Grauerholz, tall and vigorous

This burial marker for Ruski, one of William Burroughs's cats, reads B FEB 1980/D 10 FEB 1994/RUSKI. *The earliest of such markers in the yard of 1927 Learnard Avenue in Lawrence, Burroughs's last residence, honoured a Russian Blue.*

at fifty-one. James gets talking about a Lawrence cabbie who writes brilliantly, and at once onto his computer screen comes footage of that man. Warm words are spoken about other local personages.

He recalls a lecturer in the university's religion department who at Burroughs's funeral asked mourners to "pick up the torch" of battle for basic freedoms. Recalling that the rite included a reading of Tennyson's "Ulysses," James triumphantly bursts forth with its key lines: "How dull it is to pause, to make a rest/To rust unburnish'd, not to shine in use."

John Cassady briefly lived in California during 1976 with Burroughs's son, who certainly never paused to rust. Newly provided with a liver transplant, Willie would soon die from overindulgence nonetheless. "That guy was hell-bent on self-destruction," said John. "His attitude was, 'Hey, I got a new one to burn.'" Burroughs at great effort had arranged for the liver transplant, only to have Willie die at age thirty-four.

In Lawrence, Burroughs forsook suit and tie for khakis and

work shirt and charmed many by his informality. He wrote lyrics for a local punk band, the Mortal Micronotz, and James supplies a few lines: "Old Mrs. Sloane, chewing the bone, of her dead child…." He also collaborated with James in writing another trilogy that concluded with *The Western Lands*, in which an aged writer reaches "the end of words, of what can be done with words."

Asking how James views the term *beat*, I'm given printouts of scholarly opinion and then his personal take: "First of all, I wasn't there. I don't know. My impression is that *beat* is a street word of the 1930s or 1940s, meaning 'broke' or 'exhausted' or 'emotionally numb.'" And Kerouac's "beatific" angle? "I would see that as a sanitization. It means being tired, beaten up. Or ripped off, in the sense of shoplifting." He cites Times Square hipsters Bill knew, cadging restaurant patrons' overcoats for quick resale.

Burroughs liked to repeat famous last words — as those by Ulysses Grant to his nurse, "It is raining, Anita Huffington" — and *Last Words* is the title of a collection of journal entries spanning twenty-one months down to the end of his life. In this work his own final utterances before the end, on August 2, declare the lack of any final Holy Grail while affirming the painkilling power of love.

The most drug-addicted Beat personage was thus destined, ironically, to be the last major one alive. Through a window James points out the home of his mother, Selda. At Burroughs's funeral, to piano accompaniment, she sang "For All the Saints Who from their Labours Rest." Traditional honours for that radical author.

I ask about another magic rite, given after Burroughs's passing and hosted by old friend Wayne Propst on his farm north of town. James explains it as a bonfire ceremony pertaining to the Tibetan Buddhist idea of a *bardo*, a death interval between reincarnations. A high mound was formed of chicken wire to hold items related to Burroughs — traditionally, an effigy of him would have been made — and friends gathered round as flames consumed earthly things, freeing the deceased to continue his death journey.

NASHVILLE AREA

Carolyn Cassady, born in Michigan, grew up in Tennessee. I visit Nashville to see the Belcourt Theater, home of the Nashville Community Playhouse, where at fourteen Carolyn won first and second prizes for set design. Too modest: *Off the Road* gives no inkling of such honours. After long service, the place is now a cinema as it was at the beginning, with an early projector displayed in the lobby.

Carolyn kept up the pursuits learned here, telling Kerouac in an October 1961 letter about doing costumes for a San Jose *Nutcracker* production while pouring out encouragement to him — and he in a return message trying to give back some of what he had thus gained. Art for her was less an altar of sacrifice than a kind of sanctuary, it seems.

Charles Robinson, Carolyn's father, was a biochemistry professor at Vanderbilt University, happy to commute between there and

The Grand Ole Opry was here at the Belcourt Theater in Nashville during Carolyn Cassady's early youth, its format determined by performers doing fifteen-minute stints to two separate audiences in its confined space, rather than the usual half-hour shows.

Jack Kerouac once spoke of his "darling blond aristocratic Carolyn" — and here's Ravenswood Farm, the mansion in the Nashville area with a winding staircase that this Southern belle loved.

a country estate far to the south. From Exit 71 on I-65, I turn east on Route 253 and right onto Route 252, then right again into a lane named for their home, Ravenswood Farm.

Carolyn attended a Nashville private school, and in Bracknell she showed me high-school English textbooks at a level that would challenge college students now. Opposite a line from Matthew Arnold's *Sohrab and Rustum*, "The blade, like glass, sprang in a thousand shivers on the helm," I saw the teenage Carolyn's pencil drawing of a hand holding that broken sword.

Her autobiography will tell of parental undemonstrativeness — stemming, perhaps, from the behavioural psychology whose exponent, John B. Watson, told that one's children needed coldly scientific treatment: "Never hug and kiss them." Yet on a 1951 visit, *Off the Road* suggests, there was warmth between her parents and Neal, who enjoyed his father-in-law's stories (and yet could not be induced to mount a horse). Little suggestion must have been given of his errant nature, his wish to go "all out" as told in *Desolation Angels*: "He filled his car with friends and booze and pot and batted

around looking for ecstasy like some fieldworker on a Saturday night in Georgia when the moon cools the still and guitars are twanging down the hill."

GLEN LAKE, MICHIGAN

Glen Lake in upper Michigan, rimmed by cottages, was wilderness when Carolyn's father built the first of them all back in 1922. It gave her special rapport with the great outdoors, enriching also for Kerouac in woodsy Lowell, Burroughs in Forest Park, Ginsberg at his farm, Cassady on the Denver river flats. What's unique about Glen Lake is Carolyn's family's continuing link with it.

I locate Peter Robinson, a son of her brother, Chuck, who readily drives me to the old family property at 8406 South Dunn's Farm Road. He recalls Fourth of July parades once staged upon an "old road" parallel to the lake, adding, "Grandpa was up here in the 1920s with a buddy at spring break, and he said, 'This is where we'll have our summer cottage.' Grandmother wasn't happy with all the money spent on it." Chuck is still involved with mining claims up in the mountains, says Peter. "Hard to keep up with him even now — that Protestant work ethic: get up at six-thirty, breakfast at a certain time. Routines. No TV." Guidance was not by religion but by science.

"My parents were not into religion and didn't ingrain us in anything," Carolyn said to me in Bracknell, "although at the Congregationalist Sunday school we learned about the Bible." Leaving a blank for church affiliation on a school questionnaire, she was told to put down "Christian" by her father. "He said that on Sundays he preferred to worship God by riding horseback. I later studied Judeo-Christian traditions." Here's a basis for her love of nature, as glimpsed in Bracknell. She links life cycles, "individuals as well as the cosmos," to Spengler's comprehensive vision. "Like winter, an implosion of everything with negative energy all through those months. Positive energy withdrawn, the world looks dead, and has to be refreshed."

Peter and I enter number 8406, breathing its old-cottage aroma. Murals of birch trees remaining on its bare walls between vertical

two-by-fours were done by the ever-active Florence, who also taught all the children how to paint. Summers at Glen Lake initially meant no neighbours but Natives and freedom to explore wherever you

Still at 8406 South Dunn's Farm Road in Glen Lake, Michigan, are books brought along by the family — Carolyn Cassady would read Charles Dickens to her mother in that print-oriented day — and also a piano they would always have to remove rats' nests from when moving back in.

wanted to go. Kerouac also felt an entitlement regarding the wilds, wishing to light campfires outside designated areas. So did I, once with my daughter doing likewise at a remote spot where in boyhood I could do as I pleased, only to have its owner detect our campfire smoke and ask us to leave.

We go down to the beach. Carolyn, visiting with the children in 1960 shortly after *Life* magazine's scurrilous Beat Generation article mentioned Neal's incarceration, was alone by the water once with Florence, apologizing for any sorrow caused. She offered to explain everything. Her mother angrily asked whether it was all true, received a hesitantly affirmative reply, and hastened inside with no wish to learn anything about the marijuana charge or how the family was coping. Her bitter judgment was that the children would be better off dead — an extreme attitude, though Carolyn's children were shown kindness here nonetheless and turned out to be those the grandparents clearly preferred.

Meanwhile Cassady's son by Diana, Curt Hansen, grew up to become vice-president of operations at the adult contemporary radio station WEBE in Bridgeport, Connecticut. One may shudder that Neal begat four kids on two coasts — and perhaps marvel at the West's declining number of children per woman: in Canada, from 3.8 to 2.3 in the 1960s alone, and disastrously in Sweden where a 1.5 rate gives rise to government-sponsored posters declaring FUCK FOR THE FUTURE. That Cassady certainly did.

When we drive away, out comes word regarding Peter's dad returned from the war "a different person." This held him back: "Aunt Carolyn was upbeat, she moved on, while my father stayed the same as his upbringing — never changed, always prim and proper." Forthcoming and genial, Peter offers to send whatever my research might require and reflects, "I would have liked to have known my Aunt Carolyn."

I also visit East Lansing, her birthplace, but find no trace of the family home on Minogue Street amid modern dormitories serving Michigan State University, termed Cow College when her father taught here. A bovine named Daisy provided fresh milk for the Robinsons, whose cream scoop now graces a wall in her bungalow. Here's the farm-to-town-to-city theme Kerouac expressed.

Is there "nothing to hang your dreams on" now in America, as she suggests? That's hard to say. It's the question of exile, a condition I felt on being dragged away from California at six. I find opportunity for dreams in Canada while doubting that America offers as much promise as before, now that militarism counts so much. Time will tell.

DETROIT

In the elite Detroit suburb of Grosse Pointe Park, I locate 1407 Somerset Avenue, to which Kerouac and Edie Parker came as newlyweds in 1944. He paid back the bail money lent by her mother by working as a ball-bearings plant inspector, then decamped for Manhattan after two months in a place too lacking in "tragedy" for proper experience as a writer. Ahead was further consolidation of the Beats, with Edie still part of that.

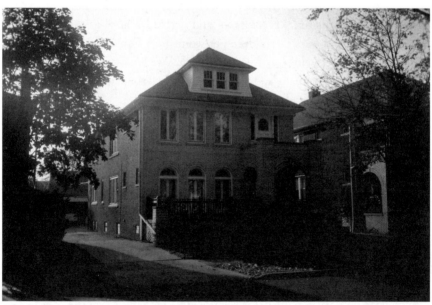

Edie Parker's mother and sister, who had an apartment here at 1407 Somerset Avenue in Detroit, welcomed Jack Kerouac in 1944 but had to contend with his prolonged occupations of the bathroom, there to read Shakespeare and the Bible.

On the Road shows Sal and Dean here in August 1949, on their return east, sleeping at a downtown all-night theatre with glimpses of the same two movies shown six times: the first about cowboys and imbuing them with "the strange Gray Myth of the West;" the other, about Istanbul, expressing "the weird dark Myth of the East." In early morning, by Sal's seat were bottles and butts and trash that might have been carried out along with himself, whereupon he envisioned being rescued — after a hunt by Dean across America for his pal's remains — only to report that he is happy in that "rubbish womb."

This scene is much discussed by academia for its sense of entropy. But on the men's actual visit, things seem to have been very different. Jack in his 1949 journals sums up the visit as "three days in Detroit trying to understand Edie." An excerpt from her memoir *You'll Be Okay*, found in the 1988 sourcebook *Kerouac and the Beats*, demonstrates their closeness on this visit (wrongly giving the date as 1947).

Unable to accommodate the travellers at home because of her mother's animosity toward Jack, Edie got them into the Grosse Pointe home of her girlfriend, Virginia Tyson. The men joined in the seven o'clock rite of "silver and candle light sit-down dinners," such as Jack had known at Edie's house, then the two went to bed, "anxious to be together again behind closed doors."

The next day Jack and Neal rounded up a "black, three-piece band" to play at a party there. Plumbers came to unplug a drain in which a pair of men's shorts were found, making everyone "hysterical with laughter." These were Neal's, as Jack later acknowledged. Partying continued until "everything ran out: beer, food, patience, hospitality." Then, Virginia's father being the announcer for Detroit Tigers baseball games, Jack and Neal spent time with players later at their hotel, and returned to play a hilarious post-binge ball game with Edie and her friends, she at first base. There's no mention of all-night theatres.

"We were just caught up in the 'excitement' of our lives, of what we were doing from day to day," Edie reflects. "Our parents left us pretty much alone, as they had during the war, our living together, Jack's shipping out, and getting married." Their generation was much as John Clellon Holmes described it: living at a fast clip to

which world conflict had accustomed them, with beatness coming along later.

Edie is mentioned in the very first line of *On the Road*: "I first met Dean not long after my wife and I split up." In the "scroll" version with unfictionalized names, however, the sentence ends, "not long after my father died." The reference to Leo might give that original text a very different slant — toward father figures rather than spouses — and with that manuscript's publication in 2007, such questions presumably will be resolved.

Twenty-three years after the 1946 annulment of Edie's marriage to Kerouac, she heard Walter Cronkite announce Jack's death. Going at once to Lowell for the funeral and then back to Michigan, the past surging anew in her mind, she read biographies of Jack that seemed inaccurate to her, then undertook to improve on them. "She would awake each day ten years thereafter at 5:00 a.m.," says the executor of Edie's estate, Timothy Moran, to "sit in her bedclothes on an old wooden chair with a notebook of paper, recording her memories in pencil."

Edie at Beat conferences would call herself Mrs. Jack Kerouac — even after two remarriages and two divorces, down to her 1993 death from diabetes — in rivalry with Carolyn as Queen of the Beats. "Edie Parker might have been a fun wife for Jack in terms of her looniness," Carolyn acknowledges. "I couldn't be as forward or unselfconscious as Edie."

A letter written by Kerouac to Edie on January 28, 1957, confirms his enduring affection and a fancy of mutual advance into loftier understanding. Hearing her voice recently on the phone had been "like a strange & beautiful dream," he said. "I have a lot of things to teach you now, in case we ever meet, concerning the message that was transmitted to me under a pine tree in North Carolina on a cold winter moonlit night. It said that Nothing Ever Happened, so dont [sic] worry. It's all like a dream. Everything is ecstasy, inside."

Epilogue:

Five Million of Stars

===

Quebec and Toronto

I tell Jacques, cooking breakfast omelettes at my Quebec hotel, about going to view the unveiling of a plaque honouring Jack Kerouac's remotest Canadian ancestor. He's impressed that this would be in the old St. Lawrence port of Kamouraska. Many friends live there, in what he describes as his "playground."

Jacques emphasizes Kerouac's wish for an uncluttered life: "not to be in a five-star hotel — but to be under five million of stars! For nothing!" (This place is four-star, but I let it pass.) Jack would as likely head toward urban temptations as to camping sites, I have to point out.

What seems like a shortcut to Kamouraska takes me on two-lane routes through many villages, police at one point halting car traffic in favour of some racing bicyclists. I shout oaths to the air, realizing I'll surely be late for the unveiling — by fifty-five minutes, actually, though a considerable crowd still lingers near the plaque.

266 ECSTASY OF THE BEATS

Urbain-François Le Bihan Sieur de Kervoac: the skills of gifted researchers were needed simply to find this name. Its owner became the first Canadian Kerouac after legal proceedings against him in Brittany involving inebriated wedding guests in the town of Huelgoat. Money had disappeared, Urbain-François was suspected of theft, and fifteen court sessions went over the details. Eventually, he saw fit to settle in Canada.

Now at Kamouraska's pioneer cemetery, clan members study the monument to its ancestor, who died at thirty in 1736. I've been told about the unveiling by Michel Bornais, secretary of the Kirouac Family Association. Its members on a 2000 tour of the ancestor's Breton homelands were trailed by the media and given official receptions in three communities. "It was a complete surprise to see how Jack was so highly considered," says Michel. Kerouac evoked "their mythical vision of America, which includes of course '*ma cabane au Canada.*'"

My cabin in Canada: the simple outdoor life, as practised once by the fur-trading *coureurs de bois* ("runners of the woods"). Michel tells how these were harassed by Catholic clergy: "CIA types spying on everything, finding out who was selling booze and having kids with Indians."

Easily cast in this role is Kerouac, chronicler of worldly delights. To editor Malcolm Cowley in 1955 he described himself, in the third person, as writing a veritable cathedral of books. "He is walking around in an ecstasy because his entire life-work is beginning to shape up," said this exuberant author. Then, as a true Beat, Jack visualized a "further beauty" in old age "of abandoning it all as just so much sad, human, and arbitrary poppycock."

What is the value of achievement or, indeed, of the individual self? The Beats found answers in that desire-renouncing religion of Buddhism. Its basis could be summarized, said Ginsberg, in a sentence from the Diamond Sutra often quoted by Kerouac: "All conceptions as to the existence of the self, as well as all conceptions as to the non-existence of the self; as well as all conceptions as to the existence of a supreme self, as well as all conceptions as to the non-existence of the supreme self, are equally arbitrary, being only conceptions."

The years blur personal identity, and yet efforts to identify one individual, Urbain-François, have inspired this clan gathering. Re-searching my own grandparents, who drowned aboard the *Empress of Ireland* on May 29, 1914, when it collided with a coal ship, I found

At the pioneer cemetery in Kamouraska, Quebec, clan members gather for the unveiling of the new headstone for the first Canadian Kerouac, Urbain-François Le Bihan Sieur de Kervoac. Kerouac's Satori in Paris *tells of the author's failed 1965 effort, both in Paris and Brittany, to discover information about this ances-tor that wasn't gained until more than four decades later.*

that the liner had passed Kamouraska around 8:45 p.m., at which time "songs were sung, jokes told, tricks performed and stories related" in an impromptu concert: innocuous vaudeville for Salvationists. From their Puritanism I departed, drawn more to the Beats' libertarian ways — and don't most of us now follow their path?

Back at the hotel next morning, I show Jacques my Kamouraska photos. He talks about Kerouac's "idea of opposition, to go face of the world," in terms ever widely used. The Beats as rebels disdaining bourgeois comforts: Norman Podhoretz in his 1958 essay said that to oppose or endorse the Beats had to do "with being for or against intelligence itself." Misleading, of course: the Beats sought ecstasy at a time of scorn for any gesture thought to be unpatriotic — somewhat as in post-9/11 America, though more exaggerated.

I continue to Montreal, where on 1970s visits I would frequent a coffee house in which Leonard Cohen literally made his mark — writing a poem with letters running thinly along the masonry of its bare-brick wall. The place closed long ago, and now I can't identify its site, or what he said.

Yet still on the St. Lawrence is Notre-Dame-de-Bonsecours, the "sailors' church" alluded to in Cohen's song "Suzanne." Like Kerouac, he lyrically mingled the sacred and the profane, a feminine colossus here looking out compassionately upon struggling males. Beat influence turned Cohen into what some call "the grocer of despair," and in California he went on to practise the Zen Buddhism that clears the mind of chatter, enabling fresh song lyrics to emerge.

The sailors' church is now kept locked. Street persons used to enter and sit beneath a Station of the Cross: "Jesus Falls a Third Time," and so on. "Everything comes to me because I am poor," says Jack Duluoz, and Cohen explores similar paradoxes.

Outside a stocky *clochard*, blaspheming in *joual*, comes over to sit beside me and gradually calm down. Acquaintances greet him. He stares at my torso. I study his profile and slicked-down hair. Suddenly, mania strikes again and he stands for a final rapid-fire curse before departing.

From the St. Lawrence Valley came Kerouac's people, and via Montreal a lifestyle inspired by his own surged back into Canada: coffee-house readings, black attire, candles, plain brick walls. Cohen

picked up the beat of cool spontaneity, still apparent in songs like "Ain't No Cure for Love" and "Everybody Knows."

"We're continually moving from whatever it is that overthrows the notion of the self, back to the burden of the self," said Cohen to journalist Ann Powers in 2001. "But if you're lucky, you come back to Boogie Street with the residue of the other experience. That cools you out." Cool, sure — and many communities in his youth, even my own, went into poetry-reading beatnik-costume faux-rebellion mode.

As this advertisement published in The Village Voice *on June 16, 1960, confirms, squares had to see Bohemia in action. Carolyn Cassady laughed about tourists doing so on Gray Line tours in San Francisco: "Take them to Vesuvio — fake, and stupid. We thought it was a silly joke."*

In Toronto I seek out 7 St. Nicholas Street where in 1960 a loft was turned into a coffee house called the Bohemian Embassy. Beatness having spread from Montreal in the pages of little magazines, this became an outpost among hard-shell Protestant Anglos. Toronto was then a "small Presbyterian town," said its owner, Don Cullen, but he and four other staff members at CBC Television chipped in $100 each to start up this "alternative" café. "The Beat Generation took a long time to get to Toronto," he said, but here it had a lively six-year run, with clouds of cigarette smoke and buckets to catch the rain.

"They had painted the inside black, and they had an espresso machine, the first anyone had ever seen, which was worshipped like a god," said Margaret Atwood, who often read her verse here. At this Beat-style rendezvous, creative people locked into one another's lives for better or worse. John Robert Colombo, who later handled the Tuesday night readings, recalls that offbeat books were then available in only one or two stores. Stern Protestantism ruling Toronto — it once had a Salvationist mayor in that era — disallowed such vice.

Non-alcoholic mulled cider was sold here without a licence so that uncomprehending police often visited. "The city was always trying to close us down," said Colombo. It did close, but reopened later in the recycled port facilities of Harbourfront. Colombo put at the helm a local book editor and ex-student of mine, Greg Gatenby, who engineered what became known as the International Festival of Authors.

Carolyn presented *Off the Road* at Harbourfront, thus endeavouring to demythologize the Beats — if that's possible. Ginsberg upon dying was given the Podhoretz treatment, broadcaster Michael Coren declaring that he represented "ugliness" and the political right, "joy." Columnist Rick Salutin astutely replied that Allen "embodied neither joy nor gloom alone, but an attempt to reach the former through the latter, as did Buddha, to whom Ginsberg was sometimes affectionately compared."

Over at Victoria College (now University), I took my BA a few years before Margaret Atwood did here, shortly gaining distinctly negative views of the Beats. "The perfect woman in *On the Road* is a

woman who lets her man come and go as he pleases and smiles all the time," Rosemary Sullivan quotes her in *The Red Shoes* as saying. "Now that's a woman. Who could be that? Or who wanted to be that?"

Carolyn can't figure out who that "perfect woman" might be in the book. "Can't be I — I threw them out. Doesn't sound like LuAnne. What other is there?"

Sullivan adds that Carolyn was deluded by Neal's "bohemian extremism" and thus "became its victim, destroying her chances at art as she tended the home front with the children, while Cassady roamed through his drug heaven and multiple mistresses in the name of raw experience." Yet hardly ruined were those "chances at art," Carolyn being long active at portraiture and honoured in her chosen field of costume design. That "home front" metaphor obscures the joy both parents felt at nurturing a family, and hers at being treated as an equal by two men often seeking her advice. She herself chose "raw experience" in taking Jack as a lover and embracing bohemian life later in England, with no immediate signs of being destroyed.

"The truth shall make you free," reads the radical message of St. John, carved upon Victoria University's Romanesque main portal. From here, and in these terms, I went forth to teach high-school English with dead poets offered alongside the new. Students thus learned to tell Keats and Yeats apart but also the two Morrisons, Van and Jim. Gingerly, I added to the curriculum *Howl* and *On the Road*, about living on the cheap and on the edge as did the Romantics.

At the Kerouac festival I heard an update on the Beats by Cory, a tall Saskatchewan teenager who drove forty-two hours straight with a friend to be there. "In Saskatoon we create forums to discuss the holy, not meaning acceptance of faith as in Christianity or Buddhism. Now it's a melting pot of everything, spirituality in many different forms — we're searching, just as they were." What a great attitude, like Carolyn's "go for something good that's going on." The Beats, often painted in dark hues, offer the young much that's affirming.

St. Michael's College, like Victoria a part of the University of Toronto, is where Marshall McLuhan pondered the media from his Catholic worldview. So did Kerouac. "McLuhan says we're getting

more oral so I guess we'll all learn to talk into the machine better and better," he said in 1968, long before cellphones, yet next year he deplored what he saw as the media guru's opinion "that the linear reasonableness of the printed word is out." That's not quite what McLuhan meant, but it reveals deep regard for what Kerouac held sacred: literacy.

The written word for Jack was "the only way to keep the record straight." On the morning of his death he was at work in his notebook, preparing for a new novel. Describing the holy task of writing and printing words, it would be named after Leo's last shop in Lowell, Stoplight Print.

During Toronto's hippie era, San Francisco's Human Be-In emboldened locals to mount an imitative "Love-In" in Queen's Park, facing St. Michael's. Hippiedom gave a scent of Buddhism along with suspicion that it couldn't possibly turn life around. But it did, Toronto the Good being eased out around the time rock music came in.

Where the old Varsity Stadium once stood, I recollect the 1969 Toronto Rock & Roll Revival at which I took in the last North American gig by Jim Morrison. Later the Doors' organizer, Ray Manzarek, well summed up the Beat aesthetic: "That sense of freedom, spirituality and intellectuality in *On the Road* — that's what I wanted in my own work."

Now, my wife, Judy, loves the Doors' music — for its "intensity, very fine poetry, a hypnotic quality" — but won't get into *On the Road*. Why? "The music, you get caught up in it for three minutes, but you're not focusing on the message," she explains. "I love that one, 'Go to the whisky bar,' but never in my life would I actually go there! By contrast, reading a couple of hundred pages about dysfunctional people throwing their lives away — you can't escape it."

Kerouac never came to Toronto, although several times Burroughs did — and while publicizing David Cronenberg's *Naked Lunch* locally in 1991, first experienced chest pains that led to triple-bypass surgery, extending his life. Ginsberg on a 1966 visit, after wandering the streets until 5:00 a.m., had expressed the need for a communal hall where ingesting "sacramental herbs" would permit the discovery of "inner space."

Up here we know about space, our vast prairies and northlands stretching below "five million of stars." But following the Beats into "inner space" — what might that be? "Closing your eyes and looking," said Allen. "It's far bigger than the universe."

At a love-in at Toronto's Queen's Park in May 1967, citizens witnessed guitar strumming, bongo playing, flower display, gratuitous fashion photo ops, the wearing of funny hats — "World's Worst Folksinger" — and, of course, poetry recitation.

Chronology

═══

1736	Urbain-François Le Bihan Sieur de Kervoac dies in Quebec.
1868	Jean-Baptiste Kerouac marries Clementine Bernier.
1880s	Pinkus Ginsberg emigrates from Russia to New York.
1889	Leo Kerouac is born in Saint-Hubert, Quebec. Kerouac family moves to Nashua, New Hampshire.
1895	Louis Ginsberg and Gabrielle Lévesque (Memere) are born.
1914	William Burroughs is born in St. Louis, Missouri.
1915	Leo Kerouac marries Gabrielle Lévesque in Nashua, New Hampshire.

1919	Louis Ginsberg marries Naomi Levy in Woodbine, New Jersey.
1922	Jack Kerouac is born in Lowell, Massachusetts.
1923	Carolyn Robinson (later Carolyn Cassady) is born in East Lansing, Michigan.
1926	Kerouac's brother, Gerard, dies in Lowell; Neal Cassady is born in Salt Lake City, Utah; Allen Ginsberg is born in Newark, New Jersey.
1936	Lowell flood takes place; Kerouac envisions *Dr. Sax*; Burroughs receives Harvard University BA.
1940	Kerouac attends Columbia University; Carolyn Robinson goes to Bennington College.
1941	Kerouac family leaves Lowell; Jack Kerouac leaves Columbia University, goes to Hartford as a writer.
1942	Kerouac joins U.S. Merchant Marine and sails to Greenland on SS *Dorchester*, then is discharged later in the year.
1943	Kerouac joins U.S. Navy and is discharged later in the year, meets Edie Parker and Lucien Carr; Ginsberg meets Burroughs.
1944	Carr's "New Vision" is formulated; Kerouac meets Ginsberg and Burroughs; Burroughs meets Joan Vollmer; Carr kills David Kammerer; Kerouac marries Edie Parker.
1945	Kerouac, Burroughs, and Ginsberg live with Joan Vollmer and Edie Parker; Neal Cassady meets and marries LuAnne Henderson.
1946	Leo Kerouac dies; Jack Kerouac's marriage to Edie Parker is annulled; Kerouac writes *The Town and the City*; Herbert Huncke introduces

the word *beat* to Kerouac and friends; Cassady and LuAnne Henderson go to New York where Neal meets Ginsberg.

1947 Kerouac meets Cassady; Carolyn Robinson meets Cassady, Kerouac, and Ginsberg in Denver; Burroughs's son, Willie, is born in Texas.

1948 Cassady has marriage with LuAnne Henderson annulled, marries Carolyn Robinson in San Francisco, then goes east with LuAnne to New York; Kerouac meets John Clellon Holmes; Ginsberg receives BA from Columbia University.

1949 Kerouac, Cassady, and LuAnne go to San Francisco; Cassady marries Diana Hansen; Kerouac uses the term *beat generation* for the first time.

1950 Kerouac and Cassady go to Mexico; Kerouac marries Joan Haverty; Cassady writes "Big Letter" to Kerouac; Kerouac publishes *The Town and the City*.

1951 Cassady goes to New York; Kerouac writes *On the Road*; Jan Kerouac is conceived and Jack Kerouac leaves Joan Haverty; Burroughs kills Joan Vollmer in Mexico City.

1952 Kerouac begins affair with Carolyn Cassady, writes *Dr. Sax*.

1953 Kerouac writes *The Subterraneans*; Burroughs publishes *Junkie*.

1954 Kerouac hitchhikes to California from New York, visits Neal and Carolyn; Kerouac's Buddha versus Cassady's Edgar Cayce; Ginsberg goes to California.

1955	Kerouac spends time with Gary Snyder, Lawrence Ferlinghetti, Kenneth Rexroth, Philip Whalen, and Michael McClure in San Francisco; Ginsberg reads *Howl* in public for the first time at Six Gallery in San Francisco, with Kerouac in attendance.
1956	Kerouac writes *Visions of Gerard*; Burroughs is given apomorphine cure; Ginsberg publishes *Howl*.
1957	*Howl* trial takes place; Ginsberg, Burroughs, Peter Orlovsky, and Kerouac spend time at Hotel El Muniria in Tangier, Morocco; Kerouac publishes *On the Road*.
1958	Cassady goes to prison; Ginsberg settles with Peter Orlovsky in Manhattan's East Village; Kerouac publishes *The Dharma Bums* and *The Subterraneans*.
1959	*Pull My Daisy*, the film, is produced; Kerouac appears on *The Steve Allen Plymouth Show*; Burroughs publishes *Naked Lunch*; Kerouac publishes *Maggie Cassidy* and *Dr. Sax*.
1960	Burroughs settles in London; Ginsberg and Kerouac take LSD; Kerouac goes to Big Sur, publishes *Book of Dreams*, *Lonesome Traveler*, and *Visions of Cody*.
1961	Ginsberg publishes *Kaddish and Other Poems*; Kerouac and Ginsberg take psilocybin supplied by Timothy Leary; Kerouac begins child-support payments for daughter, Jan.
1962	Kerouac publishes *Big Sur*.
1963	Neal and Carolyn Cassady are divorced; Kerouac criticizes Ginsberg's radicalism, publishes *Visions of Gerard*.

1964	Burroughs publishes *Nova Express*; Cassady drives Kerouac to New York to meet Ken Kesey and the Merry Pranksters — last time Jack and Neal meet; Kerouac moves with his mother to St. Petersburg, Florida; Caroline (Nin) Kerouac, Jack's sister, dies.
1965	*Naked Lunch* is legally absolved; Kerouac travels to Paris, publishes *Desolation Angels*; Ginsberg performs at Royal Albert Hall in London, England.
1966	Kerouac sells house in St. Petersburg, buys new home on Cape Cod, and moves there with his mother; Jack publishes *Satori in Paris*; Gabrielle Kerouac has a stroke; Jack marries Stella Sampas.
1967	Kerouac sells house on Cape Cod and moves with Stella and his mother back to Lowell; Jack travels to Rivière-du-Loup and Montreal's Expo 67; Ginsberg participates in Be-In in San Francisco.
1968	Kerouac, Ginsberg, and Burroughs have troubled final reunion before *Firing Line* television show; Cassady dies in Mexico; Burroughs and Ginsberg attend Democratic Party Convention in Chicago; Lucien Carr, Kerouac, and Burroughs have reunion in New York; Kerouac, Stella, and Memere move back to St. Petersburg; Jack publishes *Vanity of Duluoz*.
1969	Kerouac dies in St. Petersburg, Florida.
1971	Cassady's *The First Third* is published; Burroughs publishes *The Wild Boys: A Book of the Dead*.
1973	Gabrielle Kerouac (Memere) dies.

1974	Ginsberg and Anne Waldman create the Jack Kerouac School of Disembodied Poetics at the Naropa Institute in Boulder, Colorado; Burroughs settles in New York and meets James Grauerholz.
1978	Nova Convention held in New York.
1981	Jan Kerouac publishes *Baby Driver*.
1984	Ginsberg publishes *Collected Poems: 1947–1980*.
1987	Burroughs publishes *The Western Lands*.
1988	Jan Kerouac publishes *Trainsong*.
1990	Joan Haverty, Kerouac's second wife, dies; Stella Sampas, Jack's third wife, dies.
1992	Burroughs has "Ugly Spirit" exorcised.
1993	Edie Parker, Kerouac's first wife, dies.
1996	Jan Kerouac dies in New Mexico; Herbert Huncke dies in New York.
1997	Ginsberg dies in New York; Burroughs dies in Lawrence, Kansas.
2001	*On the Road* manuscript roll is auctioned and sold for $2.4 million to James Irsay, the owner of the National Football League's Indianapolis Colts; Ken Kesey dies in Pleasant Hill, Oregon.
2005	Lucien Carr dies in Washington, D.C.

Family Trees

Kerouac Family Tree

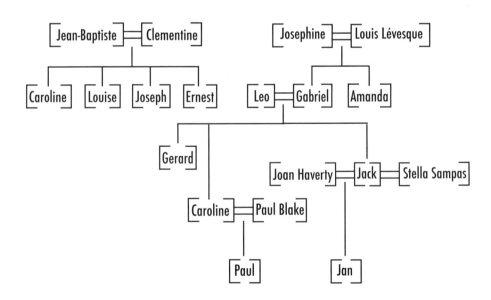

Ginsberg Family Tree

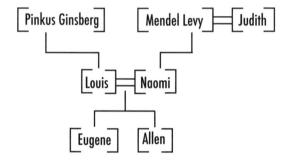

Burroughs Family Tree

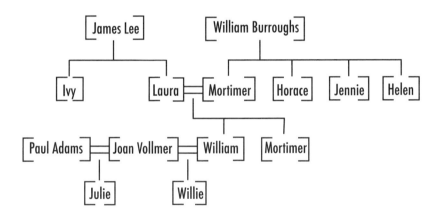

Cassady/Robinson Family Trees

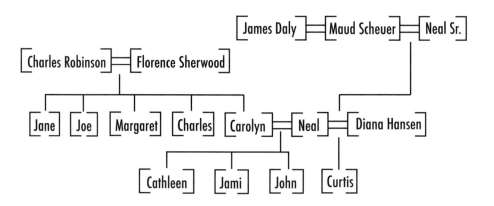

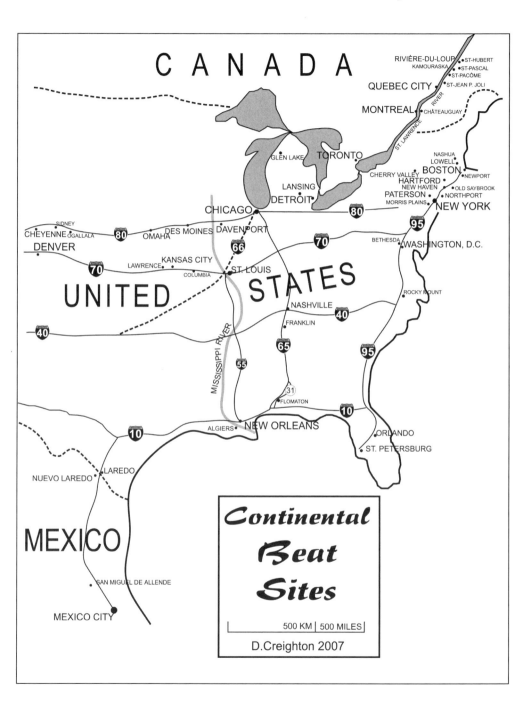

CANADA

RIVIÈRE-DU-LOUP • •ST-HUBERT
KAMOURASKA• •ST-PASCAL
•ST-PACÔME
QUEBEC CITY •ST-JEAN P. JOLI

MONTREAL • •CHÂTEAUGUAY

ST. LAWRENCE RIVER

GLEN LAKE• TORONTO
NASHUA•
LOWELL•
BOSTON
CHERRY VALLEY• HARTFORD •
LANSING NEW HAVEN• •OLD SAYBROOK
DETROIT PATERSON •NORTHPORT
CHICAGO MORRIS PLAINS•
80 NEW YORK

SIDNEY DES MOINES DAVENPORT
CHEYENNE OGALLALA 80 OMAHA
DENVER 66 70 BETHESDA• WASHINGTON, D.C.

UNITED STATES

KANSAS CITY
70 LAWRENCE• COLUMBIA ST. LOUIS
ROCKY MOUNT•

NASHVILLE 40
FRANKLIN•
40 65

MISSISSIPPI RIVER

55 95

31
•FLOMATON
10
NEW ORLEANS
ALGIERS• ORLANDO•
10 •ST. PETERSBURG

LAREDO
NUEVO LAREDO•

MEXICO

•SAN MIGUEL DE ALLENDE

MEXICO CITY

Continental
Beat
Sites

| 500 KM | 500 MILES |

D.Creighton 2007

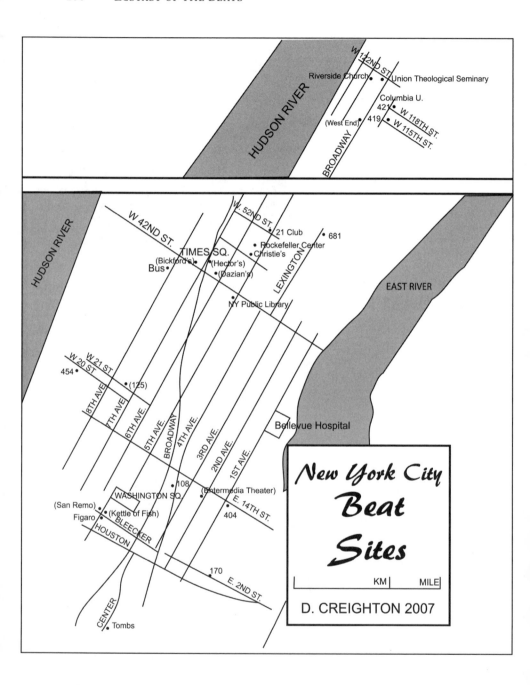

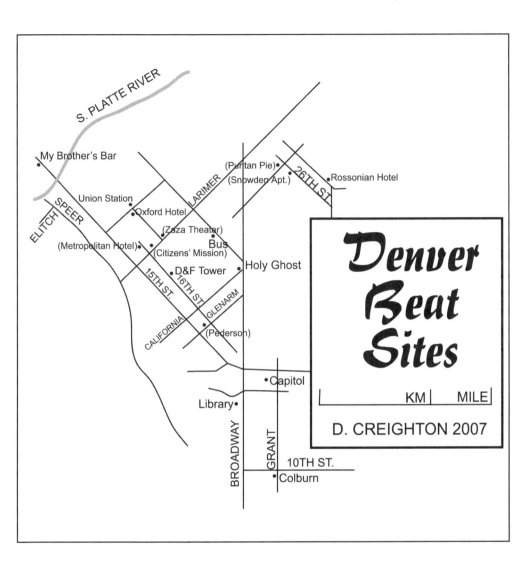

S. PLATTE RIVER

My Brother's Bar

SPEER

ELITCH

Union Station

Oxford Hotel

(Metropolitan Hotel)

(Zaza Theater)

Bus

(Citizens' Mission)

D&F Tower

15TH ST.

16TH ST.

CALIFORNIA

GLENARM

(Pederson)

LARIMER

(Puritan Pie)

(Snowden Apt.)

26TH ST.

Rossonian Hotel

Holy Ghost

Capitol

Library

BROADWAY

GRANT

10TH ST.

Colburn

Denver Beat Sites

KM | MILE

D. CREIGHTON 2007

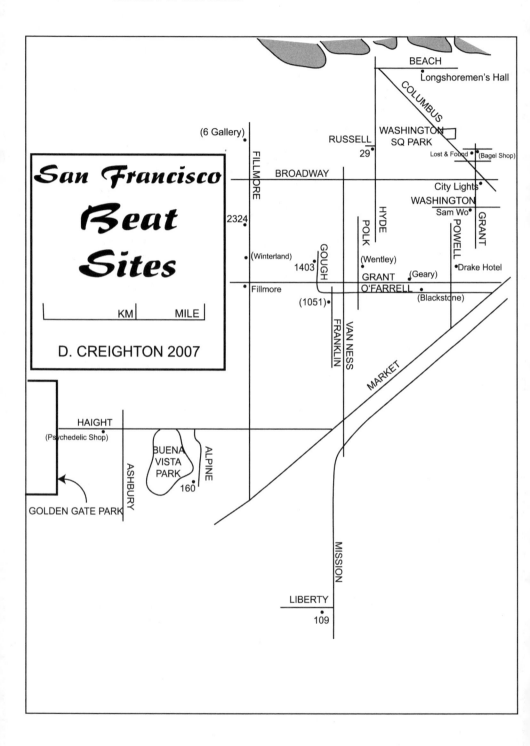

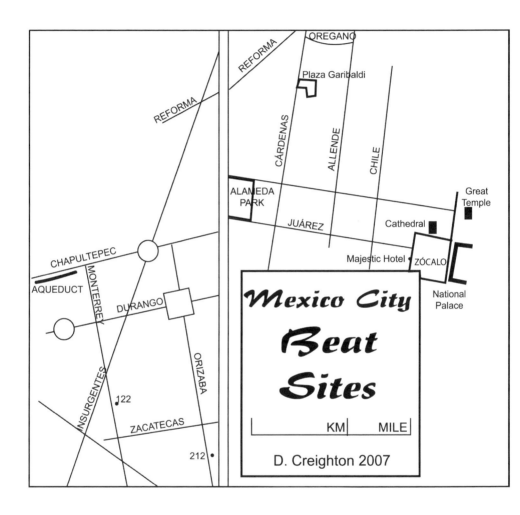

Mexico City Beat Sites

D. Creighton 2007

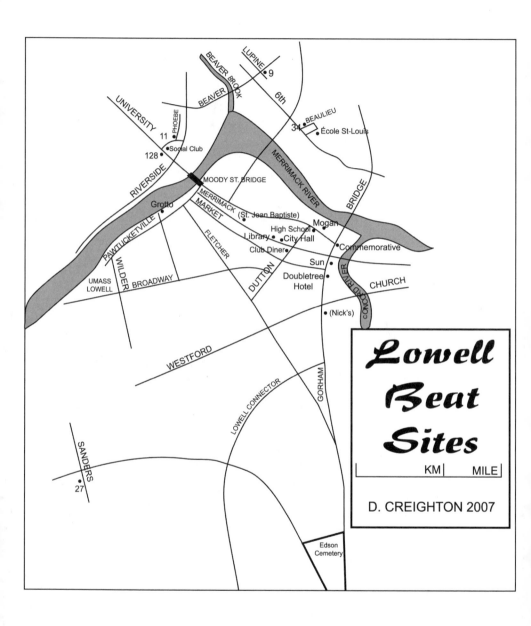

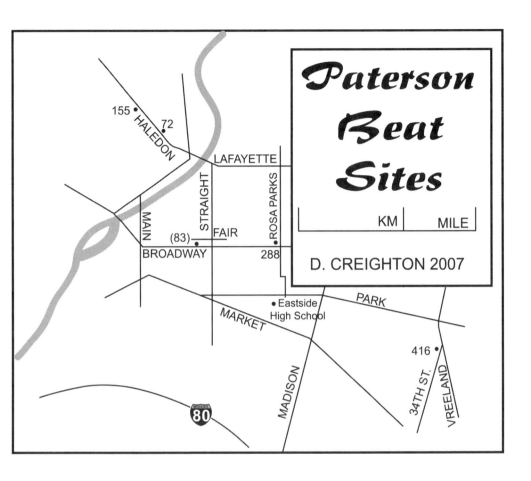

Suggested Reading and Viewing

═══

Amburn, Ellis. *Subterranean Kerouac: The Hidden Life of Jack Kerouac*. New York: St. Martin's Press, 1998.

Amram, David. *Offbeat: Collaborating with Kerouac*. New York: Thunder's Mouth Press, 2001.

Anctil, Pierre, ed. *Un Homme Grand: Jack Kerouac at the Crossroads of Many Cultures*. Ottawa: Carlton University Press, 1990.

Antonelli, John. *Kerouac*. Beverley Hills, CA: Active Home Video, 1985.

Archambault, Gilles. *Le Voyageur Distrait*. Montreal: Stanke, 1981.

Austin, James. *The Beat Generation* (cassette). Santa Monica, CA: Rhino Records, 1992.

Beaulieu, Victor-Lévy. *Jack Kerouac: A Chicken-Essay*. Translated by Sheila Fischman. Toronto: Coach House Press, 1975.

Berrigan, Ted. "Interview with Jack Kerouac." *The Paris Review* No. 43 (Summer 1968).

Bremser, Bonnie. *Troia: Mexican Memoirs.* New York: Croton Press, 1969.

Brinkley, Douglas, ed. *Windblown World: The Journals of Jack Kerouac 1947–1954.* New York: Viking Penguin, 2004.

Brooks, David. *Bobos in Paradise: The New Upper Class and How They Got There.* New York: Simon & Schuster, 2000.

Burroughs, William. *The Cat Inside.* New York: Viking, 1992.

_____. *Naked Lunch.* New York: Grove Press, 1959.

_____. *Nova Express.* New York: Grove Press, 1964.

_____. *The Western Lands.* New York: Viking Penguin, 1988.

_____. *The Wild Boys: A Book of the Dead.* New York: Grove-Atlantic, 1992.

_____. *Word Virus.* James Grauerholz and Ira Silverberg, eds. New York: Grove Press, 1998.

Campbell, James. *This Is the Beat Generation: New York, San Francisco, Paris.* London: Secker & Warburg, 1999.

Cassady, Carolyn. *Heart Beat: My Life with Jack and Neal.* Berkeley, CA: Creative Arts Book Company, 1976.

_____. *Off the Road: My Years with Cassady, Kerouac and Ginsberg.* New York: William Morrow and Company, 1990.

Cassady, Neal. *Grace Beats Dharma: Letters from Prison 1958–1960.* New York: Crown Publishers, 1993.

_____. *The First Third*. San Francisco: City Lights Books, 1971.

Charters, Ann, ed. *Beat Down to Your Soul: What Was the Beat Generation?* New York: Penguin, 2001.

_____. *Jack Kerouac: Selected Letters 1940–1956*. New York: Viking Penguin, 1995.

_____. *Jack Kerouac: Selected Letters 1957–1969*. New York: Viking Penguin, 1999.

_____. *The Portable Beat Reader*. New York: Viking Penguin, 1992.

_____. *The Portable Jack Kerouac*. New York: Viking Penguin, 1995.

Chiasson, Herménégilde, director. *Jack Kerouac's Road*. Quebec: National Film Board of Canada video, circa 1980.

Christy, Jim. *The Long Slow Death of Jack Kerouac*. Toronto: ECW Press, 1998.

Clark, Tom. *Jack Kerouac*. New York: Paragon House, 1984.

Cook, Bruce. *The Beat Generation: The Tumultuous '50s Movement and Its Impact on Today*. New York: Charles Scribner's Sons, 1971.

Dickstein, Morris. *Gates of Eden: American Culture in the Sixties*. New York: Basic Books, 1977.

Edington, Stephen. *The Beat Face of God*. Victoria, BC: Trafford Publishing, 2005.

_____. *Kerouac's Nashua Connection*. Nashua, NH: Transition Publishing, 1999.

Foreman, Janet. *The Beat Generation: An American Dream*. Renaissance Motion Pictures, 1989.

Geiger, John. *Nothing Is True, Everything Is Permitted: The Life of Brion Gysin*. New York: The Disinformation Company, 2005.

George-Warren, Holly, ed. *The Rolling Stone Book of the Beats*. New York: Hyperion, 1999.

Gifford, Barry, and Lee, Lawrence, eds. *Jack's Book: An Oral Biography of Jack Kerouac*. New York: St. Martin's Press, 1978.

Ginsberg, Allen. *Allen Verbatim: Lectures on Poetry, Politics, Consciousness*. Edited by Gordon Ball. New York: McGraw-Hill, 1974.

_____. *Collected Poems: 1947–1980*. New York: Harper & Row, 1984.

_____. *Howl and Other Poems*. San Francisco: City Lights Books, 1956.

_____. *Kaddish and Other Poems: 1958–1960*. San Francisco: City Lights Books, 1961.

Gleason, Ralph J., ed. *Jam Session, an Anthology of Jazz*. London: The Jazz Book Club, 1961.

Grauerholz, James. *The Death of Joan Vollmer Burroughs: What Really Happened?* Accessed at *http://oldlawrence.com/burroughs/deathofjoan-full.pdf*.

Grauerholz, James, ed. *Last Words: The Final Journals of William S. Burroughs*. New York: Grove Press, 2000.

Holmes, John Clellon. *Go*. New York: Ace Books, 1952.

_____. *Gone in October: Last Reflections on Jack Kerouac*. Hailey, ID:

Limberlost Press, 1985.

_____. *Nothing More to Declare.* New York: E.P. Dutton, 1967.

_____. *Visitor: Jack Kerouac in Old Saybrook.* California, PA: Unspeakable Visions of the Individual, 1981.

Horovitz, Michael, ed. *Poetry of the "Underground" in Britain.* Harmondsworth, Eng.: Penguin, 1969.

Huncke, Herbert. *Guilty of Everything.* New York: Paragon House, 1990.

Hunt, Tim. *Kerouac's Crooked Road: Development of a Fiction.* Hamden, CT: Archon Books, 1981.

Jarvis, Charles E. *Visions of Kerouac.* Lowell, MA: Ithaca Press, 1974.

Johnson, Joyce. *Door Wide Open: A Beat Love Affair in Letters, 1957–1958.* New York: Viking Press, 2000.

_____. *Minor Characters: A Young Woman's Coming of Age in the Beat Orbit of Jack Kerouac.* Boston: Houghton Mifflin, 1983.

Jones, James T. *Jack Kerouac's Duluoz Legend: The Mythic Form of an Autobiographical Fiction.* Carbondale, IL: Southern Illinois University Press, 1999.

_____. *Use My Name: Jack Kerouac's Forgotten Families.* Toronto: ECW Press, 1999.

Kerouac, Jack. *Atop an Underwood: Early Stories and Other Writings.* Edited by Paul Marion. New York: Viking, 1999.

_____. *Big Sur.* New York: Penguin, 1992.

_____. *Desolation Angels.* New York: Coward-McCann, 1965.

_____. *The Dharma Bums.* New York: Viking, 1958.

_____. *Dr. Sax: Faust Part Three.* New York: Grove Press, 1959.

_____. *Lonesome Traveler.* New York: McGraw Hill, 1960.

_____. *On the Road.* New York: Viking, 1957.

_____. *Orpheus Emerged.* New York: Simon & Schuster, 2000.

_____. *Pull My Daisy.* Text ad-libbed by Jack Kerouac for the film by Robert Frank and Alfred Leslie. New York: Grove Press, 1961.

_____. *Satori in Paris.* New York: Grove Press, 1966.

_____. *Some of the Dharma.* New York: Viking, 1997.

_____. *The Subterraneans.* New York: Grove Press, 1958.

_____. *The Town and the City.* New York: Harcourt Brace and Co., 1950.

_____. *Vanity of Duluoz.* New York: Coward-McCann, 1968.

_____. *Visions of Cody.* New York: McGraw-Hill, 1973.

_____. *Visions of Gerard.* New York: Farrar, Straus and Cudahy, 1963.

Kerouac, Jan. *Baby Driver.* New York: St. Martin's Press, 1981.

Kerouac, Joan Haverty. *Nobody's Wife: The Smart Aleck and the King of the Beats.* Berkeley, CA: Creative Arts Book Company, 2000.

Kesey, Ken. *Demon Box.* New York: Viking Penguin, 1979.

_____. *Kesey's Garage Sale*. New York: Viking, 1973.

_____. *One Flew over the Cuckoo's Nest*. New York: Viking, 1964.

Knight, Arthur, and Kit Knight, eds. *The Beat Book*. California, PA: Unspeakable Visions of the Individual, 1974.

Knight, Brenda, ed. *Women of the Beat Generation*. Berkeley, CA: Conari Press, 1996.

Landesman, Jay. *Neurotica: The Authentic Voice of the Beat Generation*. London: Jay Landesman, Ltd., 1981.

_____. *Rebel Without Applause*. New York: Paragon House, 1990.

Lardas, John. *The Bop Apocalypse: The Religious Visions of Kerouac, Ginsberg, and Burroughs*. Carbondale, IL: University of Illinois Press, 2000.

Mahar, Paul. *Kerouac: The Definitive Biography*. Lanham, MD: Taylor Trade Publishing, 2004.

Mahar, Paul, ed. *Empty Phantoms: Interviews and Encounters with Jack Kerouac*. New York: Thunder's Mouth Press, 2005.

McDarragh, Fred W., and Gloria S. McDarragh. *Beat Generation: Glory Days in Greenwich Village*. New York: Schirmer Books, 1996. Includes "Anatomy of a Beatnik" (Fred W. McDarragh, Saga, 1960).

McNally, Dennis. *Desolate Angel: Jack Kerouac, the Beats and America*. New York: Random House, 1979.

Miles, Barry. *The Beat Hotel: Ginsberg, Burroughs, and Corso in Paris, 1958–1963*. New York: Grove Press, 2000.

_____. *William Burroughs: El Hombre Invisible: A Portrait*. New York: Hyperion, 1993.

_____. *Ginsberg: A Biography*. New York: Simon & Schuster, 1989.

Montgomery, John, ed. *The Kerouac We Knew*. Kentfield, CA: Fels & Firn Press, 1982.

Moore, Dave, ed. *Neal Cassady: Collected Letters, 1944–1967*. London: Viking Books, 2004.

Morgan, Ted. *The Beat Generation in New York*. San Francisco: City Lights Books, 1997.

_____. *The Beat Generation in San Francisco*. San Francisco: City Lights Books, 2003.

_____. *Literary Outlaw: The Life and Times of William S. Burroughs*. New York: Henry Holt, 1988.

Nicosia, Gerald. *Memory Babe: A Critical Biography of Jack Kerouac*. New York: Grove Press, 1983.

Plummer, William. *The Holy Goof: A Biography of Neal Cassady*. Englewood Cliffs, NJ: Prentice-Hall, 1981.

Plymell, Charles. *The Last of the Moccasins*. San Francisco: City Lights Books, 1971.

_____. *Some Mothers' Sons*. Cherry Valley, NY: Cherry Valley Editions, 2004.

Podhoretz, Norman. *Ex-Friends: Falling Out with Allen Ginsberg, Lionel and Diana Trilling, Lillian Hellman, Hannah Arendt, and Norman Mailer*. New York: The Free Press, 1999.

Roszak, Theodore. *The Making of a Counter Culture.* New York: Anchor, 1969.

Sanders, Ed. *Tales of Beatnik Glory.* New York: Stonehill Publishing, 1975.

Schumacher, Michael. *Dharma Lion: A Critical Biography of Allen Ginsberg.* New York: St. Martin's Press, 1992.

Snyder, Gary. *Myths and Texts.* New York: Totem Press/Corinth Books, 1960.

Stephenson, Gregory. *The Daybreak Boys: Essays on the Literature of the Beat Generation.* Carbondale, IL: Southern Illinois University Press, 1989.

Stone, Robert. *Dog Soldiers.* Boston: Houghton Mifflin, 1974.

Sullivan, Rosemary. *The Red Shoes: Margaret Atwood Starting Out.* Toronto: HarperCollins Flamingo, 1998.

Tytell, John. *Naked Angels: The Lives and Literature of the Beat Generation.* New York: McGraw-Hill, 1977.

Updike, John. *Rabbit Angstrom: A Tetralogy.* New York: Everyman's Library, 1995.

Waldman, Anne, ed. *The Beat Book: Writings from the Beat Generation.* Boston: Shambhala Publications, 1996.

Watson, Steven. *The Birth of the Beat Generation: Visionaries, Rebels, and Hipsters, 1944–1950.* New York: Pantheon, 1995.

Wolfe, Tom. *The Electric Kool-Aid Acid Test.* New York: Farrar, Straus and Giroux, 1968.

Index